The Female Crucifix:

Images of St. Wilgefortis since the Middle Ages

Ilse E. Friesen

Wilfrid Laurier University Press

This book has been published with the help of a grant from the Humanities and Social Sciences Federation of Canada, using funds provided by the Social Sciences and Humanities Research Council of Canada. We acknowledge the financial support of the Government of Canada through the Book Publishing Industry Development Program for our publishing activities.

National Library of Canada Cataloguing in Publication Data

Friesen, Ilse E., 1940–
 The female crucifix: images of St. Wilgefortis since the Middle Ages

Includes bibliographical references and index.
ISBN 0-88920-365-2

1. Wilgefortis (Legendary Saint) — Art. 2. Wilgefortis (Legendary Saint) — Cult. I. Title.

N8080.W55F75 2001 704.9′4863 C2001-930464-1

© 2001 Wilfrid Laurier University Press
Waterloo, Ontario, Canada N2L 3C5

Cover design by Leslie Macredie, using an image of
St. Kummernus from the Chapel of Sts. Michael and Kummernus,
Church of Axams, Austria. Courtesy of the Parish of Axams.

Photographs in text by Werner Schwarz, Bernhardt Seifert and Ilse Friesen.

Printed in Canada

Dedicated to my Austrian friends
Erika and Werner

Table of Contents

List of Illustrations

Figures

Plates

Acknowledgements

This book has emerged over the course of the past five years as the result of a series of conference presentations and field trips. The ensuing discussions, in countries as diverse as Canada, the United States and Austria, helped me to clarify the issues involved in interpreting some arguably strange, or even bizarre, visual imagery. I am grateful to all of the individuals who contributed to these lively exchanges, either in verbal or written form, on both sides of the Atlantic. I would particularly like to mention Prof. Elizabeth Nightlinger, Prof. Grady A. Smith, Prof. Christine E. Meek and Dr. Martin Kraatz in this regard.

This book could not have been written without several field trips to Germany, Austria and Italy over the course of several summers. In this connection, the dedication and hospitality of my friends Dr. Werner Schwarz and his wife Erika Schwarz of Stams, in the Austrian province of Tyrol, was particularly vital; I doubt that I will ever again find such committed assistants for any future projects I may undertake. I am also deeply indebted to the generous curator of the museum at the abbey of Stift Stams, Father Norbert Schnellhammer, who housed and organized a highly successful exhibition entitled "Woman on the

Cross" in the summer of 1998. For this occasion, we were able to bring together twenty original works of art from across Tyrol. My brother Günther Strnadt, of Vienna, and my aunt Ingrid Sprink, of Salzburg, also supported these projects with much patience and encouraging enthusiasm.

I also want to thank Wilfrid Laurier University for consistent support of my research, for providing seed money in 1995 at the beginning of this project and for enabling the manifold growth opportunities associated with my teaching position there. I am grateful to a number of my colleagues, particularly Dr. Terry Scully and his wife Eleanor Scully, as well as Dr. James Weldon and his wife Emmy Misser, for providing a forum in which to share my findings among kindred spirits. My inquisitive students have also inspired me to undertake new ventures into previously uncharted territory.

I am additionally grateful to all those public institutions and private collectors that have permitted me to reproduce the works of art that are featured in this book. There are many other people who facilitated the viewing and researching of relevant images; I am especially indebted to Ulla Kendlinger from the Stadtarchiv Burghausen and to the Mayr family of Bozen.

Sandra Woolfrey, the former director of Wilfrid Laurier University Press, originally encouraged me to submit my manuscript. My special thanks also go to my son George, the initial editor and indexer, and to Carroll Klein, the managing editor at Wilfrid Laurier University Press. Together with its director, Dr. Brian Henderson, and the other members of the staff, they provided a nurturing environment in which this book could ultimately come to fruition.

Introduction

This book is about a legendary and largely forgotten female saint whose images have recently been rediscovered and whose significance can now be interpreted in a new light. Since the Middle Ages, this crucified saint has been known by various names, including Wilgefortis (possibly derived from *virgo fortis*, or alternatively *hilge vratz*, or holy face), as well as Uncumber, Ontcommer, Kümmernis and Liberata. All of these names suggest the ability of this "strong virgin" to liberate those in bondage and grief ("Kummer"). The popular cult of this mysterious saint at one point nearly rivalled that of the Virgin Mary, but ever since the Reformation, and particularly since the Enlightenment, her veneration has been criticized and discouraged by the Catholic Church. In parts of Central Europe, her votive paintings were deliberately destroyed, wall paintings which portrayed her were whitewashed and statues and oil paintings came to be confined to church attics or storage rooms, or were simply left to deteriorate in monastery vaults.

Images of this bearded female saint, who was typically depicted being crucified upon a cross, were frequently dismissed by the official Church as a grotesque and bizarre aberration of the veneration of the crucified Christ. Scholars in various

fields have historically assumed that these strange images origi-
nated from a misinterpretation of portrayals of the robed Christ
on the cross, especially in connection with a sculpture called the
Volto Santo in Lucca, Italy, which is perhaps the most famous
example of the Byzantine or Eastern type of the robed crucifix.
This early medieval statue of the "holy face" was once the focus
of mass pilgrimages along roads leading from Central and
Northern Europe to Italy. Copies of this miracle-working robed
crucifix were also produced in order to provide a substitute for
pilgrimages to Lucca; consequently, various communities also
had their own cult sites dedicated to the "holy face."

These local images were typically executed in the form of
wall paintings, sculptures, stained glass windows, oil paintings,
prints or book illuminations. Portrayals of this miracle-working
robed crucifix were eventually to be found across most of
Europe, ranging from Spain in the west to Slovenia in the east.
Some of these images were closely modelled on the Lucca stat-
ue, and consequently portrayed an unmistakeably male figure.
Others, however, combined the traditional bearded face with
a female body that featured well-rounded breasts, a delicate
waistline and female clothing adorned with precious jewellery.

In this study, it will be argued that the representations and
stories which were connected with these sometimes disturbing-
ly androgynous crucifixes resulted from a much more complex
and diverse set of reasons than a mere misunderstanding of a
particular image of the crucified Christ. It will be shown that
many of these later images were deliberately created in order to
portray a female saint, with or without the intention of main-
taining any visual connection with the *Volto Santo.* Additionally,
a number of male crucifixes were robed in unmistakeably female
clothing and jewellery in order to transcend strict gender bound-
aries. Over the course of several centuries, additional images,
names and legends became prevalent, all of them centring on a
crucified female saint who was held to have become Christlike,
both in terms of her physical appearance and with regard to her
martyrdom on the cross.

These visual as well as verbal depictions were created with
great sincerity, and are far from being frivolous. Indeed, they can
be said to have filled an emotional and spiritual need which the
official patriarchal Church was failing to provide at the time,
especially for women. There is evidence to suggest, however,
that both men and women were inclined to respond positively to

images that embodied or otherwise represented both sexes. This, in turn, could sometimes facilitate an intense personal identification with Christ, whose suffering was seen as having transcended gender distinctions.

Although this book deals primarily with the phenomenon of androgynous statues of crucifixes in remote alpine regions such as Tyrol, the creation of such sexually ambiguous images was by no means just a quaint medieval folk custom. Rather, the merging of genders in sacred images has its origins in various pre-Christian myths and ancient religions, in which androgynous divinities combined both male and female qualities. This integration of assorted gender characteristics provided ancient images with an aura of supernatural completeness and of awe-inspiring ultimate relevance which strictly gender-specific images were unable to fully provide.

Rather than regarding images of bearded female individuals as being derived only from obscure legends and fairy tales, however, it should be noted that in contemporary science hirsutism — defined as abnormal hair growth — is an established and legitimate topic of medical research. For at least a century, female hirsutism has been a documented physical and/or psychological phenomenon. It has been found to occur in situations of hormonal imbalance, occasionally in cases of acute ovarian cancer and also in individual cases of extreme personal trauma or sudden emotional stress.

An examination of a variety of historical images of St. Wilgefortis, which were created over the course of eight centuries, will also demonstrate that some of these works of art were deliberately intended to be ambiguous; whether one is inclined to interpret them as representing Christ or the female martyr is something for the individual viewer to decide. This, in turn, raises questions which relate to some of the most contentious and controversial gender issues of the late twentieth century. The history of this saint has triggered debates over contemporary gender roles and sexual identity, including, for example, the question of whether female hirsutism is in fact a purely medical condition or whether it can be brought about intentionally, as has been claimed in the case of the female saint who is the focus of this book. Thus, for instance, St. Uncumber — one of the many names by which the saint has been known over the centuries — is included in a list of specifically "transvestite saints" as part of an internet-based *Calendar of Lesbian, Gay, Bisexual, and*

Transgender Saints which is discussed at greater length elsewhere in this book.

From a feminist perspective, it is interesting to note that over the course of previous centuries, this bearded and crucified female saint has been called upon particularly by victims of enforced marriages and various forms of sexual abuse, including rape and incest. In this primary role, St. Wilgefortis has historically served as a cultural reference for personal accounts of physical and emotional abuse which would otherwise have been glossed over, or indeed, suppressed entirely. Thus, these images relate to an unwritten history of violence, especially against women. Insofar as women invoked the bearded saint with regard to various female health concerns, including cancer of the uterus, anxieties about infertility and complications of pregnancy and delivery, portrayals of the saint were also the focus of medical and emotional concerns, as well as prayers. Portrayed with torn ropes, she was also a comforter and intercessor for people in bondage, especially those in prison, as well as for conscripted soldiers. Finally, her presence was invoked by people who were dying, insofar as she was believed to have wrested life out of death through her own Christlike agony. In this connection, it was believed that she personified the promise of eventual resurrection for the faithful. Some of her portrayals, in fact, were originally created for charnel houses and burial chapels that were situated next to graveyards; some of these locations are still preserved today.

In order to assess the images of this particular saint in their original context, it has been necessary to develop a methodology that combines various fields of research. The investigations conducted for this book have been deliberately interdisciplinary and cross-cultural, although the ultimate basis of this study is art historical in nature. Most of the visual images which will be analyzed here belong to the largely neglected field of Central European religious folk art. In order to appreciate and understand such images as thoroughly as possible, however, certain theological issues do need to be addressed here. These include, in particular, the history of popular Catholic devotion—especially with regard to the post-biblical understandings of martyrdom and of the female body. Various hagiographical works have also served as important sources for stories about, and histories of, various saints. Additionally, various works of folklore, devotional literature and religious fiction have also yielded valuable

insights. The story of the bearded crucified female saint has also been recorded in works of literature ranging from a sarcastic discussion offered by Thomas More in the early sixteenth century to the brief yet pivotal inclusion of the saint in Robertson Davies' novel *Fifth Business* (1970). Most recently, feminist author Michèle Roberts has dealt at some length with the saint in a controversial work of fiction entitled *Impossible Saints* (1997).

In researching the great variety of Central European images of this saint in Central Europe, I was fortunate to have access to the resources of various libraries in Vienna, Salzburg, Innsbruck and Munich. Of even greater importance were several field trips to artistically and historically significant sites which I was able to conduct during the summers of 1996, 1997 and 1998. These excursions focused, in particular, on the alpine regions of both the Austrian and the Italian portions of Tyrol (Nordtirol and Alto Adige, respectively). These sometimes adventurous tours would not have been possible without two devoted friends from my student days in Innsbruck, the biologist Dr. Werner Schwarz, an expert photographer and daring driver, and his wife Erika Schwarz, a tireless organizer and impeccable navigator.

In the course of searching for traces of this obscure saint, the three of us primarily approached older inhabitants of the remote villages which we drove through during the course of our travels. On several occasions, retired schoolteachers or aged sacristans and organists proved to be particularly helpful. Additionally, a number of parish priests, both young and old, showed keen interest and were immediately willing to help us in unearthing rare or long forgotten paintings and sculptures; some of these works had been hidden away for decades, or even centuries, in private buildings, chapel attics or charnel-houses. Other clerics, however, were not hesitant to express stern disapproval or keen impatience with what they regarded as the frivolous pursuit of an unorthodox and obsolete cult figure.

Such criticisms would appear to be justified, at least on the surface, by the directives of the *Sacrosanctum Concilium* of Vatican II (1963), in which one can find the statement that "incongruous" practices may "foster devotion of doubtful orthodoxy." Zealous efforts, both before and following these new directives, resulted in numerous churches being stripped of any traces of the former veneration of the crucified female saint—often to the pride of certain clerics, but to the regret of numerous parishioners and visitors.

Some of the sites that were visited as part of the research-gathering process for this book were far removed from human habitation and, being located in dense forests or on high cliffs, were accessible only via stony and steep paths, a number of which were hard to find and harder yet to climb. Some of these excursions proved to be richly rewarding, resulting in access to rarely seen treasures that included medieval frescoes and Baroque sculptures. Other trips were less successful and ended in front of locked doors or covered windows that prevented even the faintest glimpse into the interior. The most abrupt conclusion to one of our excursions took place amidst an abandoned pile of large stones which appeared to be the only remaining trace of a former Kümmernis chapel.

One of our most delightful discoveries involved a historic site in South Tyrol that had become private property. This little sanctuary had not only been difficult to find, but was initially impossible to reach, as it was hidden behind a high stone wall and protected by a gate with a built-in alarm system which in turn was guarded by a German shepherd dog. Once trust had been established with both the owner and the animal, we were able to examine items that far exceeded our expectations: in addition to photographing and cataloguing both a statue and a painting of the saint, we were given access to the contents of a private archive that consisted of hundreds of handwritten pages outlining almost all of the legends and former locations of depictions of the mysterious saint.

In spite of our success in locating these and other long-forgotten images and records of the bearded female saint, this research cannot claim to be entirely original. Already in 1934, two German scholars, Gustav Schnürer and Joseph Ritz, conducted an investigation into the saint's life and times, which was published under the title *Sankt Kümmernis und Volto Santo*. This book was written primarily from the perspective of folkloristic Germanic studies and was illustrated with more than a hundred images. It also included various depictions originating from non-German speaking countries. Until recently, this book had constituted the most comprehensive treatment of the crucified female saint, albeit from a culturally limited and very one-sided perspective. In spite of their diligence, the authors neglected to undertake any comprehensive art historical investigations, with the result that a number of the images in their book are incorrectly identified. Additionally, various chronological and factual

data are either incomplete or otherwise misleading. More than half a century later, much of their work remains to be modified or updated.

In a 1997 lecture at Wilfrid Laurier University in Waterloo, Ontario, the contemporary feminist theologian Mary T. Malone expressed the opinion that women, over the course of five thousand years of patriarchy, had only had four options of "disobedience" towards the predominant culture available to them. These consisted of adopting the roles of either martyr, virgin, mystic or heretic. It is my contention that St. Wilgefortis can be said to have embodied not just one, but in fact all four, of these counter-cultural roles. Although she was noted primarily as a virgin and martyr, the third of Malone's categories, that of mystic, is also relevant here because of the saint's mystical identification, both in the popular mind and allegedly from her own perspective, with the crucified Christ. The fourth role, that of heretic, is also relevant here, albeit only indirectly and posthumously; not only her images, but also her cult, were frequently condemned as unorthodox and offensive. Increasingly, this condemnation was accompanied by the destruction of votive paintings and other images that depicted her likeness.

As a result of the growing suppression of her cult in recent centuries, St. Wilgefortis has been largely forgotten, and many of her shrines were either destroyed or left to deteriorate. In the context of a contemporary culture that has been challenged and changed by feminism and postmodernism, however, the intriguing visual depictions of the bearded female saint, which both display and downplay gender differences, can be said to speak to us in new ways. At a time when there is far less certainty regarding spiritual orthodoxy and sexual normality than ever before, they challenge us to ask new questions. In the face of ever-growing doubts about the validity of absolute values, we are increasingly open to the possibility of viewing controversial or unusual historical artifacts from new perspectives.

It is in the spirit of such greater openness and flexibility that this book has been written — particularly with the hope that through the use of visual imagery it may be possible to bring about a greater understanding of the link between a broad-based and inclusive view of human corporeality, on the one hand, and the acceptance of alternative expressions of spirituality, on the other.

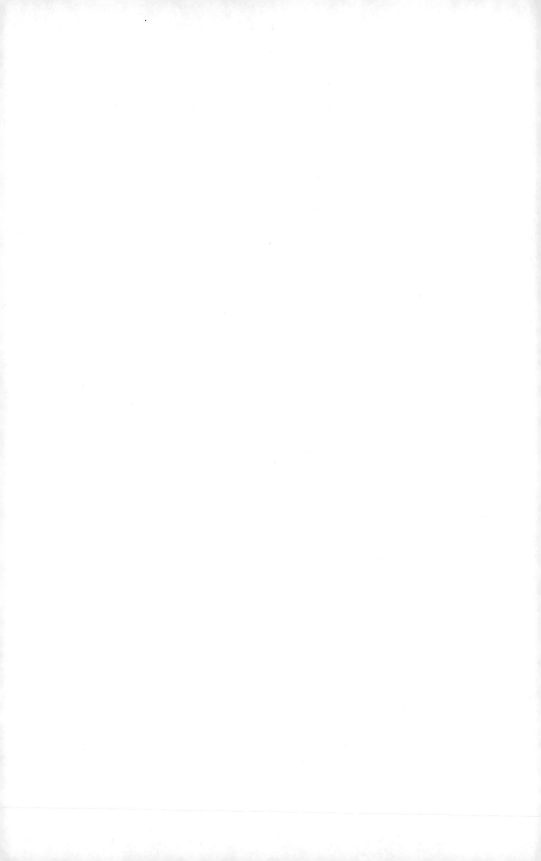

Chapter 1

The Crucifixion as the Resurrection: The *Volto Santo* and the Triumphal Crucifix

I n this chapter, the historical and theological significance of Christ's crucifixion will be examined. This overview provides a context in which depictions of the crucified saint Wilgefortis may subsequently be interpreted and understood.

The idea that life arises out of death, or that sacrificial death can bring about renewal, can be found in ancient myths involving the rebirth of nature as well as in narratives about heroic individuals. As stated in a recent symbolism-based interpretation of the Bible, "the ascension of the victorious hero—half-man, half-god—is a theme common to the mythologies of all peoples."[1]

In Christian thought, the belief that the crucifixion of Jesus on Good Friday contained within it the promise of the resurrection on Easter Sunday remains one of the most fundamental messages of the New Testament. From such a perspective, the cross was regarded less as a degrading instrument of torture and execution than as the supreme symbol of victory over death.

In the Gospel according to John, the nailing of Christ to the cross constitutes nothing less than a "majestic elevation to glory."[2] In the Pauline Epistles, similar insights can be found (Romans 6:9, I Corinthians 15:55 and 57). Out of reverence for

Notes to chapter 1 are on pp. 139–140.

the sacred nature of Christ's Crucifixion, Constantine the Great, the first of the Roman emperors to convert to Christianity, abolished crucifixion as as a method of execution. Constantine's mother, the Empress Helena, who was credited with having found Christ's "true" cross in Jerusalem in 327, was in turn a major influence on the subsequent cult of the cross. At the beginning of the fifth century, Emperor Theodosius II commissioned a cross inlaid with precious gems, brought it to Jerusalem and placed it on Golgatha. This devotionary artifact is an example of what is known as *crux gemmata* – in other words, a bejewelled cross.[3]

Already in the early Christian art of the fourth century one can point to the existence of numerous reliefs on Roman sarcophagi portraying the cross crowned with a victory wreath, while birds, serving as symbols of eternal life, were shown standing on the crossbar. This iconography is borrowed from the established "formulas for [marches of] Triumph" of the Roman Empire. In this way, "the iconography of Triumph shows the way to the iconography of the Resurrection."[4]

An example of this tradition of the glorified cross can be found in the mosaic created during the sixth century, specifically between 533 and 549, in the apse of the church Sant' Apollinare in Classe, located in Ravenna. In this mosaic, a huge golden bejewelled cross appears in the heavens, offering a glorious vision of paradise. Christ, alive and victorious, is depicted on a medallion at the centre of this cosmic cross.

According to the original biblical accounts, Christ was crucified on a wooden cross. During the Middle Ages, this less than glamorous material came to lend itself to numerous symbolic and pious interpretations of the death of Christ. These descriptions, both visual and written, reflected a belief that the Crucifixion and redemption had both occurred at the site of Adam and Eve's original transgression, a site characterized by the presence of the tree of life. This location was believed to be the symbolic axis of the world, situated, as it was, directly above the reputed grave of Adam. This detail is contained in several Crucifixion scenes dating from this period.[5]

The inscription on a bronze crucifix dating from about 1080 and displayed in the cathedral of Minden in Westphalia explains that, on the wood of the cross, Christ redeemed Adam's original sin, which had been brought about by eating the fruit of the tree: "Hoc reparat xps [*sic*] deus in ligno crucifixus qd [*sic*] destrucit

Adam deceptus arbore quadam."[6] Another Latin inscription on a South Tyrolean Crucifixion scene dating from the twelfth century states that Christ had accepted his death in order that mortality would be conquered. As described in the poetic words of this inscription, Adam falls asleep on the cross so that Eve may be formed from his rib, whereas Christ has died on a cross in order to redeem them both.[7]

The twelfth-century theologian John of Cornwall drew a link between the Crucifixion and the Resurrection through the mystical imagery of four dimensions of the cross, namely breadth, length, height and depth. He saw in the breadth of the cross the compassion expressed through the suffering of Christ. In the length of the cross he saw the manifestation of the Resurrection, whereas in the height and depth of the cross he saw the glory of the Ascension and the revelation of God's wisdom.[8]

This idea of a mystical cosmic cross originated in a letter cited in Ephesians 3:17-19, wherein the author states that "you, being rooted and grounded in love, may have power to comprehend with all the saints what is the breadth and length and height and depth, and to know the love of Christ which surpasses knowledge, that you may be filled with all the fullness of God."

Consequently, beginning in biblical times and continuing through the centuries that followed, the connection between the Crucifixion and the Resurrection became a well-established part of Christian tradition, with the result that Christ was portrayed not as a mortal, but instead as eternal and divine.[9] This interpretation, which associated sacrificial and redemptive suffering with the glory of the Resurrection, was subsequently expressed in images of the crucified Christ which came to be called *Christus triumphans*, or triumphant Christ. Between the tenth and the twelfth centuries, monumental wood carvings of the triumphant crucifix were created across Europe, particularly in Spain, France, Belgium, Germany, Switzerland, Italy and Austria.

In these works, the imagery of suffering has been largely replaced by that of acceptance and victory. In this context, Christ is typically portrayed as standing in front of the cross, rather than hanging on it; his arms are horizontally and voluntarily stretched out. His eyes are frequently open rather than closed, symbolic of his eternal vigilance and his victory over death. In some examples, his head is covered by a bejewelled crown instead of a crown of thorns, thereby affirming his divinity and

majesty. As a result, the crucified Christ in these works has become an *imperator triumphans,* or *Christus Dominator,* a triumphant and commanding ruler, who is merely resting on the cross after the heroic and cosmic battle has already been won.[10]

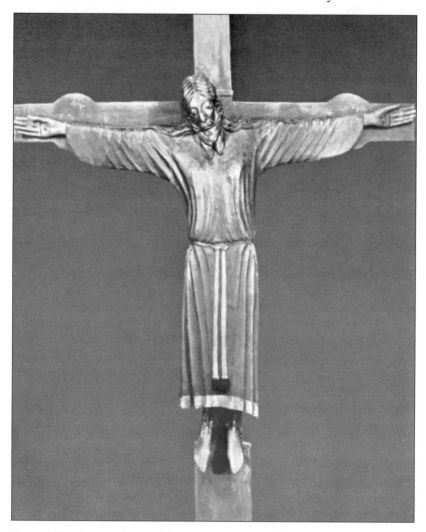

Figure 1. *Volto Santo,* sculpture, 12th or 13th century. Cathedral of Lucca, Italy. Pattis and Syndicus, *Christus Dominator: Vorgotische Grosskreuze* (Innsbruck: Tyrolia-Verlag, 1964)

About one in every ten of these monumental wood carvings portrays Christ dressed in a long robe, rather than being covered by the more frequently depicted loincloth. This type of fully robed, crucified Christ reflects an eastern or Syrian-Palestinian tradition which tended to portray Christ in the role of a divinely

ordained High Priest. This theme originated in the New Testament letter to the Hebrews (especially in chapters 5:10 and 6:20), in which Christ was envisioned as a High Priest. One of the earliest examples of a robed Christ on the cross can be found in book illuminations in the manuscript of the so-called Rabbula Codex of 586, which is preserved in the Bibliotheca Laurentiana in Florence.[11]

The most famous wood carving of a robed, crucified Christ has become known as the *Volto Santo* or *holy face*, and is preserved in the Cathedral of Lucca. This statue, originally called *La Santa Croce,* or *The Holy Cross,* became the main symbol of the city of Lucca. It was one of the most famous devotionary images of its time, as well as a focus of pilgrimages during the Middle Ages.[12] This crucifix was mentioned by Dante in his *Divine Comedy,* in a scene during which various devils, at one point, mock the awkward position of a victim as resembling that of the *Volto Santo* (*Inferno XXI, 48*). Although the first mention of the *Volto Santo* had occurred as early as 1107, the original statue was probably replaced, most likely during the thirteenth century, by a copy originating in a workshop linked to the sculptor Benedetto Antelami.[13]

Figure 1
Volto Santo,
12th–13th C.
Lucca, Italy

In 1123 the city of Lucca recorded its first financial gains from pilgrimages to this revered sculpture. The carving's claim to miraculous efficacy was based on the supposed presence of actual relics in the opening of the back of the head of the crucified figure. In a document dating from 1098, these relics were said to consist of a part of Christ's crown of thorns, a nail from the cross, a small ampulla of Christ's blood and some hair.[14] According to an early medieval legend, the statue had mysteriously arrived in Italy in 742 from Palestine. The legend further stated that the statue had been carved by Nicodemus, with the help of angels, following his witnessing of Christ's crucifixion, using an impression of Christ's body upon the burial shroud.[15]

This statue, carved from cedarwood, depicts the crucified Christ as being alive. In order to emphasize this as fully as possible, the eyes have been inset with glass, the head is gently inclined, and the arms are horizontally outstretched. Only small nails are visible on the palms of the hands and on the feet. The toes are pointed downward, so that a hovering or levitating, rather than a standing, pose is suggested. In spite of this, the feet are supported by a ledge, or *suppedaneum,* beneath the soles.

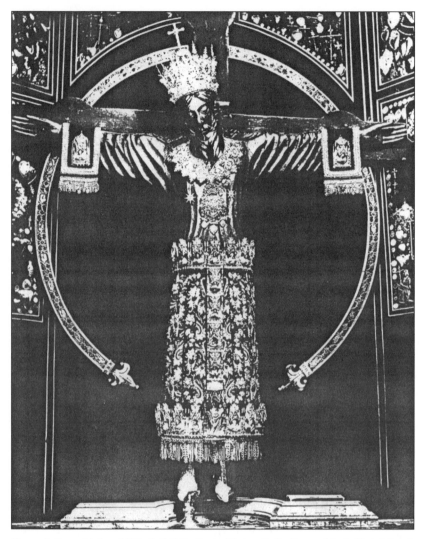

Figure 2. Barrachini and Filieri, *Il Volto Santo: Storia e Culto* (Lucca: Maria Pacini Fazzi, 1982).

The robe, a *tunica manicata*, was originally painted purple, indicative of a royal garment. It is girded with a delicate *cingulum*, or belt, which features two equally long ends.[16] Both the robe and the belt suggest the priestly costume that Christ will supposedly wear during the Second Coming, as described in the Book of Revelation, "clothed with a long robe and with a golden girdle" (Rev. 1:13). The fact that Christ is in this work depicted as standing upright, as well as fully robed, can also be viewed as a symbol of moral integrity and strength, an idea which is expressed in

Ephesians 6:14 with the words "having girded your loins with truth." The two long endings of the golden belt, on the other hand, have been interpreted as representing the two biblical testaments which are said to have been joined together in Christ.[17]

By means of such symbols, as well as by the symmetry that exists between the body and the curving folds of the robe, dignity and solemnity are convincingly conveyed. Additionally, Christ's face reflects qualities that include surrender, fulfilment and majesty. Thus, the statue can ultimately be said to portray the transfigured Christ of the Second Coming in the sense that the crucifixion has been supplanted by these images of victory over death.[18]

Although many copies of the *Volto Santo* were created over several centuries, the symbolism of the robe as signifying sacred kingship and royal priesthood was not always fully understood or appreciated. In particular, the fact that the statue was displayed only on a few feast days every year, and on those occasions was clothed with precious dresses, ornaments, a crown and shoes,[19] contributed to the growing misunderstanding that the statue was, in fact, that of a woman rather than of Christ. Specifically, this misunderstanding was linked to the growth of a fourteenth-century legend concerning a crucified princess who had miraculously grown a beard in order to preserve her chastity and to more closely resemble Christ in her suffering on the cross.[20]

Figure 2
Volto Santo,
clothed
Lucca, Italy

An example of the growing tendency to regard the *Volto Santo* as simultaneously representing both Christ and a female saint can be found in a woodcut by Hans Burgkmair dating from around 1507. On the basis of this work, as well as numerous others, a popular cult dedicated to St. Wilgefortis, also known as Liberata, Ontcommer or Kümmernis, gradually spread across Europe during the later Middle Ages. In parts of Tyrol and Bavaria, the cult continued to flourish even into the Baroque era.[21]

Another work which was inspired by the tradition of the fully robed crucifix is a three-quarter life-size wood carving of a robed crucifix located in the parish church of Neufahrn near Munich in Bavaria. This eleventh- or twelfth-century crucifix is identified in the form of a Baroque inscription on the high altar as "S. Wilgefortis Sive Liberata, V.M. 1661. H. Jungfrau und Martyrerin Ohne Khummernuss Bitt fuer Uns." [Translated in part as: St. Wilgefortis, also called Liberata, holy virgin and martyr without grief, pray for us.][22]

This Romanesque crucifix was damaged in a fire in 1580. A subsequent restoration provided the opportunity to add large carved locks of hair to the head, which contributed to a more specifically female appearance. According to a local legend, which was illustrated in a series of large wood panels in 1527 by an unknown Bavarian artist, this miraculous crucifix had been found floating upstream on the river Isar by a couple of woodsmen. According to the legend, it had then been inspected by the bishop of Freising, and was thereupon ceremonially installed in the church of Neufahrn, where it became the focus of substantial pilgrimage activities that continued well into the nineteenth century. In all of these examples, the general form of the *Volto Santo* was preserved not only in terms of the long gown and belt, but also with regard to the crucified figure's open eyes and the lack of any apparent elements of suffering.[23]

Not all of the carvings of Romanesque triumphal crucifixes featured figures that were fully robed; however, all of them bear expressions of solemn dignity and regal majesty. One example, originating in central Italy around 1150, is the *Crucifix of Matelica*.[24] In this sculpture, Christ's head is upright and stern; his bare arms seem to be particularly elongated while being extended in an all-embracing gesture. His feet, in turn, rest firmly on a *suppedaneum*.

The *Crucifix of San Pietro* in Bologna, probably carved in a workshop in South Tyrol between 1160 and 1180, is part of a group of three figures (the other two consisting of the Virgin Mary and St. John) who are depicted standing under the cross.[25] In this carving, Christ wears a golden crown of victory. In spite of the partially nude state of his body, the power and solemnity originally found in the *Volto Santo* have been preserved here as well. This is particularly noticeable in the symmetry of the position of the figure, as well as in the regal and calm features of the face.

The life-size Bavarian *Crucifix of Forstenried*, probably carved by the Benedictine monk Alban of Seeon sometime between 1180 and 1200, is exceptionally well-preserved, including its original polychrome surface. A fragment from what was said to have been Christ's original crown of thorns was inserted into an opening in the sculpture's crown at one point. As a result, the crucifix became a famous pilgrimage site during the Middle Ages. This work of art is also significant in that it is the earliest example of a crucifix in which the feet are crossed over each other, so that only a single nail is needed to fasten them to the wood of the cross.[26]

A further example from Spain serves to demonstrate that the triumphal cross was a significant and recurring theme throughout Europe during the twelfth century. This crucifix is now housed in the National Museum of Catalonian Art in Barcelona. In both its form and details, this work fully reflects the tradition of the fully robed crucifix, of which the previously mentioned *Volto Santo* is the most prominent example.[27]

By the beginning of the Gothic era, however, Christ was increasingly being depicted as suffering, bleeding and dying on the cross, which rendered him more human and, therefore, less divine. Insofar as these subsequent emotional and intimate portrayals were meant to evoke intense compassion in the viewer, the liberating and triumphant message of the earlier Romanesque images was gradually downplayed, and indeed largely superseded. The triumphal nature of the earlier crucifixes, which had reflected the conviction that the crucifixion necessarily implied Christ's resurrection, increasingly gave way to a more pessimistic vision of the experience of mortality — a perception evermore reinforced by the growing prevalence of plagues and other great calamities during the centuries that comprised the later Middle Ages.

Chapter 2

Becoming Like Christ: Gender Integration, Imitation and Identification

Having previously examined visual depictions of Christ's crucifixion, particularly those that emphasized the seemingly feminine characteristics or dimensions of such imagery, this chapter explores the manner in which Christ's crucifixion was presented in medieval legends and literature as a basis for transcending the gender distinctions of that era. As with the previous chapter, the intention here is to illuminate the cultural context that gave rise to subsequent depictions and the eventual veneration of St. Wilgefortis. In this connection, reference is also made to early works of art that may be said to have anticipated images of the crucified female saint.

The vision of a new world order, based not only on the overcoming of class divisions but also on transcending the limitations of gender, is an essential part of biblical writings. It is expressed most emphatically in Galatians 3:28: "There is neither Jew nor Greek, there is neither slave nor free [sic], there is neither male nor female; for you are all one in Christ Jesus." It was believed that in the sacrament of baptism all barriers of race, class and sex could be abolished and overcome.[1]

Over the centuries, Catholic scholars and other authoritative religious commentators tended to interpret this biblical imperative within the confines of their patriarchal, and in many ways misogynist, societies. They believed that women could become like men by renouncing their physicality and sexuality, in the sense that a heroic effort at self-denial, resulting either in a life of asceticism or the submission to martyrdom, would make them equal to virtuous men. By clinging to the ideal of virginity, a woman could become a "*femina virilis* or virago" — in other words, a warrior maiden within the spiritual realm. In the Middle Ages, a sanctified virile (in the sense of manly) virgin could even become a "WomanChrist," a woman identified with Christ, once she reached the exalted status of dedicating herself fully to the *imitatio Christi,* or imitation of Christ.[2]

Already during the era of the persecution of the early Church, female martyrs, when describing their radical commitment to Christ, envisioned themselves as "becoming male." For example, Perpetua, a third-century Christian, saw herself in a dream shortly before her martyrdom as having acquired a male body.[3] In the words of one observer, "for women...courage, conscious choice, and self-possession constituted gender transgression."[4] Another martyr, Blandina, was perceived as having been "clothed" with the essence of the "athletic" (in the sense of conquering) Christ and becoming like him when dying naked on a cross-like gallows.[5]

Reaching a state of oneness with Christ could also be achieved through mystical union, which in turn could be cultivated by performing spiritual exercises such as prayers, fasting and various acts of self-mortification. The concept of a sacred marriage with Christ had been inspired not only by the bridal symbolism and erotic imagery found in the Song of Solomon and in the Book of Revelation, but also by secular courtship literature. On the basis of these various sources, devotional practices intended to result in a holy encounter with the "divine bridegroom" were often, although by no means exclusively, developed within Catholic nunneries, particularly among the Benedictines and the Cistercians:

> Beginning with the twelfth century and increasingly thereafter, the brides of Christ were not only allowed but encouraged to engage in a rich, imaginative playing-out of their privileged relationship with God. This bridal status, in turn, gave them an added cachet in the male imagination.[6]

Written accounts of the lives of various saints, in turn—stories that were often more legendary than factual—had already been compiled by the early Christians, but especially from the ninth century on, resulting in a growing collection of *acta sanctorum,* or deeds of the saints.[7] These stories, which frequently focused on the violent torture of virgin martyrs during the early Christian centuries, were particularly popular during the Middle Ages. One of the most popular of these accounts, for example, was the *Golden Legend,* written during the thirteenth century.[8] Such stories provided models of virtuous conduct and spiritual warfare to both men and women, with the ultimate goal of reaching a spiritual identification with the supreme example, namely Christ, through heroic suffering. This process came to involve a certain flexibility and even fluidity concerning gender roles; members of both sexes, for example, were encouraged to aspire to become Christ's beloved "bride," insofar as both the human soul (*anima*) and the church (*ecclesia*) were regarded as essentially feminine in nature. Supreme virtues such as hope, faith and love were also personified in the form of holy virgins who were said to be residing in the company of Christ.[9]

At the same time, both women and men were encouraged to cultivate "virile" qualities such as courage and moral strength in order to become as fully Christlike as possible. During the Middle Ages, paradoxically, Christ had sometimes been described in overtly feminine terms, especially those related to birthing and nursing; the Virgin Mary, in turn, had been praised for exemplifying certain manly qualities. In this connection, genders were almost interchangeable or transferable, at least with regard to religious and symbolic imagery. In the words of one observer:

> Whereas twelfth century monks sometimes call themselves women, early medieval women sometimes call themselves men. In the patristic period we find cases of women having visions of themselves standing before the throne of God as males—a sign that they are saved. And early literature has several stories of women masquerading as men in order to enter monasteries. Whereas twelfth- to fourteenth-century texts call Jesus mother, in the Carolingian period we find an iconographic tradition of the bearded Mary, the mother of God with a male attribute.[10]

During the thirteenth and fourteenth centuries, the idea of gender inversion was developed even further. This development

was not regarded as having any practical implications, however, but served merely as a means to increase one's personal level of sanctification and to encourage the transcending of societal boundaries and earthly limitations. The mystical Beguines, for example, who were members of semi-religious sisterhoods in the Netherlands and in Germany around this time, regarded God as feminine in the sense of expressing incarnate love, or *Minne*, while so-called brides of Christ were thought of as "man as *fin amant* [subtle lover] or womanChrist." In this context, the sacrament of bread and wine which was offered in the eucharistic communion ceremony could be regarded as "the metaphor and means for erotic union."[11] Through deliberately imitating Christ's Passion by means of self-inflicted pain or other forms of suffering, both genders could aspire to become as one with Christ. Both women and men could therefore envision themselves as brides of Christ, while for women such bridal imagery had the additional appeal of corresponding to societal expectations as to their ultimate role and purpose in life.

During the Middle Ages, there was yet another way for a woman to find sacred union with Christ: rather than seeking him out as a divine bridegroom in her prayers, she could also mystically enter into his open wounds through her devotion. These gashes, in particular the side wound, were seen as welcoming portals for the mystical soul, offering repose and shelter in anticipation of heavenly bliss. On the other hand, the cross itself was also portrayed, at times, like a ladder of ascent, or else a ladder was depicted as leading to the summit of the cross. Ascending to Christ's heart and surrendering to sacrificial self-discipline and self-annihilating love was seen as a *Liebestod*, a consummation of love in death.

One of the most popular books that offered spiritual guidance at this time was *The Imitation of Christ*, attributed to Thomas à Kempis (ca. 1380-1471) and published in the early fifteenth century. This treatise was influenced by a spiritual community called the "Brethren of the Common Life" and was representative of the *Devotio Moderna*, a popular movement that defined devotion as an ardent desire for God and a wholehearted dedication to his service.[12] *De Imitatione Christi*, to cite the original title of this book, affirmed contempt for earthly affairs by despising the world and its pleasures, as well as embracing self-loathing in the pursuit of Christ's teachings. Submitting to suffering was praised as being the only wise choice in life, insofar

as taking up the cross would lead to fellowship and eventual union with the divine Beloved.

In this work, which consists of four parts, Book I is titled "On imitating Christ and rejecting all the folly and unreality of this world." It stresses that "Christ urges us to mould our lives and characters in the image of his"; therefore, everyone "must try to make his whole life conform to the pattern of Christ's life." The last chapter of Book II is titled "On the royal way to the holy cross." Here, self-renunciation is the central theme:

> All that matters is the cross and dying on that cross — there is no other way to life and real inward peace except the way of the holy cross, and of daily dying to self.... If you carry your cross with gladness, it will carry you and lead you to that longed-for goal where there will be no more suffering, though there will always be suffering here.... Nothing is more acceptable to God, or more healthful for you in this world, than willing suffering for Christ.... Then you would be more like Christ, and closer to all the saints.[13]

Somewhat in contrast with the ascetic practices promoted by Thomas à Kempis was the emphasis on prayerful concentration upon the figure of the Virgin Mary who, as the mother of Christ, had shared his suffering and therefore was seen to be the supreme embodiment of compassionate love. During the last decade of the fifteenth century, a Confraternity of the Seven Sorrows of Mary was founded in the Netherlands. The devotions of this confraternity were primarily focused on the Virgin Mary as *Mater Dolorosa*, or suffering mother, particularly with regard to the torments she had suffered during Christ's Passion. In this way, Mary came to be the subject of an emphatic, emotionally charged focus on various biblical events, up to and including Christ's sacrificial death. The *Stabat Mater*, which refers to Mary standing below the cross, and the *planctus*, or lament of Mary (*Marienklage*), consequently became a focus for popular religious devotions at this time; these were encouraged particularly by the Franciscans and Dominicans. The passionate expressions of religious fervour which resulted from these intense meditations led to excessive, even self-abusive forms of behaviour among women, including wailing, breast-beating, hair pulling and losing consciousness when contemplating Christ on the cross.[14]

Therefore, not only the *imitatio Christi*, but also the *conformitas* with Christ became one of the guiding principles for spiritu-

ality during the Middle Ages. Texts and images served as didactic devices in promoting the cultivation of ascetic, even self-mortifying practices. The intention here was not only to generate compassion for Christ but also to enable personal identification with his intense suffering. By contemplating and indeed celebrating the cross, women and men were yearning to die together with Christ. The notion of embracing the cross (*Kreuzumarmung*), as originally enacted by the Virgin Mary and Mary Magdalene on Golgotha, became a widespread theme for spiritual contemplation, particularly among women. This self-dedication was regarded as being in accordance with the central biblical command of "taking up one's own cross" (Matthew 10:38 and 16:24, Mark 8:34 and Luke 9:23 and 14:27).

Specific visual examples made this theme even more personally relevant—for example, the inclusion of a female figure of love who was shown carrying the cross (*die Kreuztragende Minne*). This figure was, at the same time, also bound to Christ with a rope around her waist (*der Minne Band*) in order to be fully united with him. Examples of this imagery, which was especially popular in Germany, can be found in numerous manuscripts and woodcuts created during the second half of the fifteenth century.[15]

In this way, "crucifixion piety" became not only a spiritual disposition, but also a means of self-discovery and self-expression, especially for women. The suffering of Christ, far from being perceived as an event from the distant past, became a personal symbol of the present, fraught with immediate subjective relevance. This concentration on Christ's timeless presence aided believers in their search for personal meaning, as well as helping to define the concept of personhood in a more general sense. In the words of one observer: "Christ's body was the arena where social identity was negotiated, where the relationship of self and society, subjectivity and social process found a point of contact and conflict."[16]

Focusing upon the Passion of Christ therefore became a way of life that involved the spiritual quest for union with God; at the same time "being crucified with Christ" (Romans 6:6) was perceived as being a vehicle for personal transformation and sanctification. Christ's bleeding body was also regarded as a sacred source of birth and rebirth. Through his ultimate self-sacrifice, Christ was perceived as having shared both his humanity and his divinity with each individual who believed in him. From a

contemporary perspective, this crucifixion piety may be viewed as having been excessive or even morbid. However, we should not lose sight of the fact that medieval religiosity also contained a celebrative, ecstatic quality that provided women, in particular, with the opportunity to affirm their physicality. In this way, they could triumph over the limitations of their "weaker" gender and become empowered through their relatedness to Christ. In doing so, they were seen to be contributing to God's plan of salvation, which involved strengthening the weak and making the strong weak. As one commentator has described:

> In this way out of the flesh itself, out of what is most subject to death, is constructed the very world that can resist and transcend it: out of the immanence of the body is created the very resource of power as it legitimates itself with reference to an eternal, everlasting order.[17]

During the fifteenth century, Christ's flesh was seen as being simultaneously male and female. He was male insofar as he was the son of God and of Mary; however, his body was also regarded as female in that his flesh had been fashioned from the womb of his mother. As a result of such perspectives, the gaping wound which had been inflicted on his side while he was hanging on the cross was sometimes portrayed as being breast-shaped or even as a vulva-like womb, an opening that nourished the holy church with his blood. In this way, the Son of God was also portrayed as being the nursing mother of all humankind. Images of Christ could, therefore, be legitimately presented as either male or female. The feminine aspect of such imagery, in turn, conferred a degree of dignity on women and also resonated with their own experiences. In the words of one scholar:

> Most important, however, was the Christ of the cross. No religious woman failed to experience Christ as wounded, bleeding and dying. Women's efforts to imitate this Christ involved becoming the crucified, not just patterning themselves after or expanding their compassion toward, but fusing with, the body on the cross. Both in fact and in imagery the imitation, the fusion, was achieved in two ways: through asceticism and through eroticism.[18]

While erotic elements in the mystical love for Christ were generally expressed in terms of cautious metaphors, another, and far more direct, aspect of this fusionary process revolved around food. The consumption of Christ in the form of the bread

that was offered during the sacrament of the Eucharist offered another way in which women could assimilate Christ into their bodies. In this way, the female body became a legitimate site for a union with Christ; his sacrifice could be ecstatically received and prayerfully assimilated into a woman's flesh, thereby enabling the merging of the human and the sacred. In any event, "the extraordinary bodily quality of women's piety between 1200 and 1500 must be understood in the context of attitudes toward women, and toward [the] body peculiar to the later Middle Ages."[19]

Based on the prevalence of these personal experiences of merging with Christ in the Eucharist, it comes as little surprise to learn that many more women than men experienced appearances of the crucifix, and devoted themselves to the veneration of the *Corpus Christi,* the sacred body of Christ, and of the *Sacred Heart* of Christ.[20] Furthermore, women attached much greater spiritual significance to illnesses and physical afflictions than did men, who tended to view cures, rather than infirmities, as genuinely divine gifts. Many women also regarded stigmata and self-inflicted suffering as signs of grace; thus, wounds became a source of both extreme pain and profound exultation for them. Stigmata, while first experienced by St. Francis of Assisi, had become, by the late Middle Ages, a phenomenon claimed exclusively by female mystics; such physical marks were commonly regarded as a wholly female miracle.[21]

In general, then, the imitation of Christ was taken more literally by women than by men; holy women like Margaret of Cortona or Lukardis of Oberweimar perceived themselves as not only imitating, but actually "becoming" Christ on the cross. Lukardis, in this connection, was said to have appeared in a vision experienced by an unnamed monk, who saw her as being nailed to the cross and identified with Christ by the voice of God himself.[22] Mechthild of Magdeburg, in turn, was said to have become "identified with him, imitating Christ's passion so perfectly that she becomes herself a womanChrist."[23]

Similarly, a male contemporary of Catherine of Siena saw her in a vision as being bearded and Christ-like; she herself, in turn, envisioned that she was being nursed at Christ's breast. By restricting her diet to Communion wafers exclusively, she believed that she was living in eucharistic union with him, all the while experiencing his body as female.[24] It was, however, Julian of Norwich who was perhaps the most articulate of the

saints when evoking the imagery of the motherhood of Christ; she yearned for the literal imitation of Christ's passion in her own bodily suffering, pleading that his pains would become her own.[25] Another female mystic, Angela of Foligno, also felt lifted up and transported into the body of Christ, an experience that caused her both extreme pain and extreme joy; she felt blessed by the thought that her soul had entered into his side wound.[26]

From 1200 to 1500, a time during which the human body acquired an increasing amount of religious significance, the distinction between male and female tended to be regarded as considerably less than absolute; "theology, natural philosophy and folk traditions mingle[d] male and female in their understanding of human character and physiology." Due to this "permeability or interchangeability" between the sexes, both men and women came to regard themselves as capable of experiencing Christ's passion in a literal, physical way. Mystics of both genders, in particular, were regarded with awe and respect when imitating Christ's martyrdom on the cross to the point of "hanging themselves in elaborate pantomimes of Christ's crucifixion.... Such acts were [more] frequently described as union with the body of Christ."[27]

The attempt to integrate both sexes within the figure of Christ has a long history, beginning in antiquity. Already in early Christian art, for example, portrayals of the body of Christ frequently featured a subtle suggestion of maternal characteristics, especially slight swellings of the breast. This delicate allusion to androgyny can be observed in numerous examples of sculptures and mosaics, both in terms of the nude crucified body as well as the draped figure of the enthroned heavenly king:

> Once this feminine aspect of Christ had gained an acceptability, later artists, whether in the Middle Ages or beyond, felt free to exploit it without apologies. Judging from the rich tradition of the effeminate imagery of Christ, it appears that people were not uncomfortable with such a Savior.[28]

Even Christ's hairstyle in these works of art, featuring long locks and the absence of a beard or moustache, suggests not only his youth but also a maiden-like, almost hermaphroditic appearance. This merging of physical characteristics resulted in, among other things, the mistaken identification of a fourth century statuette of the seated Christ as a "Seated Poetess." Furthermore, the presence of small breasts can also be observed in numerous sar-

cophagi of the fifth century in Ravenna which feature an "ambiguous Christ," in contrast to the decidedly masculine appearance of the apostles who are depicted at his side.[29]

To some degree, this phenomenon can be explained in terms of pre-Christian antiquity, when gods such as Apollo and Dionysus, and even Jupiter, the supreme god, were sometimes depicted as possessing feminine characteristics. This was done in order to symbolize their gender-inclusive power and all-encompassing fertility. In tandem with such visual references from the past, the biblical image of Christ was also imbued with life-giving powers, such as the giving of new life, the provision of "living water," and the giving of his body and blood for nourishment. In this way, "the reconciliation or unification of the opposite sexes served in early Christianity as a symbol of salvation."[30]

With regard to the portrayal of a "Chameleon Christ," it has been suggested that women perceived Christ as being more female than male, and therefore encouraged images of him that featured feminine characteristics. This could very well have been a significant factor in the creation of numerous works of early Christian art, especially sarcophagi, since these were frequently commissioned by female patrons such as wives, mothers and widows. The images, symbols and details portrayed on these reliefs were therefore frequently reflective of women's experiences, with an emphasis on qualities such as nurturing, self-giving and compassion. On the other hand, divergent images of Christ were also being produced throughout this period; these focused on the bearded and strictly masculine characteristics and body forms of an older, more ascetic type of Christ. Apparently, no normative or otherwise "objective" images emerged in early Christian art, however, since Christ was then being perceived as "utterly mysterious, undefinable, changeable, polymorphous." As a result of this, "the same Lord appeared now as abstract sign, now as human figure, now as Child, now as Man, now as Woman."[31]

A similar attempt to integrate both male and female characteristics in visual depictions of Christ can be observed in early medieval sculpture. Monumental Romanesque wooden crucifixes, for instance, portray Christ as triumphant and regal on the cross; however, in many of these works, small breasts are delicately featured both on nude and on robed figures. Since several of these triumphal crucifixes depict Christ wearing a long gown (the ancient eastern symbol of kingship and priesthood),

these figures were later, certainly from the Gothic era onward, understood to portray a virgin martyr such as St. Wilgefortis or Kümmernis.[32]

The presence of apparently female breasts on these statues of Christ makes such misunderstandings somewhat understandable, however. Even in the *Volto Santo* of Lucca, discussed above, Christ's body displays a slight swelling of breasts – the details of which are delicately emphasized by the curvilinear folds carved on the garment that covers the chest. Even after this statue had been additionally clothed with precious gowns and jewellery, as was then customary, the contours of small breasts were still visible under the clothing. No wonder, then, that several other Romanesque crucifixes, featuring either nude figures or else fully robed ones, were later recarved, renamed and clothed in fashionable female costumes. Such alterations occurred in various locations throughout Central Europe, thereby giving rise to the creation of various legends, folklore and folk art throughout the region.

In the Benedictine convent of St. Walburg in Eichstätt south of Nuremberg, several nuns even produced their own religious images during the late Gothic era. They created awkward, yet highly expressive graphic works that served as an integral part of their personal devotions. A crucial part of their creative output (referred to as *Nonnenarbeiten,* or nuns' handiwork) consisted of a group of single-leaf drawings. Of the twenty-five sheets that are still preserved, twelve have been attributed to the same artist, an anonymous nun known only as the "Kümmernis painter" – a reference to one of the most significant images in the set. Together with various other pious images which originated around this time, this particular drawing of the female crucifix came to serve as a model for the personal and mystical *imitatio Christi*:[33]

> Although this drawing lacks narrative detail, it can be correlated
> with the legend of a female martyr included in a miscellany from
> the convent's library that recounts how the saint grew a beard
> and suffered crucifixion to avoid marriage and preserve her vir
> ginity. Based on a misinterpretation of the *Volto Santo* and its
> copies...the legend enjoyed a special veneration among nuns
> because it celebrated female virginity and martyrdom in the imi
> tation of Christ.[34]

In another drawing from this group, one finds a large circular shape delineating a heart, a symbolic space through which a

pious nun could find herself admitted to the eucharistic banquet, thereby sharing the table with God and Christ.[35] This heavenly intimacy served as an incentive for a sanctified virgin to envision herself as dwelling in the company of God, as well as encouraging her to strive towards this goal throughout her life. In another drawing, a different image of heavenly union has been chosen: here, the invitation to the desirability of achieving inner sanctity is portrayed as a command to nurture or suckle Christ (*nutri michi*). This exhortation is uttered by the Virgin Mary on behalf of her son, who is seen amidst an assembly of consecrated virgins:

> Having first allowed the nun to identify with Mary in her role as Christ's bride, the drawing now encourages her to identify with her ultimate exemplar, the Virgin, as Christ's mother. The imagery of suckling provided a common figure of spiritual inspiration and mystical union.[36]

Images of Christ's Agony in the Garden of Gethsemane provided yet another model for nuns to re-enact Christ's Passion; this was done in order to experience a sense of mystical oneness with the Saviour. Additionally, various devotional texts from this era encouraged the faithful to imitate various gestures of prayer such as kneeling, prostration and standing "cross-wise":

> Exercises such as these in effect turned each nun's place in the stalls into a private space for a theatrical, even histrionic, reenactment of Christ's Passion, especially his prayer at Gethsemane. The lives of holy women bear witness to the pervasiveness of such devotions.[37]

In addition to these general exhortations and common practices, there are records of specific women who were obsessed with certain of these exercises. The Prussian recluse Dorothy of Montau (1347-1394), for example, "in imitation of Christ's Crucifixion...stood for hours with her arms extended or suspended herself from nails in the wall."[38]

Some spiritual advisors warned against excessive religious behaviour and encouraged less drastic ways of reaching union with Christ. Bernard of Clairvaux (1090-1153), for example, emphasized on several occasions that the imitation of Christ involved a gradual ascent by means of various virtues, rather than an immediate realization. He envisioned this step-like ascent in the form of rungs of a ladder that led up to the cross. This image was taken from the biblical accounts of the dream of

Jacob, in which a ladder had bridged heaven and earth. Images of a "symbolic crucifixion," therefore, portrayed a ladder that was seen to lean up against the cross, thereby facilitating the ascent to heavenly union with God. The individual steps of this upward process included virtues such as poverty, suffering, humility, patience, obedience, hope, faith, mercy and justice; love, however, was the supreme and culminating quality.[39]

A more dramatic way through which a penitent nun could express her identification with Christ, however, was to offer up her own bleeding heart, which was portrayed as being crucified to the cross. In the cultural context of the Middle Ages, the pierced heart could either represent Christ's Sacred Heart or else the heart of his female lover. To make this distinction clearer, a woman might be portrayed as presenting her own bleeding heart, which was nailed to a cross, to Christ—a symbol of her willingness to offer herself up in loving self-sacrifice. In this way, the resulting wound on her heart was also seen as an opening that was ready for inviting, receiving and embracing the beloved one:[40]

> In place of the interior of Christ's body, the images now take as their subject the womblike enclosure at the heart of the nun's body and make it an image of her own subjectivity. Having passed through the wound in Christ's side, the nun enters a metaphorical as well as physical interior; she passes from imitation to identification.[41]

The intense and painful interaction between the divine bridegroom and the human soul was graphically depicted in a fifteenth-century single-leaf woodcut called *Christ and the Loving Soul*. This page consists of a series of twenty small, consecutive scenes, each of which is accompanied by pithy texts from an imaginary dialogue. In one of these scenes, the bride implores her lover: "Nail me in your wound; teach me to study in your wounds." Christ answers her by actually hanging her on a cross, so that she is portrayed with ropes around her wrists while being suspended between heaven and earth.[42] Given examples such as this one, it becomes easy to understand why it was that a saint such as Wilgefortis, rather than being a strange or marginal figure in medieval culture, was in fact a core symbol of, and a crucial model for, religious devotion.[43]

The history of another female saint serves to elucidate this medieval preoccupation with female crucifixion, whether

expressed in a physical form or through symbolic imagery. St. Eulalia, for example, was praised in a tenth-century hymn as "demonstrating the honour of the cross as a sign of salvation. Emulating the master on the cross she hangs from a cross."[44] Originally a fourth-century cult figure from Spain, Eulalia of Merida became the most popular martyred saint of that country; however, her story eventually became indistinguishable with that of another martyr, St. Eulalia of Barcelona. Eulalia's iconography was occasionally confused with that of Wilgefortis, although the latter was rarely portrayed as half nude.[45] Eulalia, on the other hand, was stripped, beaten, tormented with iron hooks, had her bosom mutilated, was burnt with torches and was portrayed as hanging on a rack or upon an X-shaped cross. In these examples, the emphasis on the eroticism of sexualized violence provided an element of gruesome fascination for the general public of this era.[46]

Other female saints who were portrayed as either embracing the cross or being affixed to it were Margaret of Antioch, Julia of Corsica, Bridget of Sweden and Gertrud of Nivelles, while Helena was depicted as holding the "true cross" in front of her.[47] Furthermore, the personification of the virtue of faith was also commonly portrayed as being a woman who was seen upholding a cross. Given the diverse range of female saints who were portrayed in conjunction with a cross, it is hardly surprising that several saints and holy figures were not only confused with one another but were even merged into one another's identities—a fact that can be observed in both verbal and visual representations from this era. The great amount of imagery related to the theme of the crucified woman is indicative of the religious power of this concept. In their desire to become more Christ-like, women undeniably came to have a role in shaping the prevailing popular culture of the Middle Ages.

One of the most poetic descriptions of a woman becoming Christ-like can be found in Dante's *Divine Comedy*. Here, Beatrice becomes a holy bride as well as the divine bridegroom. In the words of one observer, "she also crosses gender lines by doubling as Christ in Purgatorio XXX, when she is hailed in masculine terms with 'Benedictus qui venit.'"[48] This biblical greeting, which translates as "Blessed art thou that comes," conventionally refers to Christ, and has traditionally been sung at the celebration of Holy Communion. Here, however, it refers to Beatrice, but without any alteration of the masculine Latin ending. In

heaven, as one commentator has summarized it, "masculine and feminine traits are not only complementary but experienced simultaneously."[49]

The Origin of the Fiddler and the Legend of Gmünd

T his chapter examines the origin of imagery commonly associated with depictions of St. Wilgefortis, most notably the legend of the fiddler who appears at the foot of her cross in many of these images. The significance of the German town of Schwäbisch Gmünd is also explored in this connection. Additionally, the chapter provides an overview of the process by which depictions of a feminine-looking Christ on the cross gradually came to represent St. Wilgefortis.

Around the middle of the fourteenth century, a significant change occurred in terms of how the robed crucifix was portrayed. This was especially apparent with regard to wall paintings. Frequently, these depictions included a small second figure — specifically a man holding a fiddle while kneeling at the foot of the cross. In many cases, the right shoe of the crucified figure has been dropped from the cross and was thus being offered as a gift or a reward to the musician. The head of the crucified figure was often depicted as being turned toward this devout supplicant, facilitating a silent dialogue between the two of them; this was in contrast to the solemn frontality of the *Volto Santo* as it had been portrayed in the past. During the later Middle Ages, and once the robed crucifix had come to be under-

stood — or rather, misunderstood — to represent a female martyr, the fiddler became an increasingly integral part of the iconography of this saint. He was eventually interpreted as being a loving companion who had attempted to ease her final agony with his gift of music. Overcome with gratitude, she was said to have rewarded him with the gift of her precious shoe.

The addition of these narrative features can be said to have facilitated a more personal relationship between the spectator and the crucifix as well, in the sense that the fiddler represented and embodied the personal devotion of all who travelled on pilgrimages in order to venerate this image of grace. In later centuries, the fiddler was increasingly surrounded by other persons who, in a delicate effort to commemorate contemporary donors at the time, bore features of those individuals who contributed significantly to the commission or upkeep of the work.

Prior to the creation of these visual images, there had also been oral and written accounts concerning the robed crucifix in Lucca. Some of these accounts involved miracles that had allegedly been caused by the sacred properties of this sculpture. One of the oldest recorded miracles involving the *Volto Santo* concerned a silver shoe which, in a reprise of the previously mentioned legend, was said to have been dropped from one of the feet of the crucified figure. This gesture was subsequently interpreted as constituting a divine gift for an anonymous, pious and poor man who had travelled to the site of the sacred image in order to venerate it. Allegedly, this miracle had occurred on April 24, 1282, but already as early as 1150, a certain Abbot Nicolaus had recorded in an Icelandic *itinerarium,* or travellers' guidebook, not only an account of a miracle about a shoe, but also the vindication of a man who had been falsely accused of some wrongdoing through the power of the venerated crucifix.[1]

The story of the fiddler was apparently already widely popular during the twelfth century. Pilgrimages to the crucifix in Lucca had begun in the late eleventh century; perhaps not coincidentally, various stories of miracles began to circulate shortly thereafter. The real-life inspiration for the account of the fiddler may actually have been a pilgrim who perhaps brought the precious shoe — rather than receiving it — as a special votive offering for the sacred image in Lucca.[2]

According to another source — a medieval Italian observer from Turin — the story of the pious musician somehow became identified with that of a Frenchman named Jenois during the

course of the thirteenth century. According to a legend from around that time, the foot of the crucifix had miraculously lifted itself off the nail on one occasion and had tossed the precious shoe twice toward Jenois. The shoe was miraculously filled with coins of gold and silver which the pious man gave to the poor of the city of Lucca, after replacing the shoe onto the foot of the crucified figure.[3]

The name Jenois has been connected with that of St. Genesius, an early Christian martyr who was believed to have died during the persecution of Christians under the Roman Emperor Diocletian. During the Middle Ages, the cult of this saint was popular not only in Spain but especially in France, where he became known as St. Genesius of Arles. According to a sixth-century legend, he was not only a lawyer but also an actor and a comedian; therefore he became a patron of wandering troups of performers.[4]

During the Middle Ages, minstrels, acrobats, actors and singers were generally regarded as *vagabondi*, belonging to a low social rank with a bad reputation. During the twelfth century, French legends and poems attempted to vindicate these marginalized people; certain individuals, such as a poor minstrel or dancer, were singled out and, playing and acting in front of the Virgin Mary, were presented as enjoying her favour and being richly rewarded.[5]

Allegedly, an ancient cult dedicated to St. Genesius had existed in Lucca since the eighth century; this cult apparently preceded the veneration that came to be expressed toward the *Volto Santo*.[6] Various legends and cults connected with other individuals seem to have become intertwined with stories of miracles concerning the *Volto Santo*. In these subsequently revised accounts, the poor minstrel became the recipient of the precious shoe that was dropped from the miracle-working crucifix—a reward for the devotion he had expressed through his musical skills. In this case, the gift of music was seen to be appreciated more highly than money insofar as the musician had been too poor to express his devotion in monetary terms.

The shoe is a symbol of long-standing significance, some of which has survived in fairy tales to this day. Covering the lowest part of the body, it has often been regarded as the most humble item of clothing, albeit an essential one. Shoes were frequently viewed as symbols of power and riches, and drinking from a shoe or boot was supposed to bring good fortune. In

some European cultures, gifts were supposedly placed in shoes by saints such as St. Nicholas on special days of the year.[7] In the contemporary vernacular, wealthy people are frequently described as "well-heeled." As a container with an opening, the shoe has also been interpreted as a female sexual symbol, often in conjunction with fertility.[8] Shoe fetishism is known to have existed in ancient Egypt and Greece, while some medieval Anglo-Saxon tribes regarded the shoe as a symbol of marriage.[9]

In the Bible, to cite an additional example, shoes were described as tokens in legal negotiations, involving the ownership of property, while not possessing any footgear was considered a sign of poverty and destitution.[10] In the Book of Ruth, taking off a sandal and passing it on was not only described as a method for confirming a business transaction but was also interpreted as a token of answered prayer and intervention by God.[11]

It is interesting to note that the story of the shoe slipping from the foot of the *Volto Santo* may originally have been based on practical considerations rather than on a miraculous event. The carved figure on the crucifix originally wore no shoes, since the bare feet were pierced directly by nails. At some later point, shoes were added to the festive clothing of the statue; these had been brought by pilgrims or donated by wealthy citizens as votive offerings to the supposedly miracle-working image.

Since the crucifix, although hanging above an altar, had apparently been placed low enough to be touched, it became increasingly necessary to protect the feet from the hands of eager pilgrims who tended to touch and kiss those parts of the statue that were within easy reach. Once the right foot, in particular, began to show signs of wear and tear, the shoe would no longer fit or stay on properly. In order to prevent the shoe from slipping off, a chalice was placed under the right foot as a supportive device. This vessel also served as a container for coins deposited by pilgrims and visitors; it was conveniently open at its bottom, being connected to a large box or drawer which was situated below the altar table. Monetary offerings to the *Volto Santo* were being mentioned as early as 1213, while visual depictions of the chalice below the foot of the cross became popular during the course of the fourteenth century.[12]

The story that the fiddler might have obtained the shoe through theft appears to have originated in the fourteenth century as well. The legend of his near execution for this alleged transgression, as well as an additional story that involved the

dropping of a second shoe from the cross, were both recorded during the fifteenth century. Popular oral traditions in countries such as Bavaria, Saxony, Tyrol and Bohemia depicted these stories with additional and fanciful details: the encounter between the fiddler and the crucifix no longer took place in front of a statue in a church, for example, but rather in front of a youthful dying princess who was crucified on a tree amidst a lonely, desolate landscape.[13]

During the Baroque era, various Austrian and German legends emphasized the theme of compassion and tragic love between the beautiful princess and the loyal fiddler. The latter could not rescue her, but his untiring music was said to have soothed her agonies. In some of these legends, the shoe was a farewell gift from the dying martyr; in other legends, the shoe was dropped from the already deceased figure, or even from a statue that had subsequently been commissioned by her repentant father as a commemoration of her martyrdom. Eventually, the fiddler, sometimes seen as a hapless suitor, came to receive even more attention in these legends than the tortured princess herself.[14]

In a secular version of the story, which features a rare fairy-tale ending, the musician is described as having been able to rescue the princess due to the power of his loving melody; the shoe consequently became her engagement gift to him. Once she was liberated from her fetters (a reference to one of her names, specifically Liberata), she was also free to become his wife, according to this account.[15]

On a broader level, one can point to traces of these popular legends that survived well into the nineteenth century. In 1816, for example, Justinus Kerner (1786-1862) published a famous poem called "Der Geiger zu Gmünd," or "The Fiddler of Gmünd," which featured the story of a violinist in the city of Gmünd near Stuttgart. In this poem, Kerner connected the musician with St. Cecilia, the patron saint of music, rather than with St. Kümmernis — in spite of the fact that he may have been aware of a local tradition concerning St. Kümmernis.[16]

Only several months after the poem was published in 1816, one of Kerner's friends brought an image of a crucified woman, dating from 1678, to the poet's attention. This image was a copy of a painting that was stored at the local chapel of St. Joseph of Gmünd. Kerner's son Theobald confirmed in 1901 that his late father had creatively associated the fiddler with St. Cecilia in his

poem rather than with St. Kümmernis, of whom he only learned afterwards. Also, he stated that his father had chosen the city of Gmünd because of its general reputation for musical activities and its goldsmiths' reputation for excellence, and not because of any notoriety concerning a female saint in that area.[17]

A different poem, composed by Guido Görres and published in 1839, was called "Der Arme Spielmann," or "The Poor Minstrel"; here, the location was changed to the city of Mainz, where the poet had lived for a time and where Kümmernis had also been venerated in the past.[18] In this version, the musician was not only destitute but also old and lonely. Coming across a small church situated on the shores of the river Rhine, he perceived, through an open door, an altar lavishly decorated with the golden statue of a fair young maiden who later, in the guise of a living human being, rewarded him with the gift of her precious shoe.[19]

This gracious lady, described in the poem as "having endured severe pain and having given her blood to God," can be interpreted as being the Virgin Mary. On the other hand, she could also have been intended to represent the martyr Wilgefortis/Kümmernis, although the legend surrounding the latter contradicted the romantic ideal of graceful female beauty due to her disfiguring beard. During the nineteenth century, St. Kümmernis had come to be seen as too severe, even repulsive in her appearance; thus, she increasingly came to be replaced by the more charming feminine ideal represented by a holy maiden such as St. Cecilia. This ahistorical but imaginative change was encouraged by, among other factors, some written advice that had been given to Kerner by his pastor friend Ferdinand Ludwig Immanuel Dillenius in 1817, which emphasized the importance of depicting female beauty in the name of fine art and aesthetic sensibilities.[20]

In both of the previously mentioned poems, the fiddler was accorded more attention than his saintly benefactress. Indeed, he was singled out as a hero in his own right, and eventually came to symbolize, among other things, civic pride, self-accomplishment and the promotion of music and the arts. From the early nineteenth century on, statues, illustrations, coins, posters and souvenirs of various types were produced in Gmünd, where the fiddler was celebrated as a civic emblem of the town. He was also featured here as the single towering figure on a monument commemorating the poet Kerner.[21]

In addition to noting the literary sources which served as the inspiration for various products and portrayals that were discussed above, one can also trace the origins of such visual representations of the fiddler back to the Middle Ages, a time when he had not yet come to be regarded as a hero in his own right. The oldest depictions of the fiddler, at least in Austria, date back to the fourteenth century. A fresco depicting the legendary exchange of music for one of the crucified saint's shoes dates back to ca. 1330 or 1350. It was discovered in 1978 in a chapel next to the church of Prutz in Tyrol.[22] In the interior of the specifically dedicated chapel for the dead, or *Totenkapelle*, the image of a crucifix, along with a series of other saints, can be seen. Unfortunately, this image has not been very well preserved over the years. For example, a window opening was inserted into the wall at one later stage, resulting in considerable damage to the right side of this almost life-size crucifix.

Plate 1
Fresco,
ca. 1330–50
Prutz, Austria

In spite of this, the head of the crucified figure on the cross features a regal crown, a dark beard and relatively short hair, the details of which are all clearly visible. The area below the knees, however, has been entirely lost. The large arch surrounding the crucifix ends in a fleurs-de-lis design, thereby forming part of what appears to be a huge halo. This decorative design is clearly connected with that of the *Volto Santo,* which also features such a fleurs-de-lis arch. In this damaged fresco, the fiddler, kneeling below the crucifix, is only partially visible; however, his instrument as well as his music-playing posture are both clearly discernible. The crucified figure is depicted as having turned her head toward him, thus establishing an element of personal contact between the two.

Another Austrian depiction of the fiddler, this one dating back to 1363, is located in the *Martinskapelle,* or chapel of St. Martin, in Bregenz.[23] In this fresco, the fiddler is comparatively well-preserved — at least in contrast with his instrument. He is of small, almost childlike proportions and is shown kneeling piously under the large crucifix. The saint's discarded large right shoe has miraculously lifted itself up to hover above the bare foot of the crucifix, thereby bridging the distance to the kneeling musician. The decorative border featured below these images, however, does not convincingly suggest an altar table.

The most innovative details in this fresco are the large branches on either side of the figures, which are suggestive of trees in an outdoor setting rather than of the more traditional

church interior as found in the cathedral of Lucca. In this way, as well as through the absence of a lily-ornamented arch, this image could potentially already be referred to as "St. Kümmernis" (or "St. Ontcommer," who is typically surrounded by a landscape) rather than as a *Volto Santo* (who is always portrayed inside a church).[24] The regal and frontal dignity of the crucified figure, together with the masculine proportions of the crucifix as a whole, are nevertheless indicative of the Italian origins of this imagery. In this Austrian example, the head of the crucified figure is slightly turned towards the fiddler, a detail that suggests a silent dialogue between the two figures.

Not many other fourteenth-century examples of this imagery have survived. It is, in any case, a matter of conjecture whether northern copies of the *Volto Santo* were already being identified as depictions of "St. Kümmernis" at that time, insofar as descriptions of her image began to emerge only from the early fifteenth century on. A woodcut in a manuscript from 1492, titled *Lübecker Passionale*, identifies the *Volto Santo* as being "St. Hulpe," or a Holy Helper.[25] In this print, the youthful fiddler is depicted at the right side of the picture underneath the cross; he is seen receiving the left shoe of the crucified saint. This reversal of feet and sides is due to the printing process that was used here, and, as such, does not explain the fact that the altar, which is disconnected from the central crucifix, has been placed in an unusually marginal position.

The name "St. Hulpe" can provide an understanding of the gradual transition that occurred in Central and Northern Europe during the Middle Ages with regard to how the *Volto Santo* was identified or labelled. Copies of the miracle-working image in Lucca had originally been created with the intention of implying heavenly intervention and aid. These depictions of a holy helper, dressed in long robes, could be regarded as either male or female. In a similar fashion, the figure embodying grief ("Kummer") could also be portrayed by either an apparently male, or else an apparently female crucified martyr ("St. Kummernus" or "St. Kümmernis"). This question of gender does not appear to have had a significant impact on the relationship between the crucified figure and the fiddler in early depictions of the two. Only once the details of these figures had become more realistic and specific—i.e., from the Renaissance onward—did the issue of a beautiful female martyr rewarding an adoring male musician came to add an intriguing new

dimension to the traditional imagery. The previously mentioned written legends also played a role in this development. In the Lübeck example cited earlier, however, the body of the crucified figure is so block-like and rigid that no female form can be surmised from it.

Another example from Germany, possibly dating back as far as the fourteenth century, can be found in a church in the town of Kronberg im Taunus.[20] Here, the *Volto Santo*-like crucifix is surrounded, once again, by the characteristic arch ending in fleur-de-lis ornaments. The Italian crucifix is faithfully but somewhat crudely imitated here, especially with regard to its stark frontality and severity. The discarded right shoe of the saint has been dropped onto the altar table; both of her feet are pointed downward and seem to hover in the air without the support of a chalice or a visible cross. The slender fiddler is accompanied by two other figures, a knight and his lady, who kneel in veneration at the other end of the crucifix.

A monumental, if somewhat simplified, example of the veneration of the *Volto Santo* in Switzerland can be found in the town of Oberwinterthur in the kanton of Zurich. A stone relief dating from the second half of the fourteenth century, which portrays a robed crucifix with a small man at its side, can be found on the south side of the tower of the local parish church. In spite of the archaic appearance and simple contours of its basic design, this work is difficult to date; it may even have originated during the fifteenth century. Since the church tower was damaged in a fire in 1361 and was later reconstructed, the original setting of the relief, either on the inside or the outside the church, can no longer be clearly established.[27]

In this work, the overall imitation of the *Volto Santo* is rigidly maintained. This is especially apparent in the striking frontality of the crucified figure, as well as in the crowned head with its prominent moustache and parted beard. The outstretched arms form such a strong horizontal line that the crossbeam has become obscure; the lily-ornamented arch, in turn, functions as a large halo. In this way, the body of the crucified saint appears to be miraculously elevated.

A large discarded shoe is prominently visible below the right foot of the crucifix. The place of the fiddler, however, is occupied by a youthful figure who appears to be walking briskly toward the cross in order to touch the robe of the crucified figure. At the same time, he is touching the discarded shoe with his

own foot. This depiction is in surprising contrast to the kneeling gesture of the fiddler in almost all of the other examples cited here. Since the traditional altar table has also been omitted, the youth and the crucifix appear to rest upon virtually the same ground level. This scene can therefore be interpreted either as a misconception of the role of the fiddler, or else as a portrayal of another donor in different circumstances. In either case, however, the discarded shoe provides a clear connection to the miracles that were associated with the *Volto Santo* during this time. Clearly, the legends concerning these miracles had spread across central Europe by the end of the fourteenth century.

During the later Middle Ages, as well as into the Baroque era, the fiddler frequently bore the features of a particular donor, or in some cases, the features of the artist himself. This was done with the intention of expressing the artist's own devotion to the crucified saint. Thus, while the posture and gestures of the fiddler were generally consistent, the social class, costume, age and face of the fiddler varied considerably. Depictions of this figure ranged from featuring luxurious attire to the wearing of rags, from youthfulness to old age, from childlike features to baldness and a white beard.[28]

Not all of the votive paintings which were devoted to Kümmernis necessarily included the fiddler. Some examples, especially those created between the seventeenth and twentieth centuries and preserved in the church of Neufahrn in Bavaria, included other figures such as family members kneeling beside a bedside, a single woman praying in a church or farmers kneeling among their livestock. Occasionally, St. Kümmernis is shown surrounded only by cattle; in a few examples, she is suspended in the clouds high above a human settlement such as Neufahrn. In most of these *ex voto* panels, the dropped shoe was not necessarily an essential symbol of her beneficial powers. Of greater visual importance was the emphasis on light either emanating from her head or feet, or on a luminous cloud which surrounded her body, or even in some cases on angels or various saints (especially St. Leonard and the Virgin Mary), who were depicted standing or hovering at her side.[29]

During the nineteenth century, a number of votive panels were created which portrayed the crucified saint's male attendant as nothing more than an ordinary citizen. In these panels, he is depicted kneeling below her with folded hands, as if in prayer. Occasionally, such depictions also featured the added

detail of the gift of the shoe. Two examples of the latter phe-
nomenon originate from the Bavarian town of Burghausen, and
are dated 1860 and 1869 respectively.[30] These small panels,
which are unfortunately of low artistic quality, represent the
gradual decline of a rich artistic tradition of religious folk art
which had been inspired by the colourful legends concerning the
dying Kümmernis and her loving companion.

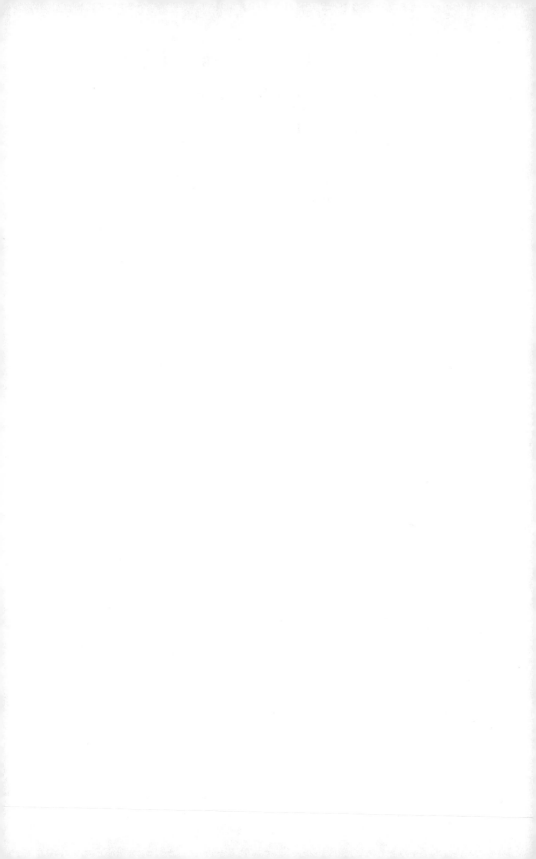

Chapter 4

St. Ontkommer and St. Uncumber:
Images from Holland
and England

T his chapter continues to examine the process by which the feminine-looking Christ on the cross was gradually supplanted by depictions of the unmistakeably female St. Wilgefortis. Particular emphasis is placed on the depiction and veneration of the crucified female saint in Holland and England during the late Middle Ages. Additionally, the possible connections between images of St. Wilgefortis and those of other female saints are considered.

In spite of the many different names by which the crucified female saint has been referred to over the course of several centuries, including Wilgefortis, Kümmernis, Liberata and Helferin, the name by which she was most commonly known in England was Uncumber. The Dutch variant of this name is Ontcommer.[1] These names reveal the function of the saint: she helps to free her supplicants from cumbersome concerns so that they may become "un-encumbered" and thus unburdened and liberated, as indicated by her Latin name Liberata. St. Ontkommer is typically portrayed as having "escaped" the ropes that tied her to the cross. These symbolic names suggest that this saint served not only as a personification of, but also as a liberator from, human predicaments and burdens.

Notes to chapter 4 are on pp. 143–146.

It is very likely that both the names Wilgefortis and Uncumber originated in the Netherlands during the fifteenth century. According to the *Bibliotheca Sanctorum*, "Vilgefortis," a virgin saint, was first mentioned in a *Dutch Martirologio* in 1476. Here, she was referred to as the daughter of a king of Portugal.[2] She was also mentioned in the official *Roman Martyrology* of 1583, which in turn was based on earlier sources published in 1568 by Johannes Molanus, a professor at Louvain. It was Molanus who, for the first time, merged Wilgefortis with the Spanish martyr Liberata, treating the latter name as if it were the Latin translation for "Ontcommer." Additionally, he described her as a princess from Portugal who had been promised to the king of Sicily, but who had preferred death on the cross to the loss of her virginity.[3]

Hans Burgkmair's woodcut of 1502–07 with the inscription "Die Bildnus zu Lucca" reinforced the already established Netherlandish tradition that the saint "lies buried in Holland in a church called Stouberg," a site which most likely refers to Steenbergen in North Brabant.[4] Unfortunately, nothing has remained in this town that could serve as a reminder of a formerly flourishing cult site, since all Gothic buildings, sacred as well as secular, have been destroyed. Already during the sixteenth century, Calvinist reformers were eradicating sites that had been popular Catholic cult centres, including Steenbergen.[5]

A curious explanation for the princess as "Portuguese" can be found in the name of a small settlement in the vicinity of Steenbergen; it was called "Portugal" since it had apparently been the property of a Portuguese nobleman more than a century before the cult of St. Uncumber began to flourish.[6] In this way, the princess could be claimed as a local saint, while her story took on exotic and extraordinary overtones at the same time.

It is likely, in any event, that the church of Steenbergen once housed a medieval statue of a robed crucifix, which may have been a copy of the *Volto Santo*. Apparently, this image came to be venerated as a female bearded saint around 1400. This devotionary statue could originally have been commissioned by the Counts of Steenbergen, who were contracted to perform military services for Italian city states such as Pisa and Lucca. Additionally, Italian merchants may have acquired copies of the miracle-working crucifix of Lucca for various sanctuaries or private homes in their new Dutch business environments.[7] The lack of historical evidence with regard to medieval religious works of

art in Steenbergen does not detract from the fact that the "female" crucifix was held in high esteem in that area at around that time.[8]

Visual images connected with the cult of "Sinte Ontcommer" were first mentioned in archival records in the Netherlandish region which today includes both Holland and Belgium at the beginning of the fifteenth century. The earliest surviving document indicates that an altar for "Sente Guilleforte" or "Sente Ontcommer" was installed in the Church of Our Lady in Ghent, on February 5, 1400.[9] The various names of the saint are imaginatively explained in a Flemish manuscript dating from the second half of the fifteenth century: just before "Wilgeforte" died on the cross, a voice from heaven declared that God henceforth wanted her to be called Ontcommer, since she would become like a mother to all who were troubled. Consequently, those who called on her would become unencumbered (*entkommeret*).[10]

In a document dating from 1419, Duke Adolf I of Cleve donated an altar in honour of "sunte Wilifortis" the saintly virgin, who is also referred to here as "sunte Unkommer."[11] This document serves as evidence for the fact that the saint served not only as a patron for poor and powerless women but was also venerated by aristocratic persons, many of them male. Even court circles and high-ranking church officials, in fact, commissioned works of art that portrayed her image. These works were created by leading artists of the time, frequently with very costly materials, as will be shown below.

During the course of the fifteenth century, the iconography of St. Ontkommer began to diverge substantially from its roots in the *Volto Santo*. For example, a miniature in a prayer book of Netherlandish origin, dated ca. 1400, and now in the Schlossbibliothek in Aschaffenburg, portrays, for the first time, the saint being tied to a cross with ropes, rather than being nailed to it.[12] Here, her beard is delicately depicted around her chin, and she wears a crown. Her body is characterized as unmistakeably female under the long gown, featuring delicate breasts, slender hips and curving thighs. Her knees, in turn, are slightly bent in order to support her weight. A new, Netherlandish feature involves the inclusion of two men standing below the cross. One of them is crowned and dressed in a lavish costume of almost oriental splendour. He appears to be her outraged father, and is joined either by an unsuccessful suitor or else a servant.

In this way, a new type of composition featuring the crucified saint was created. Due in large part to this change, the *Volto Santo* tradition was largely superseded in this region, with the result that the gift of the shoe and the presence of the fiddler seem not to have become significant in the Netherlands. In these portrayals of Ontkommer, no confusion with the image of Christ appears possible; she is merely the young bearded princess whose father had her crucified in a lonely countryside.

Her name "Sinte Oncomer" can be found on a miniature attributed to the Master of the *Morgan Infancy Cycle* which has been dated to ca. 1415. This Book of Hours, a book of daily devotions, was written in Dutch, and is now housed in the University Collection of Utrecht.[13] In this image, certain details are visible which were crucial for the establishment of the saint's Netherlandish iconography. In particular, these include the "Tau"-shaped cross and the tightly pulled ropes that encircle her long and full skirt, which in turn covers both of her feet. She wears no crown, but her head is encircled by a halo; her white and full beard is greatly emphasized. She appears to have been abandoned amidst a valley located in a rocky landscape that features only a single tree.

Neither this setting nor the abstract background of the page, which is decorated with ornaments in red and gold, suggest any connection to the *Volto Santo*, which had traditionally been placed above the altar inside a sanctuary. Since Ontkommer's shoes and feet were no longer of symbolic significance, they could now be hidden under her long dress. The story of the fiddler, who had inspired such imaginative artistic creativity in central Europe, seems to have had no resonance at all in the Netherlands.

Another miniature, attributed to the same Master of the *Morgan Infancy Cycle*, is also dated ca. 1415. It provides further evidence that St. Ontkommer played an extensive role in the religious life of the Netherlands at that time. This Book of Hours, now in the University Library of Liège, was "possibly made for a woman," since several prayers appear to feature specifically feminine endings. In this miniature a very different depiction of the saint is revealed.[14]

Holding a large cross upright in her arm, she is placed in the company of other well-established saints such as Francis, Mary Magdalene and Dorothea. St. Francis, the central figure, is portrayed as youthful and beardless, in contrast to St. Ontkommer, who wears a bushy beard that is only partially concealed by the

cross she holds. In spite of the beard, she exhibits the feminine elegance of an aristocratic lady. She holds a book in her right hand, while her left hand holds the cross, together with a piece of untied or torn rope. In this manner, Ontcommer is shown as having escaped from her bondage, in accordance with the symbolic meaning of her name. Both the cross and the rope, traditionally instruments of her martyrdom, have here become attributes of her liberating power. This miniature of St. Ontkommer is the first of twenty-three illuminations in this prayer book, which was probably created for a nun living in one of the houses of the Third Order of St. Francis. This connection would explain the central position of the ascetic male saint who is so different in appearance from the other, female saints.[15]

In a more general sense, it is useful to bear in mind the fact that the production of Dutch book illuminations from the late fourteenth to the fifteenth century was part of a religious movement called the *Devotio Moderna*. This reform movement, initiated by Gert Groote, came to include a variety of religious groups, including one called Brothers and Sisters of the Common Life, many of whose members were skilled in various crafts. All of this resulted in the appreciation and production of edifying books in the vernacular, which were treasured and read by all classes of society.

Some of these Books of Hours became famous as the most splendidly decorated books of the late Middle Ages. Women played a significant role in the creation of these books. Not only were they valued as artisans, copyists and skilled labourers, but they also commissioned some of these books themselves, with particular emphasis on personally significant texts and inspirational visual details.[16]

In this way, St. Ontkommer gradually became one of the most popular saints of the Netherlands, her legend promulgated both by the religious movement of the Brothers and Sisters of the Common Life as well as by the upper classes of society. The Hapsburgs, in fact, adopted her as one of the saints of their dynasty, together with a host of other saints who had been venerated by the Burgundian court, after Burgundy became part of the Hapsburg possessions. In a particularly notable example of the depiction of these saints in the arts, Wilgefortis can be found embroidered on a liturgical garment that was part of the treasuries of the Golden Fleece, an order that became closely associated with the House of Hapsburg over the years.

It may seem surprising that a strangely bearded female martyr would be accorded such prestige and recognition as opposed to other more established or physically attractive saints. But it was precisely the disfiguring beard that made St. Ontkommer so intriguing during the fifteenth century, a period during which there was a considerable fascination with emaciated recluses and unkempt hermits, all of whom tended to possess excessive growths of hair. Many of these half-legendary figures constituted a kind of counter-culture to the generally self-indulgent and pleasure-loving middle and upper classes. At a time when costly garments and lavish costumes were treasured and publicly displayed, the stark and shaggy depictions of destitute saints such as Mary Magdalene and Mary of Egypt were particularly noteworthy.

This interest in an alternative, even primitive lifestyle reflected a nostalgia for an existence without cultural restraints. Escapist dreams were especially prevalent at a time when explorers ventured into new continents, compiling new, if not always factual, reports which sometimes referred back to fanciful texts from antiquity that described various aboriginal races. Formerly considered as uncouth and even monstrous, these "wild" people (*Wilde Leute*) were, in the late Middle Ages, envied as more vigorous and perhaps even more virtuous than "civilized" members of society because they appeared to live in harmony with nature. Even St. Ontkommer was, on occasion, grouped together with these "wild" women because of her beard.[17] Some unusual aspects of the portrayal of female saints can be found on the *Liturgical Vestments of the Order of the Golden Fleece*. These are lavishly and minutely gold-embroidered textiles which are preserved as part of the treasures of the Schatzkammer in Vienna. Altogether, there are eight of these Burgundian vestments. Together with accompanying altar coverings, this set constituted a so-called "chapelle entiere," which was used only on special feast days when a *Missa Solemnis*, or solemn mass, was celebrated by this highly ceremonial and prestigious Order. These items have been described as "the most costly vestments in the world"; they have also been regarded as "the finest work achieved in the art of European embroidery."[18]

This spectacular set was probably commissioned by Duke Philip the Good of Burgundy. It would appear that these textiles were only given to the Order of the Golden Fleece at a later date, since no specific emblems of the order are embroidered on the

vestments themselves. Only the preference for the colour of crimson red may have a symbolic connection with the blood on the legendary fleece itself. These treasures were first mentioned in an inventory of the order in 1477, but appear to have originated, at least in part, in the years prior to 1450.

The designs of the figures, as well as the individual scenes, were inspired by many of the greatest Netherlandish artists working at that time, including Jan van Eyck, the Master of Flémalle, Rogier van der Weyden and Hugo van der Goes.[19] The layout of the two dalmatics, or liturgical garments, which are of particular interest for this study since they include St. Ontkommer along with other Burgundian saints, has been attributed to the workshop of Rogier van der Weyden.[20]

The main scenes depicted on the three pluvials, which were also a part of this set of liturgical garments, and were worn by the officiating priest and his two main celebrants, constitute the iconographic program of a deësis (a composition in which Christ represents God and is placed in the centre, while the Virgin Mary and John the Baptist are found on either side of him). The remaining design of the pluvials consists of multiple honey-combed segments which are filled with depictions of angels, prophets, apostles and a great number of saints. As a result, these vestments have rightly been called "a textile All Saints Feast."[21]

While the dalmatic worn by the deacon features three rows of male saints, the other vestment, called a tunicle, was worn by the subdeacon and displays female saints in three rows. On the back of the tunicle, the first saint in the second row on the left side can be identified as St. Ontkommer, or Wilgefortis, on the basis of her beard and of the cross she is holding. In the other panels, saints such as Apollonia, Martha, Cecilia, Christina, Agnes and Dorothea can be recognized, but there are many other, less familiar saintly women who were significant as local patrons of specific French and Netherlandish sites at that time.[22]

In one of the most significant publications concerning these treasures, Wilgefortis (Kümmernis) is described as "bearded, crowned, with the cross, in a blue dress with red used for the belt and the lining of the sleeves, while the undergarment and mantle is green."[23] As was the case with the Master of the *Morgan Infancy Cycle* who was discussed earlier, the saint is portrayed here as standing, while holding a large cross with both hands. Pieces of rope are seen dangling from the cross and are grasped by her right hand; these details characterize her as a victorious

martyr who has been liberated from the cross, especially since she is standing, rather than helplessly hanging from the cross. Holding the cross triumphantly in her arms can also be interpreted as personifying her as Faith in a general sense, especially when the work is viewed from a distance, from which her beard is less readily visible.

One of the most delicate, and more traditional, depictions of St. Ontcommer can be found in an exquisite Book of Hours titled *Gebetbuch der Maria von Burgund*, or *Prayerbook of Mary of Burgundy*, a work which was probably illuminated in the late 1470s. This celebrated codex, which is preserved in the Nationalbibliothek, or National Library, in Vienna is arguably one of the most beautifully illuminated books ever created. It was produced for the richest heiress of Europe at that time, Mary of Burgundy, who was twenty years old and about to be married to Emperor Maximilian I of Austria. This prayer book was most likely a gift from her stepmother Margaret of York, who was a sister of King Edward IV of England. Apparently, several artists were involved in creating these extraordinary pages, among them Nicolas Spierinc, who may have worked on the scene portraying the "beata ontcommera."[24]

These pages, each of which portrays individual saints, are framed by luxurious borders depicting ornaments that are enlivened by depictions of plants and animal life. Medallion-like individual paintings have been inserted in these elaborate frames in order to introduce the text. In the case of St. Ontkommer, a prayer to God Almighty is displayed, in which the saint as virgin and martyr is assigned the role of an intercessor who facilitates divine mercy.[25] In this text, her feast day is not identified as the traditional July 20, but rather as February 2. There are other inconsistencies in the book, not only with regard to the overall layout, but also in terms of variations in artistic quality; these can be explained by the hasty nature of the production of this work in order to meet the deadline of Maria of Burgundy's wedding celebrations in 1477.[26]

On the specific page in question, Ontkommer's Tau-shaped cross seems to rise out of the ground on tree-like roots. The saint's rigidly outstretched arms are fastened by ropes to the transverse beam of a cross, while her long dress is tied tightly around her ankles, thus making her feet invisible. This detail adds to her sense of helplessness and exposure, in contrast to the loosely tied ropes hanging below her wrists which suggest her

liberating and unbinding powers. Her sad and inclined face features a small beard that covers her chin, while her head is framed by long curly hair. Two gesticulating men in expensive-looking clothing are seen standing at her right side under the cross; one of them most likely represents her enraged father. Additional details which help to increase the viewer's sense of space are two tiny figures who are seen descending down a slope behind her cross.

Another Netherlandish work of outstanding quality is a small painting created by Hans Memling in 1480, which is now housed in the Memling Museum in Bruges.[27] In this work, both Ontkommer and Mary of Egypt are singled out as prominent saints, in the sense that each one is individually portrayed on the outside shutters of the triptych. The painting was commissioned by Adriaan Reins, who, as the donor, is portrayed together with various saints on the inside of the small altar.

In this work, "Uncumber" is shown standing "with crown, beard and cross," but without ropes.[28] Her beard is so delicately indicated that it almost merges with the shadow surrounding her delicate neck. Mary of Egypt, her companion, is equally beautiful and slender, and is standing in a niche with a tiled floor. Mary of Egypt is portrayed as possessing a naked upper body, symbolic of her life as a repentant recluse, and is additionally identified by the three small loaves that sustained her in the desert.

It is possible that this small triptych, although serving for private devotions, was also created for the occasion of Adriaan Reins's reception as a Brother of the St. John's Hospital in Bruges in 1479.[29] Portrayed here as a full-fledged monk, he is surrounded predominantly by female saints, all of whom were commonly invoked in situations of sudden death and terminal illness at that time. In this connection, St. Ontkommer would have been of special significance to him, since she represented a source of spiritual support to the people who were cared for in the hospital environment to which he had devoted his services. Like her companions, she is standing victoriously and serenely in a relaxed pose, similar to the exquisite figure embroidered on the Burgundian vestment mentioned above.

Between 1500 and 1515, Hieronymus Bosch painted a splendid but little-known altarpiece, now situated in the Doge's Palace in Venice, which portrays a crucified woman who has been identified as either St. Julia or St. Liberata.[30] The lives of these two

holy virgins were similar in some respects, so that this confusion might have been justified. Julia of Corsica was a noble maid who had been born in Carthage in the early Christian era; she was sold to a rich Syrian merchant named Eusebius who brought her to the island of Corsica. Since she refused to make sacrifices to heathen gods, she was crucified at the behest of the local governor Felix; monks found her body and later brought it to Brescia.[31]

In Bosch's painting, the female martyr is depicted as regal and beautiful, while the man below the cross has collapsed to the ground in an undignified and pathetic manner. One suspects the artist's sarcastic sense of humour played a role in this respect, especially since he has deliberately reversed the male-female roles of traditional crucifixion scenes in this work. While Christ has been replaced by a female martyr, the mourning women below the cross are replaced by a man who seems too drunk to show grief, let alone remorse or compassion.[32]

While one cannot prove that this crucified lady is meant to represent Ontkommer, her story would very likely have been familiar to Bosch, insofar as her iconography was firmly established in his homeland at the time. On the other hand, Bosch might have painted this triptych during a trip to Italy, or the painting could also have been commissioned by Italian merchants or diplomats who were working in the Netherlands.[33]

It is interesting to note in this connection that even an Italian art historian, Dino Buzzati, had identified this painting as depicting the martyrdom of the Netherlandish saint. Buzzati was convinced that Bosch had intended to represent not St. Julia, but rather "Ontcommer, cioe Liberata o 'Virgo Fortis,'" [Ontcommer, that is to say Liberata or Wilgefortis.] He also quoted Zanetti's study of Venetian painting, written in 1771, in which this panel was ambiguously described as portraying either a male or a female martyr, but not specifically St. Julia.[34]

In Bosch's painting, the addition of a beard to the beautiful female martyr is so subtle that one could almost miss this crucial detail. Given the presence of the beard, however, she is clearly intended to represent St. Ontkommer. It is possible that Bosch was aiming to please both southern and northern customers in this regard: Italian patrons could relate to the image representing St. Julia, the patron saint not only of Corsica but also of the city of Livorno.[35] At the same time, Bosch shrewdly managed to merge this image with his own local tradition, exaggerating the role of the grotesque man under the cross who was traditionally

intended to represent either the father of the crucified saint or a frustrated suitor.

Bosch painted this saint, dressed in luxurious clothes, in radiant colours. For her dress he used bright green; for her mantle, red. Although she is tied to the cross, she seems to hover weightlessly and with open eyes, without any indication of pain or bloodshed. Her hair is long and beautiful; she also wears a crown, a detail that would be surprising in the context of St. Julia, who was of noble birth but had been sold into slavery, unless the crown is meant to be a symbol of her martyrdom. St. Ontkommer, on the other hand, was always a royal princess, and is typically portrayed as wearing a regal crown. The saint's feet are not visible, since her long gown is gathered by ropes below her ankles. Even this detail, however, connects her with other portrayals characteristic of St. Ontkommer.

Additionally, it has been imaginatively suggested that this saint might symbolize a Christian version of Daphne, a beautiful nymph, who with divine assistance had escaped after being pursued by Apollo, and who had preferred painful transformation to the loss of her virginity. When viewed either as representing Ontkommer or else a Christian Daphne, these paintings do not denote distress or trauma, but rather, portray calmness, thereby celebrating moral strength and victory. In this way, an otherwise gruesome theme becomes "an edifying image of faith."[36]

Bosch was active at a time when the intense piety of the Middle Ages had reached its climax. The main attitude expressed in devotional literature during the artist's lifetime was the *Imitatio Christi*, a spiritual orientation that advocated total acceptance of, and submission to, God, in the face of all adversities. Thomas à Kempis, the main author of this spiritual movement, was joined by other theologians and mystics during the fourteenth and fifteenth centuries, all of whom believed that suffering was a divinely ordained agent which served to purify the soul in the same way that fire purifies gold.[37]

From this perspective, pain was not shunned, but rather, prayerfully invited and welcomed as a special sign of grace and divine election. Furthermore, it was believed that sacrifice and martyrdom prepared the human soul for mystical union with its "divine lover." Some popular images in illustrated manuscripts of that time show Christ carrying his cross, followed by a personification of human love or *Minne*, who, while portrayed as

carrying her own cross, is also tied to Christ by a rope that extends from his waist and pulls her along behind him.[38]

In a similar way, Mary Magdalene, when portrayed as embracing the cross at Golgotha, was also seen as personifying the ideal of the *Imitatio Christi*, in that she was the primary example of a penitent sinner who sought oneness with Christ through her own sorrows, thereby dedicating her life to remorse and tearful self-denial. In this manner, a number of different saints, identified by various symbols, served to communicate various pious messages, including one that stated that Christ was ready to embrace as his bride those who had become worthy of him by suffering through personal ordeals of their own.[39]

The veneration of St. Uncumber in England developed in a somewhat different, and not always positive, direction. Ultimately, in fact, it degenerated into gross superstition. Almost all of the shrines and images of this saint were lost due to the zeal of reformers under the reign of Edward VI, "whose commissioners valued her clothes," and consequently removed them from at least two of her cult sites, including Worstead, Norwich, and Boxford, Suffolk.[40] As a result of such acts of vandalism, it is difficult to gain a balanced picture of her significance in medieval England.

However, the veneration of the *Volto Santo* had an established place in English history long before this image was misinterpreted as depicting a female saint. King William II (known as William Rufus), for example, who ruled from 1087 until his death in 1100, swore by the *Volto Santo*. His favourite oath, in fact, was "per vultum de Luca", or "by the Holy Face of Lucca," an expression he frequently used in anger, but also in surprise or approval, as recorded on several different occasions throughout his lifetime. Apparently, it was characteristic for a medieval king to utter a special personal oath; other kings apparently swore in somewhat stranger ways, including by the eyes, feet or even teeth of God.[41]

A sculpture of a "draped" crucifix, albeit missing its head, has been preserved in Langford, Oxfordshire. Dating from around 1000, this remarkable work, with delicate hands and a straight body robed in a long, belted gown, was certainly understood to represent Christ.[42] In the course of time, however, the connection to the "holy face of God" of Lucca, as well as the meaning of the robe as a symbol of the cosmic Christ, were forgotten. Instead, a bearded female martyr connected with a very different range of symbols emerged in their place.

While Wilgefortis is not included in English martyrologies, a hymn was nevertheless written in her honour and included in a prayer book published in 1533 for use by the diocese of Salisbury:

> Hail, holy servant of Christ, Wilgefortis, you loved Christ with all your soul; as you spurned marriage to the king of Sicily, you kept faith to the crucified Lord. You suffered the torments of imprisonment by order of your father; a beard grew on your face, a gift you obtained from Christ because you wished to be His; you confounded those who wished you to marry. When your impious father saw you thus deformed, he raised you up on the cross, where you quickly in your virtue gave back your pleasing soul, commended to Christ. Therefore, we reflect on your memory with devout praise, O virgin; O blessed Wilgefortis, we request you to pray for us.[43]

Images portraying this saint were apparently not created across the country, but only in certain regions, especially East Anglia, since the latter "had close trading connections to fourteenth century Flanders."[44] Therefore, it appears likely that the English veneration of St. Uncumber originated in the Netherlandish veneration of St. Ontkommer sometime after 1400. After 1500, however, this cult increasingly met with criticism and derision, due especially to the onset of the Reformation.

The most extraordinary figure of St. Wilgefortis or Uncumber can be found in Westminster Abbey in London, in the chapel of Henry VII. This chapel, begun in 1502 and "almost complete" in 1512, contains "what is probably the most complete series of saints in Europe." Ninety-five statues on the inside of the chapel have been counted, while additional statues on the exterior have disappeared over the years.[45]

The statue of Wilgefortis is located in a prestigious place on the right side of the tomb of Henry VII. There, she forms a group together with four other female saints, including Dorothy and Barbara, and also (presumably) Martha and Mary Magdalene. On the left side of the tomb is a corresponding assembly of other holy women, who are grouped together with one male saint, Matthew. Wilgefortis is characterized by a full beard and a wreath-like crown; she is immersed in reading a book which rests on a Tau-shaped cross which has been placed in front of her body. This cross appears to have the function of a lectern. With regard to this portrayal, the saint has been described as:

A virgin saint who was so pestered by lovers that she begged Heaven to allow her to grow a beard to disgust them. Her legend was probably derived from an ignorant person who saw a draped crucifix of the ancient Lucca type for the first time and mistook it for the figure of a woman. St. Uncumber was in favour with unhappy wives who wished to be relieved of their husbands.[46]

This last reference to the role of this saint, while admittedly based on subsequent popular superstition, cannot be said to have applied to her depiction on this specific tomb. For instance, it would not at all explain why the king and his queen were motivated and inclined to include Uncumber among their favourite saints on the exterior of their tomb. Rather, what is being commemorated here is St. Uncumber's compassionate role as someone who would assist her faithful protégés in their final hour, so that they could die "un-encumbered" by grief and anxiety.[47]

The various remarkable figures surrounding the tomb of Henry VII express great dignity and solemn monumentality. In order to make them appear even more memorable and distinctive, many of them wear fanciful hats and elaborate robes. These statues were created at the very end of the Gothic era by various local craftsmen. On the tomb itself, the king and his queen are portrayed in a traditional pose, lying side by side dressed in regal attire, with their hands folded in prayer. This tomb was carved by Torrigiani, a pupil of Michelangelo who, with this work, introduced the Renaissance era in England.[48]

By the end of the Gothic era, after 1500, St. Uncumber had increasingly become the focus of superstitious veneration, often being used by women for self-serving, sometimes even devious ends. In the *Dialogue Concerning Heresies* of 1529 (Book II, chap. 10), Thomas More sarcastically discussed various saints and their shrines, and also expressed the obsession with obtaining relics from them. In an especially biting passage, he concentrated on St. Wilgefortis:

> For she, the good soul, is, as they say, served and content with oats. I cannot see why this should be so unless because she has to feed a horse for an evil husband to ride to the devil on. For that is the thing for which she is sought—so much so that women have therefore changed her name, and instead of St. Wilgefortis, they call her Uncumber, since they reckon that for a peck of oats she will not fail to uncumber them of their husbands.[49]

Here, we learn of the interpretation of the saint's name that specifically dealt with women trapped in dysfunctional marriages; we are also informed of her function as the patron saint of farm animals, in particular of horses. This combination failed to make sense to Thomas More's critical mind. He was apparently not aware of the tradition on the continent according to which Wilgefortis protected both the fertility and the general health of people and of their livestock—a tradition that commanded popular respect in southern Germany, among other regions, until well into the nineteenth century.

Another source concerning the apparently questionable role of St. Uncumber can be found in the town of Worstead, a site once famous for its cloth manufacturing. In the local church of St. Mary's, begun in 1389, a rood screen features "one of the strangest English saints, Maid Uncumber or Wilgefortis." A popular verse connected with her image stated "if ye cannot slepe, but slumber, Geve otes unto Saynte Uncumber."[50] This rhyme was originally written by John Bale (1495-1563), an Irish bishop and sometime satirist who ridiculed the alleged powers of various saints.[51] This reference harkens back to the traditional practice of bringing oats as an offering to the saint in order to win her favours, similar to the explanation that had been provided by Thomas More. The visual image in Worstead, a tempera painting on a wood panel ca. 1512, was badly damaged by the iconoclasts of the English Reformation; nevertheless, the saint can still be recognized as the crowned and bearded princess who is bound to the cross with ropes around her hands and feet.[52]

For people of that time, the steps required to engage such a protectress would probably have seemed quite sensible and straightforward. In difficult circumstances, individuals were willing to bring votive offerings, and in return gain support, or at least the assurance of future relief and timely intervention. Personal concerns, especially regarding family relationships and property claims, appear to have been so urgently felt at times that even a mere object could serve purposes similar to images of St. Uncumber. For example, the village of Winfarthing in Norfolk became a pilgrimage centre at around this time due to an allegedly miracle-working sword. In a publication dating from 1563, *Reliques of Rome*, this venerated weapon was referred to as "the Good Swerd of Winfarthing." It was said to assist people not only in retrieving lost and stolen objects and goods such as horses, but also, in a more superstitious and even cynical

sense, in assisting women to free themselves of an unwanted spouse: "It helped also to the shortening of a married man's life if that the wyfe was waery of her husband would set a candle before that swerd every Sunday for the space of a whole yere, no Sunday excepted."[53]

It comes as no surprise to learn that such practices as praying for somebody's early death eventually helped to undermine the respectability of some religious traditions, including the veneration of various saints.[54] Once superstition, occult practices and psychological abuse had distorted and replaced former sources of spiritual support, the established medieval tradition with regard to St. Uncumber was doomed to become obsolete.

Chapter 5

"Wilgefortis Sive Liberata": The Bavarian Cult of the Female Crucifix in Neufahrn

H aving previously examined the depictions and associated veneration of St. Wilgefortis in medieval Holland and England, this chapter focuses on the saint's rise to prominence in Bavaria. In particular, it examines the wide variety of functions and purposes that came to be associated with the female saint over the course of several centuries, as well as the multiplicity of images depicting her in a variety of theological and other contexts.

The settlement of Neufahrn was first described in 804 as being located in close proximity to an ancient Roman road. By 810, a church belonging to the domain of the bishops of Freising had already been built there. The main Gothic structure of the church, however, dates from the fifteenth century. The church was probably reconstructed in 1441, at a time when indulgences were being granted to Neufahrn by the bishop of Freising. In 1466, the church was endowed with a private sponsorship, which enabled the reading of masses in honour of the Holy Spirit. In 1499, the church was rededicated, apparently to St. Bartholomew and later, during the Baroque era, to St. Wilgefortis. Today the church is officially dedicated only to the Holy Spirit,[1] in spite of the fact that the most significant works of art within it, such as

Notes to chapter 5 are on pp. 146–147.

sculptures, oil paintings and frescoes, all celebrate the cult of St. Wilgefortis.

The most famous of these objects is the wooden statue in three-quarter life-size, which depicts a crucified and crowned figure dressed in a long robe. This statue has been dated to the early twelfth century, and is one of the oldest sculptures to be found anywhere in Germany. This crucifix was apparently intended as an imitation of the *Volto Santo* in Lucca, which, as mentioned earlier in this book, was one of the most venerated images of the Middle Ages, and was even mentioned by Dante in his *Divine Comedy* (*Inferno* XXI, 48). Both the Italian and the Bavarian statues reflect the ancient Oriental and Byzantine tradition of the fully robed and crowned Christ on the cross, who is portrayed as having triumphed over death.

The Neufahrn crucifix was damaged in a fire in 1580, but was restored around 1600, with special attention being devoted to the left arm, right finger, toes and hair. Additionally, the statue as a whole was given several new coatings of paint. This crucifix was later placed into the centre of the Baroque high altar (in or around 1660) with an inscription below the crucifix that reads: "S. Wilgefortis. Sive Liberata, V.M. 1661. H. Jungfrau und Martyrerin Ohne Xhümmernuss Bitt für Uns."[2] In this manner, the crucifix was identified as representing a female virgin and a martyr who was venerated under the three different names of Wilgefortis, Liberata and Kümmernis. It is possible that this robed crucifix had not originally been venerated as a woman, however, and was only specifically identified as a female martyr at some point during the Baroque era.[3]

In 1797, the Romanesque statue on the high altar was again restored because the wood on the inside of the carving had begun to show signs of decay. During the course of a restoration in 1878, a painter identified only as Kufner attempted to eliminate what was then considered to be "the abhorrent facial expression of the crucifix"; fortunately, however, the entire building and all works of art in it were subsequently cleaned and restored to their original appearance of 1660.[4]

During the course of the Baroque era, the medieval crucifix of Neufahrn became the focus and centre of extensive pilgrimages. During the eighteenth century, about sixty processions to Neufahrn took place in any given year. Since Wilgefortis, according to her widespread legend, had rewarded a poor fiddler, she had also become the patron saint of min-

strels and artisans. The musicians' guild in nearby Munich was particularly involved in organizing pilgrimages to Neufahrn; members of this group annually donated a large candle in her honour, and featured an image of the saint on their guild's banner. But it was not just musicians who came to pray to Wilgefortis for protection and prosperity; she was also the patron saint of domestic animals, as several of the *ex votos* in the church demonstrate. In many cases, she was implored to alleviate marital stress and family violence. Additionally, she was viewed as instrumental in granting fertility to humans and animals alike. In 1607, the chaplain of nearby Eching, one Gregorius Hörll, recorded a total of forty-five miracles in Neufahrn which had occurred during a span of fifteen years and were believed to have been performed by her. Between 1738 and 1740, various other miracles were recorded in the archival documents of this church.[5]

Over time, Neufahrn became the centre of the cult of Wilgefortis for all of southern Germany. Indeed, pilgrimages continued well into the nineteenth century, with some taking place as recently as the 1950s. As late as 1920, three annual pilgrimages were still being conducted by villagers from the surrounding countryside.[6] Unfortunately, many of the *ex voto* paintings which had decorated the walls of the church, and which commemorated answers to prayers over the course of four centuries, were deliberately burned on Good Friday of 1905 in order to eliminate what some believed was a local superstition and aberration from the true Catholic faith.[7] Nevertheless, twelve *ex voto* paintings, dating from the sixteenth to the early twentieth centuries, have survived in the church. They give testimony to a continuous local tradition of the veneration of the crucified female saint.

It is not possible to establish exactly at what point the Romanesque crucifix began to be interpreted and venerated as a female saint. In 1527, however, local legends concerning the discovery of a miracle-dispensing robed crucifix, and the subsequent transportation of this holy object to Neufahrn, were documented in seven large panel paintings. In 1607, the local chaplain, Gregorius Hörll, carefully recorded the Neufahrn legend concerning Wilgefortis-Kümmernis in the last pages of a fifteenth-century liturgical book which is currently preserved in the State Library of Munich.[8] The German text of this legend begins with the following words:

Anno dni IHS Maria 607 [sic] 20 Martij. Das Leben Leiden und
Sterben der h. Jungfrauen S. Kumernus, Welche In dem Jare 1403
erhebt und in die Zall der Heiligen geschrieben ist worden. De
vest allemal an S. Dionisij abend felt (9. Oktober).[9]

 This text establishes the fact that the crucified female saint
had been venerated since the fifteenth century. In 1650,
Electoress Maria Anna, second wife of Elector Maximilian I, had
inquired about this crucified saint in a letter to the local abbot,
Gregor von Weihenstephan, who in turn was only able to refer to
an "old church book" as a source for further information — a
book that unfortunately does not exist any more, but which may
have originated in the Netherlands. Since the Bavarian court had
close political connections to the Netherlands during the fif-
teenth century, it is possible that the legend and cult of this saint
had been brought to Bavaria from the Netherlands rather than
from Italy.[10]
 In 1661, the year in which the new Baroque high altar had
been dedicated to St. Wilgefortis, her legend was recorded in
Munich and a copy of the resulting text was displayed on a tablet
in the church of Neufahrn. Around this time, the legend of the
poor fiddler, who had been rewarded with a golden shoe that
had dropped from the feet of the saint, was added to the previ-
ously existing legend of Wilgefortis in Neufahrn. The Bavarian
text of this tablet in Neufahrn can be translated as follows:

St. Commeria or Wilgefortis was the daughter of a heathen king
of the Provence or Sicily. By a pious man she was converted to the
Christian faith, and vowed to remain a virgin like the Mother of
the Lord. Her father, however, designated her to become the wife
of a heathen king of Portugal. She declared that she was a
Christian and would never accept an earthly man as her husband.
Enraged about this, her father had her tortured with red hot irons
and she was cast into prison, until she would follow his will and
make sacrifices to idols. But the imprisoned saint implored the
Lord to disfigure her in such a way that no man would ever
desire her. Thereupon she took on the appearance of a man, and
a rich beard framed her face. When her father saw her again, he
was horrified. He asked her what had reduced her to this state.
When she declared that she had asked the saviour who had died
on the cross to take all beauty from her in order to make her
resemble him, her father had her nailed to a cross so that she
would indeed resemble the dying Christ. But she praised God
and preached from her cross for three days, in such an intense

manner that many thousands of people, even including her father, were converted to the Christian faith. In order to atone for his crime, the father thereupon built a church in honour of St. Scholastica; inside it he placed an image of his daughter cast in gold. Many miracles were said to have taken place here in the years that followed. The body of the saint rests in Steinwart [*sic*] in the sand, or in Pöringen in Holland. There it was ceremoniously elevated in 1404.[11]

The popular story of the fiddler, which had been incorporated into the Bavarian version of the legend by the seventeenth century, was based on miracles which were said to have been caused by the *Volto Santo* in Lucca during the Middle Ages. The story, as recounted in differing versions throughout Central Europe, caused the robed crucifix to become particularly popular among musicians.[12] A woodcut created by Hans Burgkmair ca. 1507 portrays the poor fiddler kneeling at the feet of the crucifix. Interestingly, however, the statue is identified both as *Volto Santo* and as Wilgefortis, whose lengthy Netherlandish legend appears on the same page. Burgkmair, a humanist and court artist under Emperor Maximilian I, thus encouraged the fusion of (or rather the confusion between) the crucified male and female figures which in turn encouraged the spawning of numerous further variations of the legend, such as the one from Neufahrn.

The high altar at Neufahrn, with its Romanesque crucifix that is identified by the Baroque inscription as female, does not actually include the kneeling fiddler. Instead, it is angels who surround Wilgefortis, the two largest of them genuflecting, and pointing to her various names in the tablet situated below her, while smaller *putti* prayerfully and joyfully encircle her. In contrast to other portrayals of the robed crucifix that follow the *Volto Santo* tradition, Wilgefortis does not wear shoes that can be dropped. Rather, her nude feet are firmly placed on a *suppedaneum*, a supporting ledge for the feet; this detail would make her giving of a shoe impossible. Her dress is simple and straight; it clings tightly to her body, although not specifically suggesting a female form. The arms are horizontally extended, with large nails piercing her palms. Her hair falls in big waves behind her shoulders, and her beard and moustache, although short, are quite distinct. A large crown, which was added during the Baroque era, reaches to the top of the cross. Golden rays and clouds surround her head and upper body, heightening the religious significance of the statue.

In addition, the shrine of the high altar is surmounted by a sculptural group depicting the coronation of the Virgin Mary by both Christ and God the Father, while the dove of the Holy Spirit hovers above her. Standing to the side of the shrine are statues of St. Bartholomew and St. Mary Magdalene, who were at the same time the patrons of each of the two side altars. Above them one finds smaller statues of the saintly bishops Korbinian and Lantpert, figures connected to the bishops of Freising. At the summit of the high altar is a statue of St. Michael, who is seen weighing souls. This altar, with its unusual program and richly carved decorative details, has been attributed to the Freising sculptor Tobias Schmid. The side altars, although somewhat more modest in design, were also completed in 1661, and serve to accompany the splendid visual program of the high altar.[13]

In keeping with an understanding of heavenly hierarchies that would be acceptable to the Catholic church, the Virgin Mary is placed above Wilgefortis on the high altar. This superior position, however, is challenged by the larger and central position of the female crucifix in the shrine, which is visually the most crucial focus of the high altar. To people entering the church and not coming close enough to ponder the inscription at the foot of the cross, the statue might actually have passed as a figure of Christ on the cross, and was perhaps venerated in that way by some. Perhaps from the sixteenth century on, a certain blurring of the male or female aspects of this crucifix can be said to have occurred — the male one being more traditional, while the female one was more spectacular. The image of a crucified female martyr would have addressed a range of concerns, especially for afflicted women, which went beyond the mere veneration of a crucified Christ. The legend of the musician also becomes more intriguing from the perspective of gender relationships when the crucified saint is viewed as female. In particular, the roles of protectress of animals and patron saint of fertility could easily be connected with a female saint. Although the Catholic clergy had a vested interest in the ongoing flow of pilgrims to the site through the cult of a miraculous crucifix, there was also considerable unwillingness to glorify Wilgefortis at the expense of Christ or the Virgin Mary. This reservation expressed itself most vividly in the alteration of one of the fresco scenes on the ceiling, as well as in the destruction of many ex voto paintings in the church.

The five frescoes on the ceiling were originally created in 1715. These narrative scenes are in turn framed by festive stucco

garlands. The ceiling decoration was commissioned by the abbot Ildefons Huber from Weihenstephan, whose heraldic family crest can be found above the oratory on the south side of the altar room. The frescoes portray the local legend of the robed crucifix with imagery which is similar to the Late Gothic panel paintings situated in the sanctuary below.

One of the most daring and innovative scenes of the ceiling, however — one which originally depicted the glorification and apotheosis of Wilgefortis — was deliberately destroyed, and subsequently replaced in 1933 by the much more traditional scene of the Baptism of Christ.[14] This alteration suggests that the tolerance for the rather unorthodox cult of the female crucifix had its limits. These were apparently overstepped once Wilgefortis had become the sole focus and heroine of the ceiling. It was safer to replace this daring scene with a biblical story in which the Holy Spirit, to whom the church was dedicated, is glorified instead of Wilgefortis.

It is interesting to note that the remaining fresco scenes portray a more overtly male body than the robed figure in the seven panel paintings of 1527, from which the frescoes received their inspiration. Thus, the crucified body portrayed in the frescoes has very short hair and a short beard; the garment seems to be almost transparent, making the shape of the legs fully visible. Neither the upper body, nor the dress, indicate any specifically female forms. The figure looks almost naked, and the stars on the skin-like gown appear to resemble, at least from the distance in which these ceiling frescoes are seen, the wounds of the flagellation. Therefore, the appearance of the miraculous crucifix on the ceiling frescoes is based more on the Italian tradition of the *Volto Santo* than on the local Neufahrn crucifix, with its more feminine characteristics.

The first fresco above the high altar depicts a group of woodsmen discovering the crucifix, which is seen miraculously floating against the current on the river Isar in Bavaria.[15] One of the two men has struck the crucifix rather disrespectfully in the area of the loincloth-like belt in order to pull it ashore with his axe, whereupon the crucifix begins to bleed. In the second scene, which adjoins the previous one above the altar room, the local bishop of Freising, surrounded by his attendants, piously receives the crucifix after it has been pulled ashore.

The third scene is the largest and has been given a central position on the ceiling. Here, the bishop supervises the trans-

portation of the crucifix, which has been placed on a cart pulled by a pair of oxen. In the landscape background, heavenly rays of light are seen bursting through clouds in order to illuminate the crucifix, while a group of infirm people at the left side of the scene lift up their crutches to thank the miraculous image as they are healed.

The fourth scene has been replaced, as mentioned above, by the depiction of the Baptism of Christ, a fresco which not only interrupts the sequence of the story of Wilgefortis, but is also composed from a reversed viewpoint for the spectator. The fifth scene, placed on the ceiling directly above the organ, continues the narrative of the miraculous cross, depicting the painter who dared to cover it with the wrong colour (red instead of blue). The meaning of this story cannot be understood, however, since all of these ceiling frescoes are painted in grisaille — or rather in monochrome tones of brown; the colour of the garment of the miraculous crucifix was traditionally blue, symbolic of Christ's heavenly powers and cosmic reign. The agitated painter, with his outstretched hands and fiddle-like palette, resembles the figure of the poor musician who, in other depictions, had often been an integral part of the story connected with the *Volto Santo*.

Interestingly enough, the poor fiddler does not appear to play an essential part in these visual documents, since he is neither to be found anywhere near the main sculpture on the high altar, nor on the seven panels of 1527. Only one of the existing *ex voto* paintings in the church, which is also the oldest one, dated 1679, includes the fiddler. This is all the more puzzling since Neufahrn was particularly favoured and sought out by local musicians, as mentioned above. Since, in the Bavarian version, the miraculous crucifix floated along the river Isar before ultimately being housed in the church of Neufahrn, the fiddler has no obvious role to play here. On the other hand, the fiddler was part of the written Baroque text of the legend that was framed and hung inside the church.

The most remarkable depictions of the near-mythical discovery of the miraculous crucifix of Neufahrn are the unique seven large wood panels which together form a narrative group; only one of them is dated 1527. While these paintings cannot be attributed to any one artist, they are important examples of Bavarian local art and cultural history. Smaller tablets with written texts are inserted at the bottom of each of these panels, so

that the picture and the words are complementary. The first text in the German vernacular reads:

> Hie rindt das bild herauf auf der Yser, da haben yer etlich geholzt in der aw bey mindering hat ainer mit ainer axt daraufgeschlagen da ist pluet heraus gerunen. [Here the image floats upstream on the Isar, when some cut wood in the meadow near Mintraching; when one man hit it with an axe, blood appeared.]

This first scene graphically portrays two men wielding their axes, thus framing the large floating cross with their gestures. The river landscape is gracefully designed to surround the shape of the large crucifix; its outstretched arms appear to create a bay on the other side of the river, where a castle and a village are situated, surrounded by trees and mountains. The crucified body is dressed in a long blue robe held in place with a golden belt and is decorated with a golden neckline, hem and cuffs. A large crown has been placed upon the bearded head, which is in turn surrounded by a large halo. Both feet and hands are nailed to the cross, leaving dark marks on the body.

Plate 3
Miraculous
Crucifix
Neufahrn,
Bavaria

In the second panel we find the short inscription: "Here comes the bishop with the procession and lifts up the image." The bishop, at the head of his train of attendants, is seen bending down to retrieve the floating crucifix, which is partly in the water and which majestically fills the entire foreground of the panel.

On the third panel we read: "Here the bishop places the image on a cart and puts two oxen to it which pulled it to Neufahrn." This cart is barely large enough to hold the wooden crucifix; as a result, the bishop seems intent on balancing the cross between the large wheels of the cart. The oxen are conspicuously small-sized in order not to take attention away from the main figures. As in the previous panel, the bishop's attendants are lined up in a row, tightly grouped together behind the crucifix. The foreground is characterized by a road that leads to the distant church; only a little room is left above the heads of the attendants to include some trees, mountains and a cloudy sky.

The fourth image is identified by the inscription: "As soon as the image had arrived, a blind woman and a crippled man were helped." Here, the crucifix has already been placed inside the church. Six people have arrived to pay their respect to the image; three of them are portrayed in a kneeling position, while two others appear to have only arrived as they step through the

large openings at both sides of the sanctuary, which offer a view into the surrounding landscape.

On the fifth panel we read: "A painter gave the image the wrong colour red, and as soon as it was done he went blind." The same room as the one shown on the previous panel has now become the workshop of the painter, whose apprentice is busy grinding colours; additional tools are neatly arranged in front of him.

While the first four panels use an oblong horizontal format, the three final panels of the series change to a vertical format. This facilitates a closer view of the crucifix while also allowing a reduction in the number of persons present. On the fifth as well as on the sixth panel, we find only the painter with his apprentice, while the final panel includes only a single bystander.

Plate 4
Miraculous
Crucifix, 1527
Neufahrn,
Bavaria

The bright red colour of the gown of the crucified figure in the fifth panel is rather glaring, and is in sharp contrast to the blue gown which is seen in all the other panels. Even the boy on the left is wearing a bright red jacket, while the painter himself wears a red cap. It is interesting to note the text at the bottom of this panel, according to which the colour red was seen as an offence to the statue, so that the painter was punished by temporary blindness. As mentioned before, this occurrence can only be explained in view of the reverence given to certain traditions and symbols, including symbolic colours.

The disrespectful painter is portrayed as touching the red gown with his paint brush. His bulging eyes appear to be closed, thus indicating his temporary loss of sight. In the following sixth panel, the crucifix has again received its proper blue colour, and the painter is seen standing upright and looking eagerly upward, while his apprentice now wears a white shirt as he dutifully prepares a large amount of blue colour. The inscription reads: "He vows to restore it to its original form and he received his sight again." As previously noted, this is the only panel that is specifically dated 1527.

Since the style and the use of details is essentially the same in all seven panels, one can conclude that all of them come from the same time and the same South Bavarian workshop. This would place these paintings within the so-called Danube School at the height of the German Renaissance. The quality of the panels, however, does not allow for any comparison with the great masters of that period. Consequently, the Neufahrn panels are noteworthy only in a specific cultural and geographic context.

The seventh and final panel portrays the crucifix together with only a single additional figure, while a high ladder is placed at the left side. The inscription reads: "Two men tried to put up the image; the one hit the cross on the top when blood trickled out." This eerie event itself is not portrayed; instead, the presence of an empty ladder suggests that the man on the left side has escaped in fear, while the pious man to the right is found raising both of his arms in adoration. Behind his feet lies an axe. Though not stained by blood, this tool is the only reminder of the miraculous incident. The pious man's position is similar to that of the painter in the previous panel.

In this manner, the seven panels guide the viewer through the crucial stages of the discovery, transporting and housing of the miraculous crucifix at Neufahrn. Surprisingly, the crucified body depicted in these panels does not resemble the Romanesque statue on the high altar of the church, an image that is much more rigidly depicted—as seen, for instance, in its horizontally outstretched arms. In the medieval carving, the face is also more elongated and narrow, with larger eyes. It also features longer and wavier hair, which is parted in the middle of the forehead. The panels, by contrast, portray a crucified figure that looks more like a living person. The head, for example, is gently inclined; the gown is richer in its folds and wider around the ankles. The golden decoration on the neckline is conspicuously different, as well: while depicted in a long and narrow V-shape on the statue, it is round and curved on the panels. The crown on the painted figures is smaller and substantially different from that of the wooden sculpture, a fact which may reflect the existence of an earlier shape before another crown was added to the image on the high altar during the Baroque era. Also noteworthy is the difference in the feet; on the panels they are turned downward and pierced by nails, while the feet of the statue seem to stand freely and firmly upon a wooden support.

It is conceivable that the later Renaissance artist attempted to render the miraculous crucifix more realistic and contemporary. This hypothesis is not altogether satisfying, however, insofar as it was believed to be an offence to change the appearance of a venerated image—an issue which the fifth panel so vividly portrayed in the form of a warning and punishment. Another problem, in this connection, is the absence of the fiddler. The legend of the dropping of a shoe as a gift to the musician has no apparent relevance in the context of a crucified fig-

ure who has both naked feet nailed to the cross, as depicted in the panels.

A possible explanation for substantial variations in the depictions of the robed crucifix can be found in the fact that several traditions, expressed both in legends and through images, had reached southern Germany by the early sixteenth century. A relatively flexible approach to storytelling permitted the co-opting of new and different versions of, and additions to, tales such as the description of the miraculous cross floating along the Isar, with the result that Neufahrn was able to claim the miraculous crucifix as specifically relevant for itself. Thus, an imaginative adaptation of popular narrations could strengthen and consolidate the relevance of a pilgrimage site such as Neufahrn, creating a new basis for the offering to pilgrims not just of stories about supernatural events of the past, but also of claims concerning ongoing miracles.

Thus, the local adaptations of the legend concerning the miracle-working robed crucifix offered unique ways of personally connecting with a sacred image. On the basis of the works that have survived in Neufahrn, the identification of the robed crucifix as female does not apparently occur before the Baroque era. Thus, the local cult of the robed crucifix appears to have become linked with that of Wilgefortis-Liberata-Kümmernis shortly after 1600.

On the other hand, a panel dating from 1513 in Eltersdorf, near Erlangen, already identifies a robed crucifix, accompanied by a fiddler, as "the saintly virgin and martyr St. Kümernüss" [sic]. Additionally, the written description accompanying a woodcut created in ca. 1507 by Hans Burgkmair in Augsburg and accessible across southern Germany, indicates that the robed crucifix was understood to portray both a female saint and, at the same time, the *Volto Santo*. Therefore, an identification with the female crucifix could already be said to have existed in Neufahrn as early as the sixteenth century.[16]

The Baroque pulpit at Neufahrn, carved during the second half of the seventeenth century, portrays at its top a small but richly decorated statue of the robed and crowned crucifix, accompanied by a fiddler who is shown kneeling at the foot of the cross. The crucified saint has her hands nailed to the cross. Her feet, however, are hanging freely, thus allowing the dropping of a golden shoe, a symbol of the gracious reward that awaits not only the fiddler but also the faithful who trust in

miraculous heavenly powers. Here, it is the left shoe that has been dropped; this object appears to be suspended next to the fiddler's face, and is meant to be visible to the people gathered in the church below. The draped body is glorified with carved golden rays that seem to emanate from the cross. In a booklet which offers a complete description of the artifacts in the church of Neufahrn, this statue is identified as Saint Kümmernis,[17] in spite of the fact that the legend concerning the crucifix and the fiddler, as portrayed in the *Volto Santo*, could also be understood to be referring to Christ on the cross.

Among these Neufahrn artifacts, the first written identification of the robed crucifix as being specifically female can be found on an *ex voto* panel dating from 1679. St. Kümmernis is featured here, accompanied by her faithful fiddler, for whom she has dropped her golden shoe onto a white altar table. This small panel is also the earliest of the surviving votive paintings in the church. The date 1679 is part of an inscription that commemorates the miraculous healing of three children of a certain Hanns Breindl von Linsing through the miraculous power of this female saint. The children are clothed in white, a colour that emphasizes their tender age and frailty. Followed by their father, they are arranged according to size and age as they kneel in front of the female crucifix positioned inside an austere sanctuary featuring a red floor. The fiddler has been given considerable prominence in the centre of this otherwise unassuming composition. St. Kümmernis, dressed in a blue-green robe, is shown with her arms stretched out horizontally; her wrists are bound to the cross by ropes. Her light beard is of medium length, obscuring her neck, while her crown is relatively small and does not feature any special light effects.

This work is a typical example of the genre of religious folk art that was particularly popular during the Baroque era in Catholic Europe. In these expressions of popular piety, a miraculous healing or intervention by a heavenly being is celebrated and commemorated. *Ex votos* can therefore be regarded as painted documents of thanksgiving. Usually, one finds inscribed on them a brief identification of the donor who commissioned the panel, together with a date.

In the church of Neufahrn, twelve such *ex voto* panels have survived; each of them focuses on the miracle-working powers of St. Kümmernis, who is sometimes also identified as Wilgefortis. The frames around the paintings are in almost all

cases black and of simple design. Consequently, *ex votos* could be placed unobtrusively in rows and groups along the walls of the church. Today, they are displayed on the right-side aisle of the church, together with two other *ex votos* which separately glorify the Virgin Mary and St. Leonard.

In the *ex voto* of 1679, similar to the statue above the pulpit, the legend of the fiddler has received some visual attention. He is part of a tradition that had apparently not been connected, up to that time, with the Romanesque statue on the high altar. The seven large Renaissance panels, which were discussed earlier, also appear to have been created prior to the visual acknowledgement of the legend with the fiddler. The small *ex voto* of 1679 points to the fact that the Netherlandish type of the female crucifix, namely Ontcommer, whose hands were tied to the cross rather than nailed, existed side by side with other variations of the legend of Kümmernis, which were based more specifically on the *Volto Santo*.

The next oldest *ex voto*, dated 1733, portrays an elegantly dressed father who is seen kneeling before the sickbed of his child. The apparition of the Madonna and Child above the door of the bedroom is given central significance. A small image of the robed crucifix is positioned at the Madonna's side, and is placed directly above the patient's bed. The saint, who is not identified in this panel, even drops her legendary golden shoe onto the child's pillow as a sign of intervention and healing grace. In this painting, the saint looks rather masculine because of her pointed dark beard and moustache. Also different from other images of the martyr is the way in which her gown is gathered below her knees by ropes that tie her body to the cross. These ropes identify the crucified saint, once again, as the Netherlandish Ontcommer, who was called Kümmernis in Germany. In this *ex voto*, she is portrayed as an intercessor, directing human concerns to the glorified Virgin Mary. Although not in a central position, Kümmernis's cross constitutes a visual and spiritual bridge between the human and the heavenly worlds.

Plate 5
Ex Voto, 1751
Neufahrn,
Bavaria

Another *ex voto*, dated 1751, only features the initials "H.G." In this work, a woman is portrayed kneeling by herself in a chapel in which the robed crucifix is hanging above the altar. A red cloth of honour is spread behind the crucifix, while the altar is decorated with large candlesticks and vases of flowers. The praying woman has almost assumed the role of the fiddler in front of this crucifix, but no shoe is dropped for her since the feet

of the crucifix are firmly tied to the cross. A short beard delicately frames the gentle face of the crucified figure, which looks more feminine in this instance due to the absence of a moustache. In spite of the lack of an inscription, one can assume that, on the basis of other, similar depictions in the church, this crucifix was intended to portray Kümmernis.

A further *ex voto*, dated 1759, is identified neither by names nor by initials. Here, a man is seen kneeling in prayer in front of the sickbed of his wife. The robed crucifix above the pious man is placed on an elaborately decorated altar which also features two candlesticks. A canopy-like crowning with richly gathered red curtains frames the robed crucifix. The crucifix appears rather feminine, especially in the absence of a moustache. The body, with its narrow waist and curving outline, also suggests a female rather than male figure.

An *ex voto* from 1776, in turn, portrays the robed crucifix as surrounded by four flying *putti*. Since other human beings are not included here, the panel has been symmetrically designed, and addresses itself more to the viewer rather than portraying a particular story of healing. The robed figure on the cross, while turned slightly to the right, is presented as a focus for meditation and contemplation. The empty steps in front of the delicately designed altar room invite the viewer to come forward and participate in the veneration of this crucifix. Due to the beard, moustache and straight body, this figure clearly possesses a male body, in spite of the slight indication of female breasts. The depiction of nails as well as ropes on the hands and wrists suggests the reliance on a dual tradition which has, once again, merged both the Italian *Volto Santo* and the Netherlandish Ontcommer into the same devotionary image.

Another *ex voto*, this one dating from 1777, is identified by the long name "Antonius Wild Herrn Wierth von Greinöcktz." A husband and wife are portrayed as praying the rosary in thanksgiving while kneeling near their herd of cattle in an open landscape. A female crucifix is seen suspended on heavenly clouds above them, together with St. Leonard, who is shown kneeling, his prayers apparently directed to the crucifix. According to Catholic tradition, both saints were venerated as patrons of domestic animals, and both were invoked in cases of diseased herds. Here, the healing of the animals is portrayed by showing them peacefully grazing on a meadow below the two saints. The robed crucifix is the predominant image in the sky due to a red

cloth of honour which is spread behind the cross; this colour is in stark contrast to the blue of the robe which the crucified figure is wearing. Additionally, white rays emanate from the nude feet and touch the animals with healing extensions of light.

The childlike and rather plump proportions of this *ex voto* are very different from the regal severity of the medieval crucifix on the high altar. One is left wondering to what extent this commanding statue may have influenced the design of the other *ex votos* in the church, because details and colours appear to be chosen in a rather free and flexible manner.

Another *ex voto*, dating from 1790, reinforces the idea that "St. Virgin and Martyr Kummernus," as she is called, is the protectress of horses and cattle. Here she has, once again, miraculously healed those who turned to her for help. The inscription, although partly damaged, makes it clear that the prayers of the kneeling man have been answered. The crucified female saint is depicted to the right of a mountainous landscape. She is suspended above the animals, her hands not only nailed but also tied to the cross. Rays of healing light emanate from her upper body toward the horses and their owner. The sky is illuminated by soft reddish hues, symbolizing the saint's heavenly abode.

An *ex voto* from 1798 portrays a similar situation, with a proprietor identified as "Johanes Dalmair Engl. von Giettersam" and his wife praying in the midst of their domestic animals. The heavenly realm is shared by the crucified saint, who is surrounded by a red cloth of honour, and the kneeling St. Leonard, whose chains are visible on his hands. In the centre of the painting, between the saints, an ornate and yet simplified cross, outlined in red, serves to indicate the presence of Christ. This abstracted cross, however, makes it clear that the crucified saint on the left is certainly not Christ, but rather Kümmernis. The latter is, once again, paired with St. Leonard, both of whom were patron saints of cattle and livestock.

Only two *ex votos* from the nineteenth century have been preserved, one dating from 1840, the other from 1890. In the former, the Baroque tradition is kept intact. Here, the panel portrays the saint, who is unmistakably female and without a beard, as tied to a cross which is placed in the midst of numerous cows, pigs and horses. In the left background, a small church building is depicted, featuring a crucifix on its side wall. The inscription attests to the fact that the entire community of Geisenhausen had pledged itself to St. Kummernuss because of an incipient cattle-

Plate 6
Ex Voto, 1840
Neufahrn,
Bavaria

plague, which had, however, been miraculously overcome with the help of God.

The second *ex voto* is painted in an entirely different style, although it originated in the same community. It commemorates the 173rd pilgrimage ["Bittgang"] of the inhabitants of the previously mentioned Geisenhausen to Neufahrn on May 25, 1890 in honour of the virgin and martyr St. Wilgefortis. The inscription includes a prayer to the saint, who is implored to intercede before the throne of God on behalf of her people, so that God's mercy will save them all. In this panel, a highly realistic portrait of the village of Neufahrn is seen in the distance, while the crucified saint, supported by two angels, hovers in the cloudy sky. Her dark green robe is somewhat atypical, while her large golden halo adds unearthly splendour to her appearance. The rigid and horizontally outstretched arms, with their hands and feet nailed to the cross, together with her male, bearded face, are reminiscent of the *Volto Santo*, albeit in a somewhat modernized style. The two angels at her feet, clad in red and blue and equipped with large white wings, add a romantic touch to this heavenly scene.

Plate 7
Ex Voto, 1890
Neufahrn,
Bavaria

The final two examples of *ex votos* that honour the female crucified saint date from the first half of the twentieth century. The earlier one, dated May 15, 1921, and signed "A. Priller" commemorates the two hundredth anniversary of pilgrimages conducted by the inhabitants of the Geisenhausen parish in honour of St. "Willgefort" of Neufahrn. A short prayer to the saint, consisting of the words "Kümmernis pray for us," is printed in the upper left-hand corner. The saint, surrounded by a circle of clouds and a sphere of radiant light, is dressed in a red gown. This unusual choice of colour, which had been regarded as offensive in one of the large panels of 1527, seems to have been chosen in this case for purely artistic reasons. In any event, red, rather than blue, highlights the saint's appearance more effectively against the pale blue sky and also establishes a visual link to the reddish rooftops of Neufahrn below her. The village is thus spiritually connected with her benign presence. Her hands and feet are nailed to the cross—details that follow, once again, in the Italian tradition. Her face features a dark beard and moustache, which give her a notably masculine appearance, and she carries a huge and ornate crown of almost oriental splendour upon her head.

Plate 8
Ex Voto, 1921
Neufahrn,
Bavaria

The most recent *ex voto* in the church of Neufahrn was donated by the family of Otto Gleixner from the village of

Mintraching-Vötting on August 19, 1944. Here, St. Wilgefortis is implored to help liberate Gleixner's son from Russian imprisonment. From the inscription we learn that she can do this because she also once helped a poor fiddler in his hour of need. This inscription, expressed in simple rhyme, also includes a short prayer to the saint. Here, all of the elaborate details, such as landscapes or interior scenes, which had characterized the other and earlier *ex votos,* are excluded. Instead, the figure of the female saint is outlined in an almost abstract and simplified way.

In addition to these various *ex votos,* a small modern statue of Kümmernis can be found on top of a processional pole which is featured on the left side of the altar room. The presence of this statue is a further indication of the fact that the crucified female saint, characterized by a dark beard and moustache, continued to be seen as relevant as recently as the twentieth century. Apparently, the statue was carried to the pilgrimage site of Altötting in the 1940s in order to touch the famous Black Madonna there. This event is recorded on a framed document, displayed next to the other *ex votos* featured on the church wall.

In the town itself, painted on the side wall of a house on the main street, one can find a series of simple murals commemorating the importance of Wilgefortis to the residents of Neufahrn. These grisaille paintings, signed "Huml 1971," portray the settlement as it looked in 1920. They also depict the miraculous discovery of the crucifix in the Middle Ages.[18]

Even in relatively straightforward depictions such as these, one sees evidence of the important place which the female crucifix has held in this community. In these illustrations, she is portrayed as beardless and delicately female — a reminder of the fact that the details of the face and body varied considerably, even as her name and legend continued to be venerated and commemorated over the centuries.

The Kümmernis Chapel of Burghausen in Bavaria

T his chapter elaborates on the Bavarian-related overview which was presented in the previous chapter by focusing on a specific, localized example of a chapel dedicated to the female saint. The ambivalent reaction of the local Catholic Church hierarchy to the veneration of St. Wilgefortis is presented as an example of the unfavourable, at times even overtly hostile, reaction of the Church to this phenomenon on a broader regional level.

The picturesque city of Burghausen is located in Southern Bavaria, near Munich. Situated on the river Salzach which, since the eighteenth century, has divided Germany from Austria, Burghausen has preserved its medieval appearance to a remarkable degree. It is noted, in particular, for a kilometre-long fortress, the Castle of Burghausen, which is Europe's longest castle. While the settlement of Burghausen originated in the pre-Christian era, the monumental castle was constructed during the Middle Ages. Duke Henry "the Lion" took possession of it in 1164, and shortly thereafter, the town and castle became the property of the Wittelsbach dynasty. From the thirteenth century on, the castle served as a residence for various dukes of Lower Bavaria.

Notes to chapter 6 are on pp. 147–148.

Prior to the sixteenth century, the castle of Burghausen held great military significance as a main arsenal; extensions were built onto its fortifications as a precaution against the advancing Turks at the end of the fifteenth century, as well as against the approaching Swedes during the early seventeenth century. After 1779, Burghausen became a border town, when the Innviertel region was lost to Austria. In 1800, advancing French troops damaged the castle so extensively that, in 1809, Napoleon declared it militarily insignificant. An extensive restoration of the picturesque castle, including its six different courtyards, was eventually completed in 1970.

In view of the region's military background, it comes as no surprise to learn that the most venerated local saint of Burghausen, Kümmernis or, alternatively Wilgefortis, was specifically invoked as a protectress of soldiers and prisoners. A sanctuary dedicated to her is situated several miles to the west of the castle. In modern times, this area has become part of the so-called new city of Burghausen. A pilgrimage church on a nearby hill known as the Hechenberg belonged to a different jurisdiction in the past — i.e., not to the city of Burghausen, but rather to the town of Mehringen (or Mehring). This fact tends to complicate archival research in the area since not all of the historical sources concerning the "Kümmernisberg" have necessarily been preserved in the archives at Burghausen.[1]

One of the earliest printed records concerning plans for the projected construction of a small church on the so-called Höhenberg (Hechenberg) near Burghausen can be found in a book about the history of the city written in 1862. Here, a reference is made to an earlier structure, a chapel specifically dedicated to "St. Kümmernis ([or] Wilgefort)."[2] The subsequent sanctuary, built between 1857 and 1864, was consecrated in 1865; an inscription on the church wall informed the community that this new sanctuary now included a dedication to the Virgin Mary as well, thereby honouring both "the blessed Virgin Mary and St. Wilgefortis, who was already venerated here at an earlier time under the name of St. Kümmernis after whom the mountain was also named" [i.e., the Hechenberg hill named after Joseph Hechenberger was *also* called Kümmernisberg]. The inscription goes on to note that the grounds on which the sanctuary was situated had been donated by a citizen of Burghausen, Joseph Hechenberger.[3]

An undated booklet, probably dating from the nineteenth century, enumerates litanies, prayers and hymns for various times of the day in the popularized and simplified tradition of a Book of Hours. This booklet was published in the town of Altötting, an even more prestigious pilgrimage centre at the time, and situated in the same area. These texts honour "the holy virgin and martyr Wilgefort, who is commonly called St. Kümmernis."[4] Throughout the twenty-two pages of this booklet, God is praised for having graced his people with this virgin saint, thereby providing a source of inspiration in what was seen as a valiant and continual struggle against evil, a spiritual fight for the very essence of humanity. "St. Wilgefort" is described here as a Portuguese princess who had heroically conquered "all enemies of the soul in the youthful prime of her innocence."[5]

In this booklet, the saint is also praised for having taught her followers to despise earthly beauty in order to achieve spiritual perfection. Reference is also made to the divine gift of a "rather large beard," a miracle that had proven instrumental in preserving her virginal innocence. In the aftermath of this divine intervention on her behalf in the past, the saint could now be called upon to help other people dedicate themselves to the highly prized virtue of lifelong chastity. The saint is praised as a "heroic despiser of the world" who had ennobled her followers and had helped to lead them to God. She is described as being "pure like angels" and the "beloved bride of Christ" who had yearned to hang on the cross in order to imitate Jesus, thereby possessing him in her heart and soul.

It was commonly believed at the time that each human being had to carry a cross, and that life consisted of nothing but pain and affliction. In this context, the saint was believed to offer the power of spiritual conquest to those who believed in her, strengthening them in their suffering in order to help them to achieve moral victories in their lives. In this manner, Kümmernis-Wilgefort was praised as a heroine of faith; private and communal prayers, as well as repetitive liturgies, were chanted to her in passionate supplication and fervent thanksgiving.

These prayers were officially directed to both the Virgin Mary and to "St. Wilgefort" in accordance with the orthodox Catholic tradition that emphasizes the pre-eminence of the Mother of God. In spite of this effort, Wilgefortis was the primary focus of veneration in this region at the time. In one prayer, she is poetically acclaimed as, among other things, the "bright

light from Spain," the "brilliance and protection of the Netherlands" and the "royal rose." In addition, the prayer celebrates her glorious virtues of meekness, purity, chastity, angelic behaviour, innocence, virginity, honour, divine love, patience and holiness. She is repetitively, but exuberantly, praised as being the faithful bride of Christ, a triumphant martyr, a sacrifice pleasant to God, a protectress of faith, and last but by no means least, a "conquering heroine of suffering," victorious over her enemies. She was also celebrated as the crucified bride of Christ, the hope of the poor, the refuge of the afflicted, the salvation of those who err and the great light of heaven.

On the basis of these exalted prayers and praises, it becomes apparent that St. Wilgefortis may have been comparable in importance with the Virgin Mary at that time, at least in the popular mind. It appears that the boundaries between these two holy women had become deliberately blurred and confused in the ongoing process of exuberant adoration. In the previously mentioned Altötting text, as well, St. Wilgefortis appears to receive more attention than the Mother of God, and consequently absorbs some of Mary's most glorious and divine titles in the process. This unorthodox fact may be explained by a popular trend among many of the people who lived in the vicinity of Burghausen at the time: they not only venerated St. Wilgefortis as a female saint who embodied most or many of the qualities of the Virgin Mary, but also as a woman who was more accessible than the "Heavenly Mother."

Following the concluding prayer to St. Wilgefortis in the Altötting booklet, there is a recommendation for the intoning of a series of Pater Nosters or Our Fathers and Hail Marys or Ave Marias. These additions follow upon the praises and prayers to Wilgefortis without any apparent contradictions in religious loyalties. On the contrary, some of these prayers serve to further affirm the unity between Wilgefortis and the Virgin Mary insofar as both of them are declared to be supreme heavenly beings.

Plate 9
Prayer Leaflet,
1909
Burghausen,
Bavaria
An illustrated prayer leaflet (Gebetszettel) published in Burghausen in 1909 has also been preserved over the years. Its title can be translated as "Legend of the holy virgin and martyr Wilgefort or Kümmernis with a prayer for specific concerns."[6] The front page portrays the crucified saint in the midst of a mountainous landscape; her hands are nailed to the cross, while her ankles are bound to it with a rope. In spite of these tight fetters she has managed to drop one of her shoes towards a kneel-

ing man; the sturdy object he holds in his hands resembles a weapon rather than a musical instrument, in that the raised bow looks like a drawn sword. In this way, the kneeling man is portrayed as being analogous to a strong soldier or brave knight who receives a blessing before going into battle—at least on a spiritual level.

The same leaflet includes a prayer in which the saint is fervently implored to have mercy on all of her supplicants. It was believed that as a result of her martyrdom and virtuous nature, "St. Wilgefort" had accumulated powers in heaven which could now be made available to suffering people who believed in her ability to help them. The urgency with which such prayers and pleas were uttered was believed to exert some pressure on the saint: believers even threatened not to stop pleading with her until they were heard. In return, they pledged to always love and honour her as their benefactor.

The Catholic Church tolerated these fervent popular cults even though they frequently bordered on outright superstition, while at the same time monitoring them with some unease and ambivalence. Pre-Christian traditions and figures from ancient Germanic and Celtic myths had already been incorporated into Christianity long before, with the beginning of missionary activities in Central and Northern Europe during the eighth century. Nineteenth-century scholars commonly believed that Kümmernis had been derived from an ancient pre-Christian divinity, either a bisexual earth mother or some other mythical figure who had set an example of self-sacrifice for her followers to emulate.[7]

At the edge of a forest near the Burghausen chapel, there was said to have been an ancient *Heidenstein*, or heathen rock, which was apparently the site of ancient sacrifices that might still have been practised as recently as the sixth century. The Catholic Church set about incorporating such local traditions by deliberately linking them with Christian saints and sanctuaries. In this way, the pagan cult of Burghausen became the cult of St. Kümmernis who was, in turn, associated with the Virgin Mary. However, this tradition was gradually phased out during the course of the nineteenth century as the cult of Wilgefortis waned in popularity. The chapel was stripped of its wax votives and devotionary paintings; only a few of these objects were subsequently collected by museums of folk art.[8] By 1922, only seven images of Kümmernis were still being displayed in the chapel

itself and only one of them actually featured her miraculous beard. These small panels originated in the nineteenth century and are of low quality, a sign that the Kümmernis cult had already declined in cultural significance by this time.

As late as 1925, however, Kümmernis was still attracting attention as a curious folk saint, at least from one local historian, Karl Huber.[9] According to this scholar, the saint had been dethroned over the passage of time, even though the common people continued to cherish and honour her memory. This historian quotes an earlier source from 1710, which specified that the first Kümmernis chapel, originally built of wood in 1693 and sponsored by Maria Hechenberger, had been rebuilt in stone in 1704 by her son Georg Hechenberger in thanksgiving for having regained his health. Before 1693, an image of the saint had been hung between two spruce trees as an outdoor shrine. From the Baroque era onward, the chapel was frequented by both travellers and local townspeople; they were joined by pilgrims who walked up to ten hours on foot to get there. This cult blossomed in spite of the fact that the official Church never fully acknowledged or endorsed it.[10]

An even earlier source, this time dating back to 1628, is quoted in this publication as recounting the *historia* of the saint called Wilgefortis, Liberata or Kummernuss.[11] In this account, as well, the saint's beard is described as a divine gift that had enabled her to protect her virginity. In this way, her life and death could serve as a didactic model for promoting the virtues of chastity. This seventeenth-century author further notes that hardly any virgins in his time would have prayed for the miracle of such a beard; instead, most women would desire a marriage partner in spite of the fact that marriage would most likely be experienced by a typical couple as being crucified on a cross together. This kind of thinking appears to imply that anyone, whether single or married, might require the intervention of Wilgefortis at some point in order to cope with life's trials and tribulations.

Even earlier fifteenth- and sixteenth-century Netherlandish sources are also quoted in this 1925 article. In particular, a poetic hymn to Wilgefort, the holy handmaiden of Christ, is quoted, which praises her for her enduring loyalty to her crucified Lord. Her beard was understood to be a visible token of both her ability and willingness to answer prayers both for herself and for all who had the faith to turn to her in their hour of need.[12]

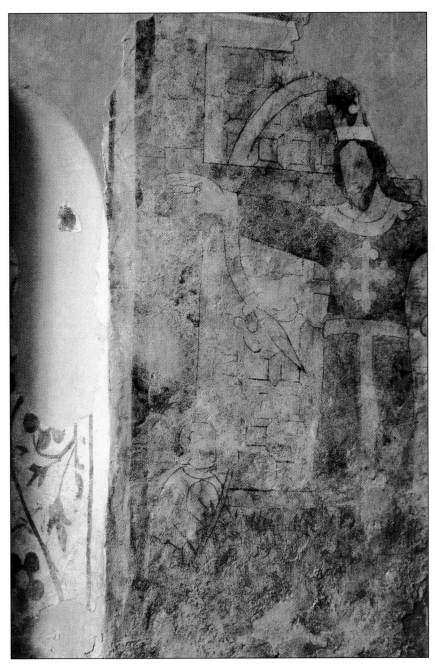

Plate 1. Fresco, ca. 1330-1350. Cemetery Chapel, Prutz, Austria

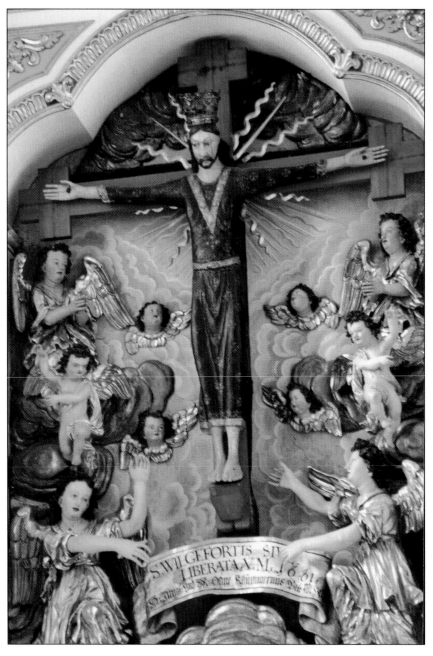

Plate 2. "S. Wilgefortis Sive Liberata." Romanesque sculpture, gilded wood, inside Baroque altar of 1661. Church of Neufahrn, Bavaria

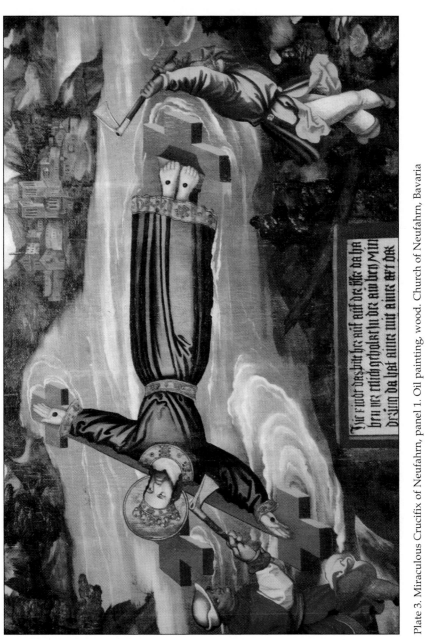

Plate 3. Miraculous Crucifix of Neufahrn, panel 1. Oil painting, wood. Church of Neufahrn, Bavaria

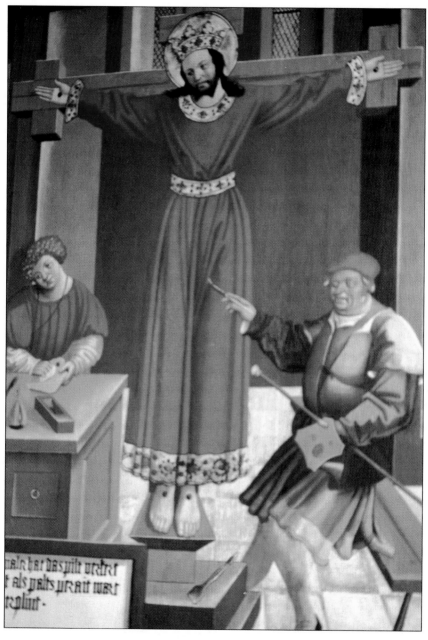

Plate 4. Miraculous Crucifix of Neufahrn, panel 5 (main section), dated 1527. Church of
Neufahrn, Bavaria

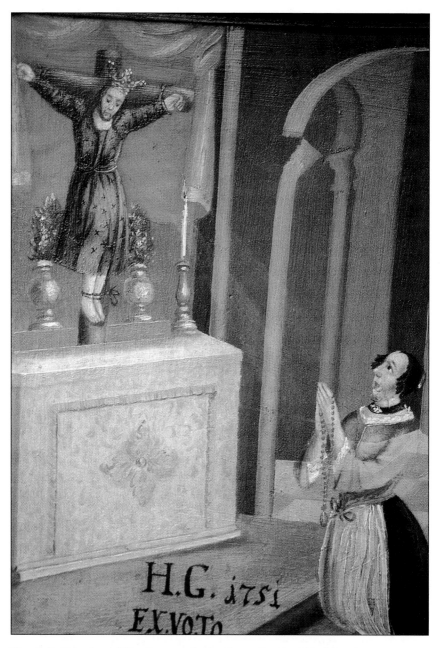

Plate 5. *Ex Voto*, dated 1751, oil on wood, 66 x 43 cm. Church of Neufahrn, Bavaria

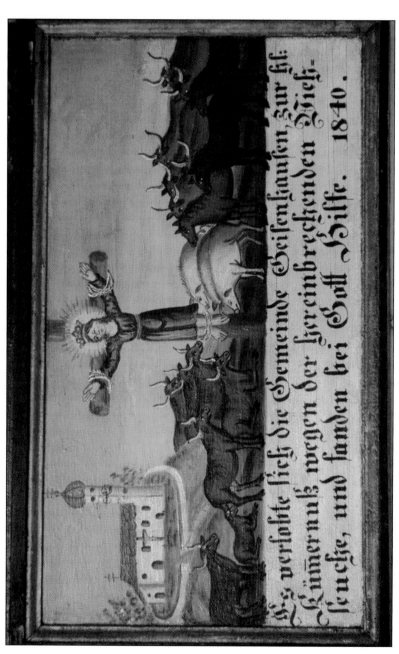

Plate 6. *Ex Voto*, dated 1840, oil on wood, 22 x 40 cm. Church of Neufahrn, Bavaria

Plate 7. *Ex Voto*, dated 1890, oil on wood, 66 x 43 cm. Church of Neufahrn, Bavaria

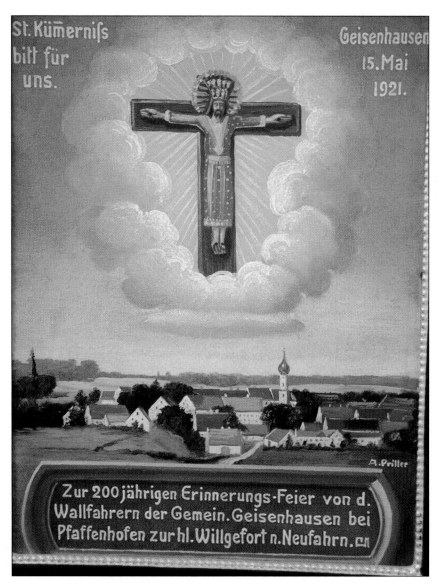

Plate 8. *Ex Voto*, dated 1921, oil on wood, 39 x 27 cm. Church of Neufahrn, Bavaria

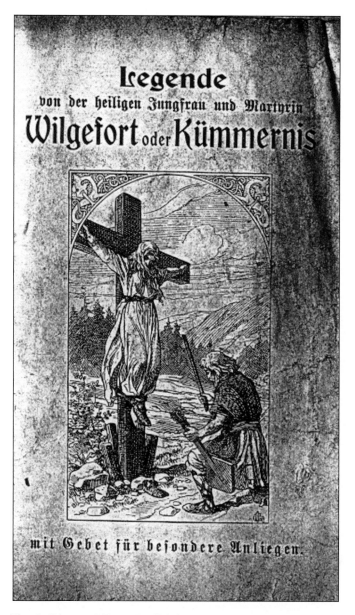

Plate 9. *Gebetszettel* (Prayer Leaflet), by Georg Sailer. Burghausen:
Altbayerische Verlagsanstalt, 1909

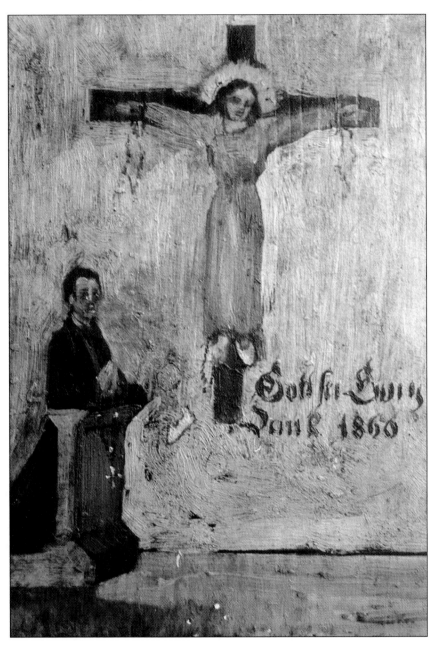

Plate 10. *Ex Voto*, dated 1860. Originally from Burghausen. Courtesy of Tiroler Volkskunst-Museum, Innsbruck, Austria

Sant kümernus

Mirabilis deus in sanctis suis
Got würckt wunderbare ding in seinen hailigen

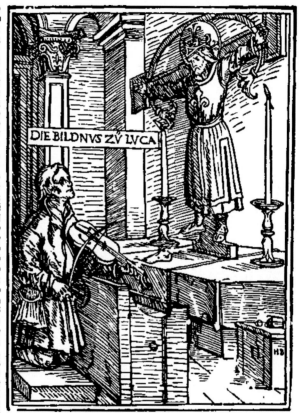

DIE BILDNVS ZV LVCA

Es was aines bayd
nischenn künniges
tochter die was schön
vnd weyß. Darumb ain
baydnischer künig ir zů
ainem gemahel begeret
das was der junckfra-
wen layd. wann sy bett
got aufser wölt zů ainem
gemahel Das thet irem
vatter zoren der leget sy
gefangenn Do rüffet sy
got in der gefängknuß
an vnd batt yn das er ir
zů hilff käm. das geschach
ach. vnnd kam got zů ir
in die gefäncknuß vnnd
tröstet sy. Do begeret sy
das er sy verwandelt in
sölche gestalt. das sy kai-
nem auff erdrich gefiel
sonder im alb in. Vnd
das er sy machte wie sy
im ain bellten gefiel. Do
verwandelt er sy vnd
macht sy im gelckch. Do
das ir vatter sach. fragt
er sy worumb sy also sä-
he. do sprach sy. Mein
gmahel den ich mir auf
er trölet hab. batt mich
also gemachet. wann sy
wolt sunst kainen dann
den gekreützigten gott.
Do erzürnet ir vater vn
sprache. Du müst auch
am kreutz sterbenn wie
mein got. des was sy wil
lig. vnd starb am kreutz
Vnd wer sy an rüfft in

kumernuß vnd anfechtung dem kam sy zů hilff in seinen nötten. Vnd baist mit namen kuminiß
vnd wirt genant sant kümernuß. vnd ligt in boland in ainer kirchen genant flouberg. Do kam
ain armes geyger hin für das bild vnd geyget so lang biß ym das gecreütziget bild ainen guldein
schůch gab Den nam er vnd trůg yn zů ainem goldschmid vnd wolt yn verkauffen Do sprach
der goldschmid. ich kauff sein nit. villeicht hast du yn gestolen. Do antwurt er. nain. das gekreü
tziget bild hat mir yn geben. man köet siech nit daran vnd fieng yn vnd wolt yn henckken. Do be
geret der geyger das man yn wider zů dem bild füret. das thet man. vnd thet dem bild den gul
din schůch wider an den füß. do geyget er wider wie vor. Do ließ das kreützget bild den schůch
wider herab vallen. Des ward der geyger gar fro. vnd dancket got vnd sant kümernuß.

Plate 11. *Sant Kumernus* or *Die Bildnus zu Luca*, by Hans Burgkmair, ca. 1507.
Staatsbibliothek, Munich, Germany

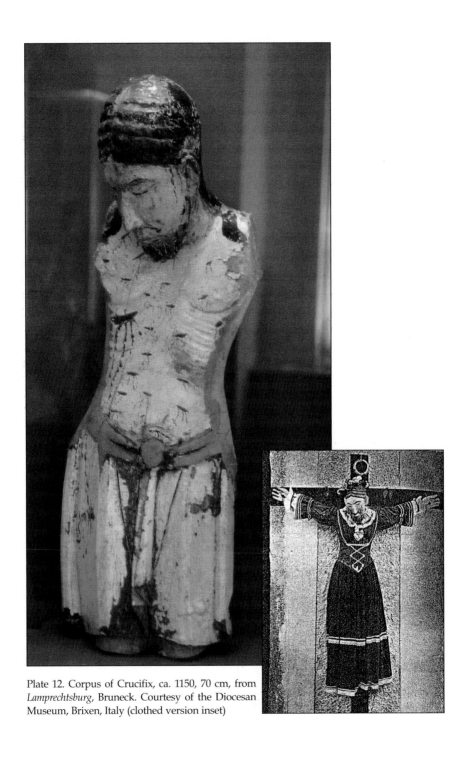

Plate 12. Corpus of Crucifix, ca. 1150, 70 cm, from *Lamprechtsburg*, Bruneck. Courtesy of the Diocesan Museum, Brixen, Italy (clothed version inset)

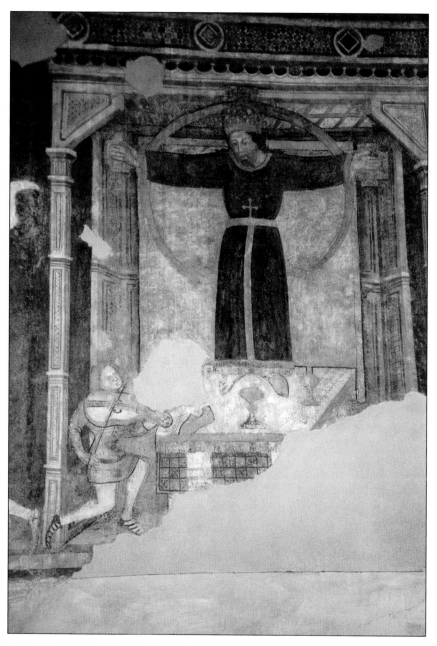

Plate 13. Fresco, ca. 1400. Dominican Church, Bozen, Italy

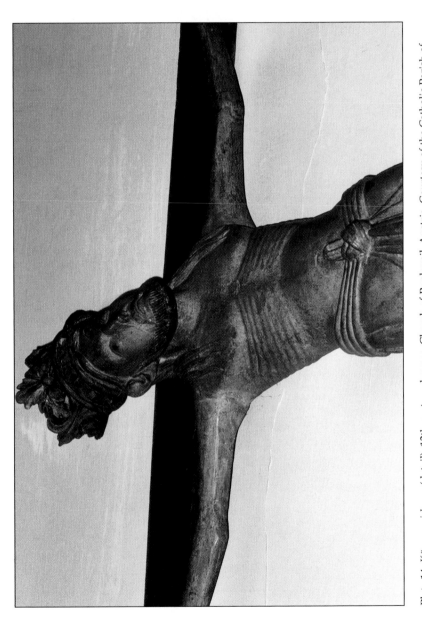

Plate 14. *Kümmerniskreuz* (detail), 12th century, bronze. Church of Rankweil, Austria. Courtesy of the Catholic Parish of Rankweil

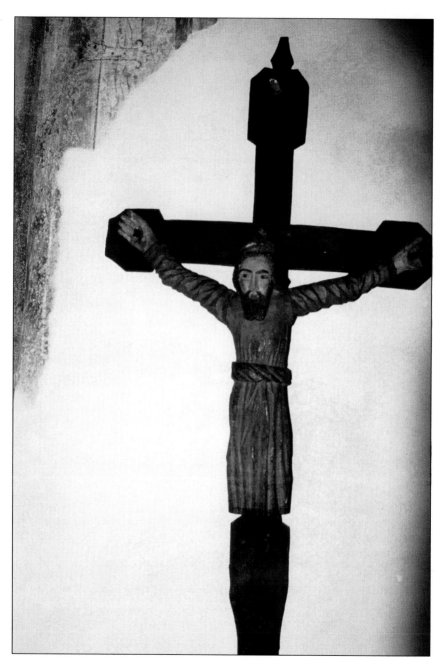

Plate 15. *St. Kummernus*, 17th/18th century, wood, 43 x 46 cm. St. Georgen ob Schenna, Meran, Italy. Courtesy of the Parish of St. Georgen

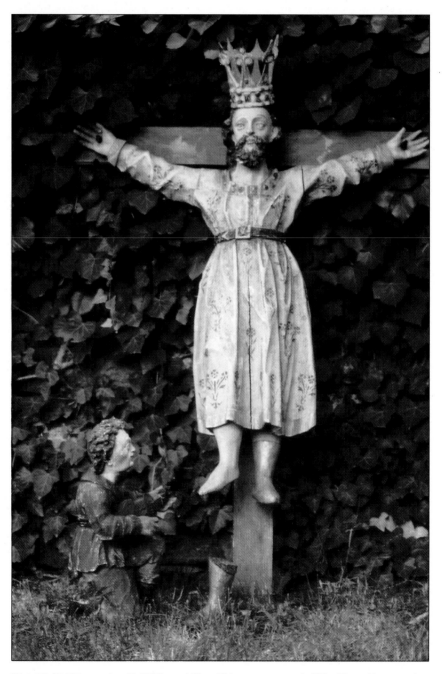

Plate 16. *St. Kümmernis with Fiddler and Shoe*, 17th century, wood, 125 x 85 cm. Troyenstein, Gries near Bozen (private collection)

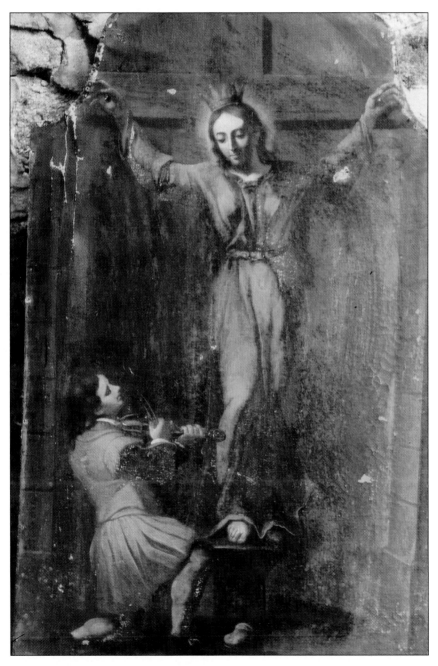

Plate 17. *St. Kümmernis with Fiddler*, 18th century, oil on canvas, 95 x 58 cm. Troyenstein, Gries near Bozen, Italy (private collection)

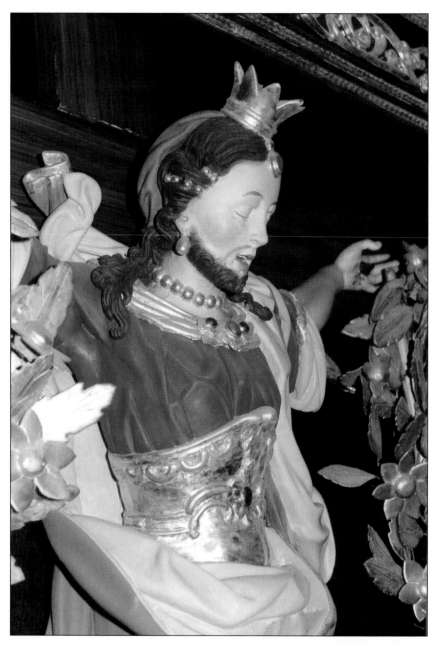

Plate 18. *St. Kummernus* (detail), 18th century, wood. Chapel of Sts. Michael and Kummernus, Church of Axams, Austria. Courtesy of the Parish of Axams

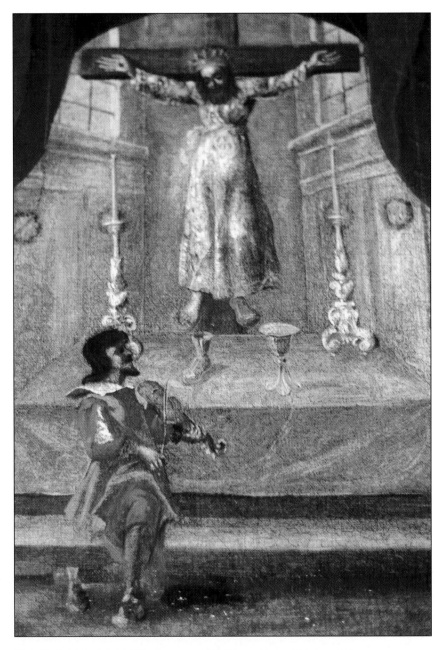

Plate 19. *Ex Voto*, dated 1687, oil on wood, 60x50 cm. Tiroler Volkskunst-Museum, Innsbruck, Austria. Courtesy of the Tiroler Volkskunst-Museum

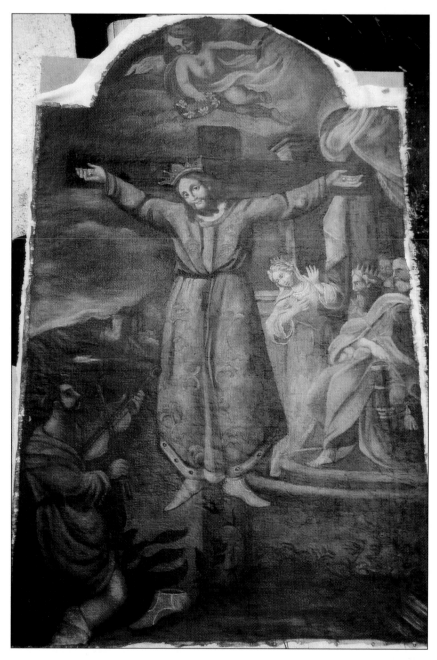

Plate 20. *St. Kümmernis*, 18th century, oil on canvas, 211 x 127 cm. Museum Stift Stams, Austria. Courtesy of the Museum Stift Stams

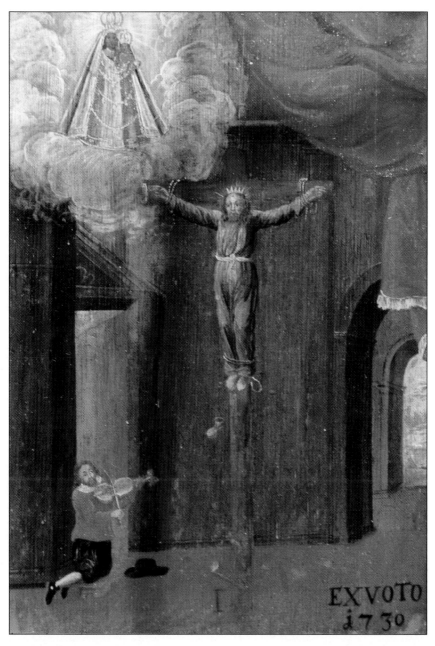

Plate 21. *Ex Voto*, dated 1730, oil on wood, 48 x 34 cm. Heimatmuseum, Kufstein, Austria. Courtesy of the Heimatmuseum

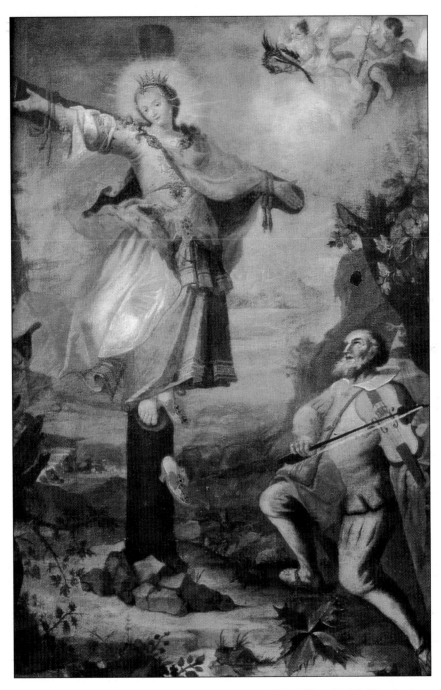

Plate 22. *St. Kümmernis*, late 18th century, oil on canvas, 200 x 150 cm. Parish Church of Uderns, Austria. Courtesy of the Parish of Uderns

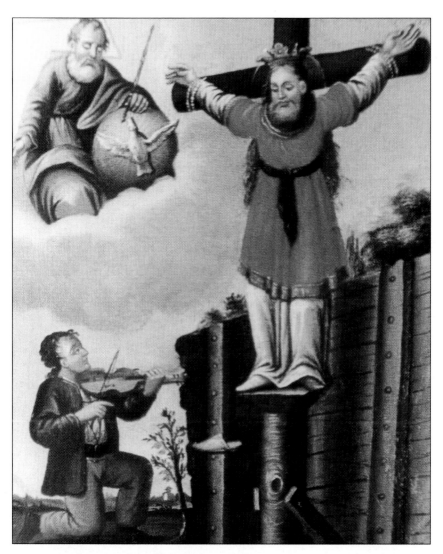

Plate 23. *St. Kümmernis*, early 19th century, oil on wood, 47 x 41 cm. Augustiner-Museum, Rattenburg, Austria. Courtesy of the Augustiner-Museum

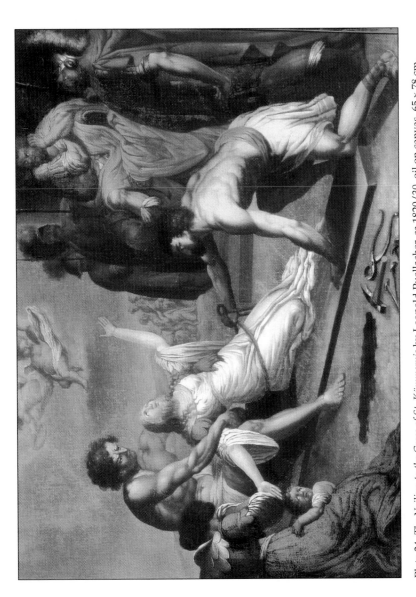

Plate 24. *The Nailing to the Cross of St. Kümmernis* by Leopold Puellacher, ca.1820/30, oil on canvas, 65 x 78 cm. St. Veits Chapel, Telfs, Austria

The many areas in central Europe in which images of the saint were venerated are indicative of the fact that her help was viewed as being essential for, among other things, healthy growth, fertility, weather and also life and death. Specifically, she was also invoked in times of war and inflation. She was additionally the patroness of agriculture, and many of her images consequently hung in wayside chapels throughout the countryside. Furthermore, she was venerated by bakers who hung her votive tablets above their ovens. While close to women who were in distress, she was also regarded as the protectress of all travellers, both literally as well as in the more figurative sense of guiding people to their final destination at the end of life.[13]

Plate 10
Ex Voto, 1860
Burghausen,
Bavaria

An article in the local Burghausen newspaper in 1949 drew attention to the long-standing tradition of soldiers walking annually on a pilgrimage from Altötting to Burghausen, an event first established in 1871 on the initiative of a local farmer. From 1813 to 1945, "Maria Kümmernis" had also been the focus of thanksgiving services offered by veterans for survival in battles and in times of war. At times, up to four thousand pilgrims were counted at these events, at which people from all walks of life would join together to pray for world peace and for the safe return of prisoners of war.[14] It is interesting to note that, for these pilgrims, the Virgin Mary had apparently acquired the name of St. Kümmernis as well, unless the double name "Maria Kümmernis" was understood to imply Mary more than Kümmernis. According to Catholic tradition, the mother of Christ was also venerated as a Mother of Sorrows (*Kummer*), or *Mater Dolorosa*; the merging of both names conveniently solved the dilemma surrounding the veneration of a separate and legendary cult figure. In any event, Kümmernis appears to have lost her independent identity — and indeed her earlier pre-eminence — at Burghausen during the course of the nineteenth century.

In 1955, the 85th *Kriegerwallfahrt* [Pilgrimage of Soldiers] took place. This event involved veterans of both World Wars, and featured expressions of thanksgiving for their survival, as well as prayers for German soldiers still held as prisoners of war. Although prayers for the victims were primarily addressed to the Virgin Mary, St. Wilgefortis was still acknowledged, if only in connection with her sanctuary; the *Kümmerniskapelle* was, after all, the focus and goal of these pilgrimages. It was still commonly believed at that time that Kümmernis had in the past offered

comfort to afflicted believers, but her legend seems to have been recounted primarily for the sake of its fairytale-like aspects by this time.[15]

A thorough renovation of this chapel in 1963 contributed to the further simplification of the interior, in that "distracting" and "stylistically unfitting" objects were removed from the interior. As a result, the altar now consisted exclusively of a statue of Mary, accompanied by St. Stephen and St. Lawrence; these works of art had been acquired from a nearby church. By now, Kümmernis served primarily as a namesake for the chapel, and little more.[16]

Nevertheless, several votive panels portraying the saint were still to be found in the *Kümmerniskapelle* by 1965 when the centennial of the neo-Gothic chapel was officially celebrated. This year also marked the ninety-fifth consecutive Pilgrimage of Soldiers.[17]

By 1970, the year of the hundredth such pilgrimage, a local bishop took a leading part in the worship service that followed it. By this time, the pilgrimage had evolved from being primarily focused on soldiers to including local residents from all walks of life. This greater inclusiveness and corresponding sense of gaiety or festiveness was also in marked contrast with certain of the grimmer aspects of Kümmernis's local appeal. In the past, for instance, her chapel had been the final site of devotion for those condemned to death; a gallows and various instruments of torture and execution were once located at the nearby crossing of two country roads.[18]

The festive sermon given on this occasion by Bishop Antonius Hofmann challenged his audience of assembled pilgrims to continue to believe in the reality of the saint's name: "Do not say that there is no Kümmernis in today's technological age," he exhorted them at one point, before going on to express his belief that grief (Kummer, or Kümmernis) affects everybody as an intrinsic part of the human condition. The bishop did, however, take care to avoid calling for the veneration of the saint herself. He noted that the Kümmernis Chapel was being filled with the reverence and devotion of many generations that day, and stated that he was gratified to see so many young people attending the ceremony. He shared his war experience of having been present at Dresden in February 1945 when 260,000 people had been killed in just two days of Allied bombing, and connected this traumatic experience with the crucified Wilgefortis-

Kümmernis, in the sense that all pains and evils should be brought to the cross. He also encouraged his listeners to continue to trust in the gift of the golden shoe, which could be received in the midst of pain. In spite of the bishop's efforts to stress the ongoing relevance, if not venerability, of Kümmernis, the local priest who concluded the ceremony made a point of noting that the purpose of this site had changed from that of worshipping a legendary saint to honouring the Virgin Mary. In this connection, he cited the fact that the name "Maria Kümmernis" had been chosen in memory of the Mother of Sorrows.[19]

One of the nineteenth-century votive panels which is preserved in the Kümmernis chapel was illustrated in the local Burghausen newspaper in 1971. In this panel, the childlike figure of the saint is portrayed frontally near the centre of the composition, while the fiddler is seen kneeling at the foot of the cross. An unusually mature-looking gentleman, wearing a white beard, the fiddler is given only a secondary and marginal role. In accordance with the medieval Italian tradition, the saint is nailed to the cross through the palms of her hands, while her feet are supported by a small wooden ledge. However, the cross is depicted in the midst of a landscape characterized by dense shrubbery; this contradicts the Italian tradition in favour of a more Dutch influence.[20]

It has been suggested that the oldest representation of the Kümmernis Chapel can be found on a *Gebetszettel* [literally, Prayer Leaf], which was an engraving by an artist identified only by his surname of Lutzenberger. This print, of which we know only that it was preserved in Burghausen until 1864, depicts the small chapel, with particular attention being focused on its slender tower which is framed by ornamental Baroque decorations. In the upper half of the print, St. Wilgefortis is portrayed as standing on an altar inside a sanctuary. In this engraving, the musician is, for once, given a more central place or position than the saint.[21]

By 1993, the *Kümmerniskapelle* had become increasingly popular as a marriage chapel, especially for couples who were celebrating their silver or golden wedding anniversaries. This popularity contributed, in part, to yet another restoration of the sanctuary. In the course of this process, previously obscured details of the interior decoration, including the heads of angels, were once again revealed; these had earlier been covered by plaster. The altar, in turn, was restored to its original gilded

appearance. However, a contemporary newspaper account of this restoration failed to make any mention of images of St. Kümmernis inside the chapel.[22]

Additionally, no mention is made in this newspaper article of the historical significance of St. Kümmernis as a traditional patron of sexual unions, families or of fertility. The legend of how she had died in order to retain her virginity, and that she had consequently also been regarded as a patron saint of marital distress, unhappy love affairs and family violence, was also omitted in this article. In general, the chapel seems to have attracted more attention for its picturesque location and general reputation for being the traditional site of large festive gatherings in the region. By the same token, people were commonly referring to "The Kümmernis" as a popular location by this time, rather than as the venerated spiritual and personal guide of bygone centuries. It would appear that the legends which once surrounded her had become too quaint and antiquated for the modern mind. Her existence may have imbued the local chapel with some notoriety over the years; one can no longer speak of any sustained significance or presence on her part, however.

Chapter 7

St. Kummernus or St. Kümmernis in Tyrol

T his chapter examines the historical prevalence of St. Wilgefortis, known locally as Kümmernis or Kummernus, in the Tyrolean region of western Austria. Beginning with an overview of the ambiguous origins of depictions of the saint in this region, the chapter goes on to describe several direct and unmistakeable depictions of the saint which were created over the course of several centuries. As with the veneration of the saint in neighbouring Bavaria, the ambivalent and sometimes hostile reaction of the Catholic Church to the veneration of this saint is examined here as well.

The region of Tyrol today encompasses both the Austrian and the Italian parts of this stunning alpine area. These territories are known, respectively, as North Tyrol and Alto Adige (the former South Tyrol). Together they contain the largest number of former pilgrimage sites dedicated to St. Wilgefortis in central Europe.[1] The most familiar name of this saint throughout this region is "Kümmernis," a word is still in usage in the German language as a female variant for *Kummer,* meaning grief, sorrow or affliction. This name therefore personifies various forms of suffering embodied in the person of the crucified saint. Moreover, the name also suggests the liberating function of the

Notes to chapter 7 are on pp. 148–150.

saint in helping afflicted believers to overcome their sufferings, as exemplified by her English namesake Uncumber, a name which is regarded as an archaic form of "un-encumber" [entküm- mern in German].[2] Thus, to call upon her was a way of coping with affliction; through an identification with her, the faithful believer could hope for a victory over adversity.

In keeping with popular tradition, some of the oldest statues of the crucified saint in Tyrol were called "Kummernus." This antiquated word is no longer in use, but its masculine ending for sorrow seems to indicate a male, rather than a female, martyr. The statues of "Kummernus" may therefore be regarded as referring to Christ the Man of Sorrows rather than pointing to a

Plate 11
Sant
Kumernus,
ca. 1502-1507

female saint. Hans Burgkmair, however, in a woodcut dated ca. 1502-1507, identified his depiction of the venerated carving of the Volto Santo in Lucca both as Christ and also as the princess "Sant Kümernus" [sic] of the Netherlands. To make this double meaning of the image as both male and female more convincing, the artist added both a Latin and a German inscription above the print to the effect that God brings about miraculous things in his saints, not only in Christ. In this way, the interpretation of the image as being representative of a female saint is given prefer- ence. An added emphasis on the female aspect of the figure is provided through the inclusion of her legend, which is spelled out on the margin of the woodcut.[3]

This puzzling double identification may seem paradoxical, contradictory and perhaps even offensive to some. Rather than being based on a mistake or lack of information, however, the reason for this blurring of genders may have been politically motivated, as well as culturally and financially advantageous. By drawing disproportionate attention to the female saint, the print may have been designed to wean popular attention and veneration away from the Volto Santo, thereby redirecting and containing the flow of pilgrims north of the Alps. Hans Burgkmair, far from being misinformed and confused about the identity of the Volto Santo, was a highly educated artist. He was closely affiliated with leading German humanists and was one of the first artists of the Northern Renaissance to explore Italian Renaissance motifs and include them in his work. He also served as one of the court artists for Emperor Maximilian I, whose main residence was in Innsbruck, and whose political ambitions were directed toward the Netherlands, the country of origin of the bearded female saint. Maximilian incorporated not only

Burgundy into his domain, but also the saints of the Burgundian region, among them the Christlike female martyr.

By proposing an alternate interpretation of the *Volto Santo*, Burgkmair substantially contributed to the blurring and confusion of gender distinctions with regard to one of the most venerated crucifixes in the Christian world. Rather than inventing this dilemma, he may have responded to a tradition that was arguably already current and popular by that time; thus, he would not necessarily have been the first artist to explore this ambiguity. His main intention may well have been to make the northern saint more attractive to the German-speaking communities of Europe by printing her legend in German alongside the Italian image. Through this juxtaposition, he presented her not only as Christlike, but as an *alter-Christus*, a female equivalent of Christ. Her name, cited in the text as "Kumini," does not reflect her Netherlandish name of Ontkommer; rather, it seems to have been imaginatively constructed in order to resonate with the German word "Kümmernis," as previously defined. In particular, the text in the woodcut states that "All those who call upon her in 'kümernus' and trials will be helped in their afflictions."

One can therefore observe a subtle blurring of male and female genders in the very names that were given to the figures on the cross, particularly "Kumernus" versus "Kümmernis." Additionally, certain carvings and paintings of these crucifixes were intended to be seen as simultaneously male and female. Such ambiguous practices were not the result of illiteracy or confusion on the part of either the artists or those who commissioned their works, but indicate instead the deliberate intention to combine both genders within one figure. The resulting images can be regarded either as Christ on the cross or as the crucified St. Wilgefortis, who by virtue of growing a beard and sharing Christ's agony on the cross, became Christlike, both in physical appearance and in popular stature.

A related practice involved the transforming of originally male crucifixes into female ones. This tendency can be observed and documented with regard to several locations, most notably Uznach in Switzerland and Neufahrn in Bavaria. This process involved either the recarving of certain statues to suggest a female body,[4] or the elaborate cross-dressing of the crucified Christ, for example the one preserved in Brixen (now in South Tyrol). These examples, among others, constitute one aspect of

Plate 12
Corpus of
Crucifix,
ca. 1150
Lamprechtsburg,
Bruneck

the unique and greatly varied cultural phenomenon surrounding St. Wilgefortis.[5]

The ambiguity regarding the gender of the figure on the cross originated, in large part, with the periodic addition of festive clothing to the previously mentioned *Volto Santo* in Lucca. On certain religious holidays, this venerated statue was decorated with costly garments, lace accessories, pieces of jewellery and precious shoes. These items were habitually donated by visiting pilgrims and local residents as offerings of gratitude for favours received and prayers answered. These items, once placed on the statue, made it appear more feminine and ornate. Ironically, it does not seem to have been the intention of these believers to transform the gender of the statue through these sartorial additions.

Nevertheless, the dramatic contrast between the adorned and the unadorned statue caused visitors to come away with two radically differing impressions of the statue—one the simple and unadorned statue itself (generally recognizable as being male, in spite of the long robe that constituted part of the carving), the other, its lavishly dressed and more apparently feminine counterpart. With the passage of time and the increasingly creative copying of the image in distant locations, it was often left up to individual believers to determine for themselves the extent to which the statue could be regarded as either male or female—or even both at once.[6]

One of the most monumental works portraying the robed crucifix is housed in the Museum of Folk Art in Innsbruck. This badly damaged panel, dated 1469, was originally part of a large altarpiece before being used as a door. It portrays an almost life-size crucifix, which displays the typical characteristics of the *Volto Santo* image, including the solemn frontality of the robed figure as well as the lily-ornamented arch that surrounds it. The bearded head carries an elaborate crown, while the nailed hands and arms are stretched out horizontally on the cross. The feet seem to be standing on an altar table, while the chalice and discarded right shoe are placed closely together in front of the feet. A small fiddler is kneeling on the left side of the panel. On the right side, we find the date written in large Gothic letters.

Of interest with regard to the gender of this image is the fact that the back of the panel features seven pious inscriptions and initials, accompanied by dates ranging from 1500 to 1600. These inscriptions were apparently written by pilgrims travelling across the Alps and paying their respect to the crucifix, which

was then located at the Monastery of Säben, the original site of the altarpiece. These "scribblings" indicate that the crucifix was venerated as Christ at that time, and not as St. Kümmernis. In spite of this, the panel has been described as an image of the "*Volto Santo* or Kummernus" in documents which are found in the inventory of the Innsbruck museum; later, however, this image became associated with the Kümmernis cult which was already flourishing in this area at around that time.[7]

With regard to the veneration of St. Wilgefortis in Austria specifically, the scholar Gustav Gugitz, in 1955, identified sixteen former pilgrimage sites devoted to her, including ten in Tyrol. He cited these as being Axams, Endfelden, Gries, Kastelrut, Lamprechtsburg, Meransen, Niederrasen, Telfs [*Veitkapelle*], Tils and Uderns. This information is no longer fully reliable, however, insofar as some of the works of art which had been present at these sites had already disappeared by the time his book was published—either having been moved to museums or else destroyed altogether. The situation was further complicated by the fact that the southern part of Tyrol had become part of Italy after World War I, with the result that most locations were renamed. An additional source of confusion is found in his publication of the following year (1956) which mentions St. Wilgefortis (or more precisely, Kümmernis) with regard to twenty-one "sites of grace" [Gnadenstätten] throughout Tyrol—without distinguishing North from South.[8] The fact that several of these sites were also devoted to saints other than Wilgefortis is another complicating factor in this regard.

In order to resolve such problems, it was necessary to undertake extensive field trips throughout Tyrol in order to establish a current record of the nature and location of these images. Research in various libraries throughout Austria yielded additional information regarding historical, theological and aesthetic aspects of the Wilgefortis/Kümmernis phenomenon. Verbal information offered by local inhabitants, including current and retired parish priests, custodians, organists and school-teachers, made it possible to gain greater understanding of these puzzling female crucifixes. Most rewarding of all was the unexpected discovery of additional images of this mysterious saint in places such as church attics, private homes and museums; other works had recently been brought to life again through restoration by removing layers of plaster which had covered certain wall paintings and cleaning oil paintings found on canvasses or

panels. In all, a total of more than thirty Tyrolian portrayals of the saint, dating from the fourteenth through the nineteenth centuries, have been catalogued.[9]

Within these images, a wide range of visual and spiritual possibilities of the female crucifix has been explored, ranging from severe masculine forms based on the *Volto Santo* to flamboyantly feminized portrayals that often bear little or no resemblance to the original male prototype. In some cases, the dress and body forms are depicted in such an overwhelmingly feminine manner that even the characteristic beard of the saint has been eliminated. In some instances, this feminization of the figure on the cross was stressed to such an extent that it resulted in the creation of figures resembling a beautiful fairy-tale-like princess who even wore high-heeled shoes on the cross.[10]

See Plate 1. Long before Hans Burgkmair's ambiguously identified woodcut (as previously mentioned), the image of the *Volto Santo* had already become a familiar devotionary theme in Tyrolean medieval art. This is seen, for instance, in the fresco at Prutz, painted as early as 1330, and therefore one of the earliest depictions of this scene. This image was rediscovered in 1978 in a damaged state under several layers of plaster in the interior and side wall of the local cemetery chapel [Totenkapelle] situated near the parish church.[11] The structure of the chapel was altered by the addition of large window openings during the Baroque era; this resulted in the destruction of a section of the fresco, so that only one arm of the figure on the cross has been preserved. It is apparent that the *Volto Santo* tradition has been adhered to rather closely in this fresco. One might note, for example, the halo-like fleurs-de-lis arch around the upper part of the cross; the ornamental background, in turn, may be a visual reference to the altar niche in the cathedral of Lucca, where the sculpture of the *Volto Santo* used to hang above an altar.

Since we do not know the original title of this work of art, it is perhaps more prudent to link it with the *Volto Santo* rather than St. Kümmernis. However, it is tempting to suggest that this image might portray the female saint after all, especially since this portrayal is merely one of several scenes, rather than a single or major image in its own right. As if to support this theory, the 1995 catalogue celebrating the origins of Tyrol refers to this painting simply as "St. Kümmernis."[12]

An additional reason for believing that the image on the cross is female centres on the role of St. Kümmernis as a helper

in death and dying. In the case of this fresco, along with later ones at Axams and Schluderns, it is interesting to note that this figure was displayed in a cemetery chapel.[13] A final reason for regarding the figure as potentially female concerns the presence of a fiddler at the foot of the cross—a factor which suggests that the figure hanging from the cross is, in fact, Kümmernis.[14] This narrative element highlights the extent to which the formerly self-contained image of the crucifix has shifted from a severely frontal perspective to a slightly sideways one, thus establishing a visual dialogue between the kneeling musician and the figure on the cross.

Regardless of the interpretation attached to the crucified figure, however, this possible indication of male-female interaction evolved, over the following centuries, into a much more definite and explicit phenomenon. This linkage of male and female was one of the reasons behind the growing increase in the popular veneration of St. Kümmernis, seen especially as a compassionate saint who could be called upon to intercede in tragic or troubled intimate relationships.

On the basis of this early depiction in Prutz, it can be argued that the cult of St. Kümmernis likely originated in Tyrol, albeit strongly connected to the visual tradition of the *Volto Santo*. The somewhat later depiction of a similar image in the Martin's Chapel of Bregenz, dating from 1363, includes for the first time a suggestion of trees surrounding the crucifix.[15] Such details can be taken as an indication that the image of the miracle-working Italian crucifix was transplanted to the outdoors and independently developed into an image of love, death and redemption, as discussed above. This development resulted in a greater scope for imaginative freedom on the part of both artists and viewers than the officially sanctioned orthodox images of the crucified Christ.

The other four surviving Tyrolean frescoes which portray the theme of the crucified saint and the fiddler also originated in the Gothic era, underscoring the popularity of this theme during that time. According to popular tradition, each of these four robed, crucified and bearded figures has been called "Kummernus." These representations are located in 1) the Dominican Church in Bozen (Bolzano) dating from ca. 1400; 2) on the exterior north wall of the parish church of St. Jacob in Dietenheim near Bruneck; 3) the entrance wall of the parish church of St. Virgilius in Altenburg near Kaltern (the present-day

Plate 13
Fresco,
ca. 1400
Bozen, Italy

Castelvecchio presso Caldaro); and 4) on the interior side wall of
the St. Cyrill Church in Tils near Brixen.[16]

In each of these examples, the *Volto Santo* tradition has been
faithfully adhered to, particularly in the significant detail of the
Lucca altar table, as well as in the previously mentioned figure
of the fiddler who is kneeling at the foot of the crucifix. In the
Dietenheim fresco, however, this small figure is so badly pre-
served that an asymmetrical smudge in the plaster serves as the
only indication of his former presence.

Another group of images consists of wooden crucifixes fea-
turing robed figures of various sizes. As with the previously
mentioned examples, these sculptures have also traditionally
been called "Kummernus," with most of them dating from the
seventeenth and eighteenth centuries. However, a few medieval
wood carvings have also survived.[17]

Some are particularly noteworthy because they were, as
mentioned earlier, adorned with items of female clothing. One of
these crucifixes, dating from 1150 and formerly displayed in the
See Plate 12. *Lamprechtsburg* near Bruneck, is now housed in the Museum of
the Diocese of Brixen.[18] This crucifix has been restored and thus
stripped of all subsequent additions, which included not only
dresses but also the substitution of arms and legs. In its original
unadorned form, the upper body is nude, with the ribcage visi-
ble under the skin. The gently curving torso vaguely suggests a
female form; a skirt-like loincloth, which is knotted in the mid-
dle, covers the hips. This crucifix does not imitate the "Eastern,"
or robed, *Volto Santo* but rather adheres to the more familiar
"Western" or loincloth-covered image of Christ on the cross.

On numerous Romanesque crucifixes, it was surprisingly
common to depict not only individual ribs on the torso, but also
a slight swelling of the breast. Examples of such details are
apparent in the triumphant crucifixes at Cologne, Essen-Werden,
Minden, Aschaffenburg, Nuremberg, Udine and Innsbruck,
among many others.[19] These details may be regarded, on the one
hand, as characteristic of an early medieval style that sought to
define the body in greater detail. Additionally, it has been sug-
gested that Christ's "feminine" life-giving and nourishing pow-
ers were being emphasized in a manner reminiscent of early
Christian art, in which Christ was at times portrayed as some-
what feminine or even androgynous.[20]

The slender body of the Lamprechtsburg statue, with its
elongated head and tight cap of hair, thin lips and short beard,

was altered in later centuries so as to appear entirely female; this can be seen in a photograph that appeared in an authoritative 1943 publication on Kümmernis.[21] In this illustration, the male body can hardly be recognized under the elaborate layer of female clothing, which consists of a long dress with a tightly fitted bodice and a lace collar. In addition, one may note long decorated sleeves that cover the subsequently added arms, leaving only the hands, pierced by nails, visible to the observer. The skirt is full and long, and entirely covers the legs. At one time, the figure also featured red stockings, together with an elaborate crown of tinsel that covered the head. All of these items, along with others which have no longer been preserved, were gifts donated primarily by female pilgrims who sought the help and blessings of Kümmernis when facing various problems, especially those of a sexual nature, inclusive of infertility.[22]

Since the publication of this photograph, the statue has been restored to its original unclothed appearance. Consequently, this crucifix, now housed in the diocesan museum in Brixen, is no longer recognizable as a "Kümmernis." Instead, it now features only the original Romanesque simplicity and severity of its partly nude male body. We do not know when the tradition of draping clothes on this crucifix first began, but it was certainly a popular practice, especially during the Baroque era, at which time numerous images of this saint were also created in the medium of oil painting.

A phenomenon similar to the crucifix in Brixen can be found with regard to a Romanesque crucifix preserved in the pilgrimage church of Our Lady of Rankweil in Vorarlberg, a province adjoining Tyrol and bordering on Switzerland.[23] This so-called "Kümmerniskreuz" [Kümmernis cross], also dating from the twelfth century, depicts a crucifix featuring a nude upper body with what might be perceived as small breasts delicately indicated above a less ambiguously defined ribcage. Here again, the symbol of a nurturing feminine Christ seems to have been at least implicitly suggested.

As with the statue in Brixen, this crucifix was draped in female clothing, specifically during the seventeenth century, in order to deliberately transform it into a statue of St. Kümmernis. In this instance, a record of at least one family of donors has survived: the von Grenzings of Feldkirch, who added the name "Sanctus Kumernus" onto the horizontal beam of the cross together with their crest. Now restored to its original unclothed

Plate 14
Kümmernis-kreuz, 12th C. Rankweil, Austria

appearance, this crucifix nevertheless continues to be referred to as a "Kümmerniskreuz" today.[24]

According to the local church guidebook, the Rankweil crucifix is connected with the *Volto Santo,* insofar as the latter statue served as the prototype for numerous copies, including the one mentioned here, which were carved during the Middle Ages. These statues were intended to make pilgrimages to Lucca unnecessary by providing local substitutes for the *Volto Santo.* This tradition of creating locally accessible images, which increasingly diverged from their common prototype, was a contributing factor in the growth of the legend concerning a female crucified martyr who had grown a beard.[25]

In contrast to the *Volto Santo,* the Rankweil crucifix does not portray a robed figure; rather, the body is only wearing a loincloth. Thus, the Rankweil image reflects the more conventional biblical account, which states that Christ died on the cross after having been disrobed. Therefore, the custom of robing nude statues of crucifixes such as the ones in Brixen and in Rankweil cannot be attributed to the veneration of the *Volto Santo,* but instead appears to have been part of a separate development found only north of the Alps.

In addition to the various robes, both originally carved and added on at later dates, which were the subject of differing interpretations concerning the gender of the crucified person, the crowns found on these figures have also contributed to the confusion surrounding the identity of the person(s) portrayed on the cross. While Christ was crowned only with thorns when he died on the cross, Kümmernis, according to her legend, was a royal princess and was therefore portrayed as wearing a golden crown. When examining images of Christ in medieval art, it is apparent that only a small number of Romanesque crucifixes were carved with crowns intended to symbolize Christ as the invincible king of the universe. For the most part, Christ was portrayed either with a lowly crown of thorns or else with no crown at all.[26] The Rankweil crucifix, by contrast, features an elaborately carved crown. Even the *Volto Santo,* in its original state, did not depict Christ wearing a crown but rather with a bare head, indicative of his humility and servanthood.

Whenever a crown is present, it is tempting to regard the figure on the cross as the portrayal of a female such as Kümmernis, especially when these crucifixes feature delicate body forms such as slightly swelling breasts and a slim waist-

line. This interpretation is especially compelling in cases where the crucifix was also adorned with robes. In particular, the presence of a crown, whether originally carved or added later on, was a significant contributing factor in the labelling of certain figures as Kümmernis by the general public. The significance of the crown as a symbol of Christ thus became less widespread. Only those images that were decidedly masculine were generally regarded as portraying Christ as king.

During the Baroque era, female crucifixes continued to be carved throughout the region. One example is the "St. Kummernus" in the church of St. Georgen in Schenna near Meran (Merano), an unassuming statue created in a folk-like style that appears more medieval than Baroque, but in fact dates from the seventeenth or eighteenth centuries. This figure has a rather masculine appearance and wears a simple crown; the hands are nailed to the cross while the feet stand on a pedestal. All of these details could equally be characteristic of a robed statue of Christ, but a locally written guidebook refers to it as depicting "St. Kummernus or St. Willgefort."[27]

Plate 15
St. Kummernus,
17th–18th C.
Meran, Italy

Another Baroque wood sculpture can be found in the cemetery chapel of St. Michael in Schluderns.[28] This figure is more prominently masculine than the other examples cited here, due to the presence of a thick and dark beard which covers the chest, reaching almost to the belt. Moreover, elaborate and stiff corkscrew curls combine to form a moustache that protrudes considerably beyond the beard. As with the figure in Schenna, this sculpture, dating from the seventeenth century, has also been traditionally referred to as "St. Kummernus." Since only her left foot is clad in a shoe, it can be assumed, in keeping with local legends, that her right shoe had been deliberately dropped as a present to the fiddler. However, in this instance, neither the second shoe nor the figure of the fiddler has been preserved.

A group of figures, dating from the seventeenth century and including the crucified saint, the fiddler and one of her shoes, was created for the St. Oswald Chapel at Troyenstein in Gries near Bozen, and is now part of a private collection.[29] These two figures, together with the shoe, can be arranged to constitute a narrative scene reflecting the popular legend of Kümmernis. The majestic crucified figure would seem to be predominantly masculine due to the presence of a short beard and moustache; the long and wide dress, however, is decorated with flowers and is held in place by a girdle, so that a more feminine body is sug-

Plate 16
St. Kümmernis,
17th C.
Gries near
Bozen, Italy

gested. The stern face of the martyr, with wide-open eyes, does not appear to acknowledge the presence of the kneeling musician. Additionally, the tall crown adds a triumphant and regal note to the figure's appearance, much as with the *Volto Santo*.

Plate 17
St. Kümmernis,
18th C.
Gries near
Bozen, Italy

Apparently, there were several shrines in Tyrol which, although originally dedicated to St. Oswald, were also connected with the veneration of St. Kümmernis. An explanation for this connection can be found in the suggestion that the fiddler who relieved the suffering of the princess through the power of his music could have been intended to represent St. Oswald coming to her rescue.[30]

Plate 18
St. Kummernus,
18th C.
Axams, Austria

An unmistakeably female crucifix of "St. Kummernus," dating from the eighteenth century, can be found on the altar of the lower chapel of Sts. Michael and Kummernus, which adjoins the parish church at Axams, near Innsbruck.[31] The originally Romanesque structure of the chapel was altered during the seventeenth century and dedicated, in 1666, with the Latin inscription "in honorem sanctae Liberatae, alias nominata Wilgefortis, germanice 'ohn Kumbernuss.'"[32] In keeping with its function as a shrine to Kümmernis, this chapel also housed a number of votive paintings, dating from 1800-1841, which were dedicated to this saint. These paintings are no longer present in the chapel; most of them appear to have been lost.

The Axams Kummernus statue features an unambiguously feminine body, which is richly emphasized by a red dress covering a long white undergarment, while a tightly fitting golden girdle graces her slender hips. A billowing blue mantle, resembling a long shawl, is draped around her body. In addition to a small crown, her hair is decorated with bright jewels. Her eyes are downcast and her mouth is slightly open as if she was in pain. Additionally, a short beard and faint moustache frame her delicate face. Her hands are stained with drops of blood due to the large nails that pierce her palms; her feet stand firmly on a supporting ledge. Since both of her feet are covered with shoes, the figure of the fiddler was evidently not intended to be present.

In contrast to the wooden sculptures discussed above, a substantial number of Kümmernis images were also executed in the medium of oil painting. Some of these works were painted on wood, others on canvas. As part of this group, a number of relatively small panel paintings were originally created as *ex votos*, or votive paintings. These works were visual expressions of

thanksgiving, and also commemorated special events in the life of a particular donor — for example, a cure for an illness or recovery from injuries incurred in an accident.

One of these votive paintings dates from 1687 and belongs to the collection of the Tiroler Volkskunst-Museum in Innsbruck.[33] Below the picture, one can read the text of the Kümmernis legend. In this painting, Kümmernis, though bearded, exhibits female characteristics that are accentuated through the presence of a light blue dress. She also wears a crown on her head, a fact which, in this instance, characterizes her as a princess, while her hands are nailed to the cross. Below her, one can discern an altar table decorated with two candles, along with a chalice and one of her golden shoes, which has fallen from her foot. All of these details were also characteristic of the *Volto Santo,* including the crucified martyr's stern, forward-looking eyes which do not seem to be aware of the musician kneeling below, near the cross.

Plate 19
Ex Voto, 1867
Innsbruck,
Austria

During the seventeenth and eighteenth centuries, paintings portraying St. Kümmernis became increasingly narrative, as the placing of the figures suggested a dialogue between them. Through the addition of fashionable articles of clothing, moreover, the crucified saint was transformed into a beautifully robed princess, a lady who graciously received the music-making admirer. He, in turn, was depicted in an ever more elegant manner over the centuries, reflecting his increased stature as a result of her rewarding attention. While the tragic aspect of this relationship was instrumental in capturing the popular imagination of the time, any sense of horror brought about by her crucifixion was downplayed through an emphasis on her serenity in suffering, as well as by the distracting display of colourful and fashionable details such as costumes, elaborate architecture and picturesque landscapes.

One of these paintings, dating from the seventeenth century, is preserved in the Monastery of Säben, in southern Tyrol. On its reverse side, the work bears an inscription identifying the saint as "St. Wiborada or Kümmernis," yet another imaginative local version of her name, apparently derived from a combination of Wilgefortis and Liberata.[34] In this painting, the saint is bound to the cross with ropes around her wrists and ankles rather than being nailed to it. As mentioned before, this depiction of ropes is characteristic of the late Gothic Netherlandish tradition surrounding this image, at a time when she was called

"Ontkommer," a name that may be translated as "one who escaped" her fetters.[35]

In the painting at Säben, on the other hand, her cross is depicted as resting above an altar, while one of her shoes has fallen onto the altar table. These details suggest a reliance on traditional Italian imagery as represented by the *Volto Santo*. Beyond the merging of these two diverse traditions, fashionable Baroque details have been added in order to draw additional attention to the figure of the saint. These include such items as high-heeled shoes and red stockings. In this painting, the slightly bearded saint appears more delicate, and therefore more approachable than was the case with the more stern and majestic images of the past. Here, she gently turns her head and thus acknowledges the fiddler's pious bearing and adoring expression.

During the eighteenth century, in particular, a number of large and increasingly ambitious paintings were created, each of which featured additional narrative details and figures. One of these paintings, created during the early eighteenth century, is located in the monastery at Stams. In this recently restored painting,[36] the imaginative richness of the composition and the quality of the brush strokes can once again be fully appreciated. As a result of the more traditional formal and frontal arrangement of the composition, the figure of the saint spans most of the width of the picture, while an angel approaches her from above bearing a wreath of white flowers.

The fiddler is consigned to the left foreground, while the seated king and his female companion are found in the right middle ground. The addition of this frightened-looking young woman is especially noteworthy and unusual. With one hand raised, and the other one touching her breast, she may be interpreted as depicting either the saint herself attempting to ward off her cruel father prior to the crucifixion, and before the appearance of her beard, or else as her mother, who grieves as she witnesses the suffering of her daughter on the cross.[37] The inclusion of the seated and brooding king can be explained as reflecting popular versions of the legend that blamed the father for harbouring incestuous feelings for his daughter and having her crucified when she rejected him.

During the Baroque era, an important spiritual link was established between images of St. Kümmernis and other heavenly beings, inclusive of the Virgin Mary and even God the Father. In a painting that bears the inscription "EX VOTO 1730"

Plate 20
St. Kümmernis,
18th C.
Stams, Austria

and is now part of the collection of the Heimatmuseum in Kufstein, the saint is portrayed inside an altar room, bound to the cross with ropes around her wrists and legs.[38]

Plate 21
Ex Voto, 1730
Kufstein,
Austria

Above her, we see a spectacular heavenly apparition of the Virgin with Child. The bright sphere of clouds which surrounds them extends to the right arm of St. Kümmernis. As a result of this detail, the crucified saint can be perceived as receiving not only heavenly approval but also additional spiritual energy from the Virgin Mary in heaven. This energy was thought to be available to those who implored the crucified saint for favours, as is symbolized by the kneeling musician below the cross. Her gift, the falling shoe, is already descending towards him, and can be seen as a promise of future rewards for all her other followers. In this way, the female crucifix serves as a bridge between heaven and earth, and as a channel for grace and deliverance. In this sense, the painting carries a spiritual message similar to that conveyed by the image of Christ on the cross, but in a feminized form.

An even more explicit connection between the Virgin Mary and the crucified female saint has been posited in connection with a large and beautifully designed late-eighteenth-century painting of St. Kümmernis which is currently located in the parish church of Uderns.[39] This work is believed to have been originally intended as the altar painting for the church, but has now been moved to the left side aisle.[40] For a time it was also placed inside the Plunggenkapelle, situated at the edge of a nearby forest. A text displayed in this chapel explains to the modern visitor that St. Kümmernis was once regarded as akin to "Mary on the Cross," a perception described in the text as having been exclusive to Tyrol during the Baroque era.[41]

Plate 22
St. Kümmernis,
late 18th C.
Uderns,
Austria

Throughout much of the history of Catholic Christianity, the Virgin Mary was elevated not only to the status of "Theotokos" (God-bearer), or Mother of God but she was also venerated as a "Co-Redemptrix," meaning that she, like Christ, had redeemed humanity—in her case as a result of her compassionate sharing in Christ's suffering and salvation.[42] As a result of this, she was able to redeem and intercede on behalf of human beings who turned to her in times of need. In an imaginative theological interpretation, Mary was therefore seen as also having been crucified, albeit in a more indirect and spiritual form. (This was sometimes depicted, though not in any of the Kümmernis paintings, in the form of arrows or swords piercing Mary's breast.) In

a manner reminiscent of Christ, who had been called a "Man of Sorrows," Mary was frequently portrayed as "Mater Dolorosa," or the grieving mother.[43]

Therefore, it is possible to interpret the painting of Kümmernis in Uderns as representing a crucified Mary—especially since, in this instance, the figure is portrayed as a heavenly queen without a beard. The painting is perhaps the most specifically feminine portrayal of St. Kümmernis known today. She is richly dressed, in the manner of a beautiful and youthful queen or princess—a fact emphasized not only by virtue of a golden crown on her head, but also because of jewels and pearls that appear in her hair and on her robe. Her lovely face is surrounded by a large halo, a sacred symbol complemented by the presence of angels approaching her from above. They offer her a laurel crown, a palm branch and a stem of lilies, symbolic of victory and of virginity, both of which specifically apply to Mary.

The saint's calm countenance and all-embracing arms, while tied to the cross with ropes, express serenity, acceptance and victory. Her windswept gowns suggest the movements of a graceful dancer. Suspended in an elevated manner on the cross, she is poised between heaven and earth; the background behind her portrays both of these realms in the form of a spacious landscape with distant mountains and a wide blue sky above. In the foreground, one of her elegant high-heeled slippers has fallen from her right foot toward the reverent musician at the foot of the cross, who in this case is depicted as an older man with a bushy white beard.

In most earlier depictions, the fiddler was portrayed as a more youthful, even at times childlike, figure. The specific reason for the inclusion of an older man in this example remains unclear; however, one may speculate that this figure depicts a donor connected with this painting—a practice that was not unheard of in post-Renaissance religious art. A second possibility is that the figure represents a self-portrait by the artist, a practice that was also relatively common in religious devotionary art throughout this period and earlier.[44]

During the early nineteenth century, new images of Kümmernis continued to be created in imaginative ways. One example is a relatively small painting now located in the Augustinian Museum at Rattenberg.[45] In this example, Kümmernis is depicted in the company of God the Father, together with a nearby dove which represents the Holy Spirit.

Plate 23
St. Kümmernis,
early 19th C.
Rattenberg,
Austria

The female saint, in spite of the long hair that reaches her waist, has a rather stocky and masculine appearance, emphasized especially by a dark and prominent beard. She is wearing a bright red robe that covers a long white undergarment. Her extended right arm reaches into the clouds toward the figure of God. As a result, she almost seems to function as a substitute for Christ as the third person of the Holy Trinity. On the other hand, however, the cross is placed in front of a rough wooden structure within an ordinary earthly landscape, while the fiddler is kneeling in the foreground, watching the shoe fall down in front of him.

These details link the crucified figure to Kümmernis more than to Christ, but without ruling out the latter interpretation entirely. This is appropriate, insofar as the *Volto Santo*, from which this imagery was ultimately derived, had portrayed Christ rather than a female martyr. Moreover, from the perspective of the popular spirituality of the time, this gender ambiguity, far from being confusing or troubling, was instead regarded as inspiring, and even comforting. This is especially true in that Kümmernis, over a number of centuries, was sometimes viewed as being more approachable than the divine Christ. Her legendary story permitted greater room for personal reflection and romantic feelings, due in large part to the poignancy and tragedy of the interaction between the princess and the fiddler, than did the officially sanctioned depictions of Christ, rigidly regulated as they were by the official Church. This stirring of emotions, together with the fact that images of her became increasingly as popular as images of more traditional and more established saints, eventually resulted in the Church discouraging, and ultimately suppressing, this popular tradition.

The most elaborate and unusual depiction of the story of Kümmernis, however, can be found in a painting located in the St. Veit Chapel at Lehen near Telfs. This work, replacing an earlier depiction of Kümmernis which had been burned by an overzealous Franciscan cleric, was painted around 1820 and has been attributed to the local artist Anton Puellacher.[46] In this work, eight figures are grouped around Kümmernis. Two of them can be seen dragging Kümmernis onto a large board while tools in the foreground are assembled in order to nail her down.[47]

This composition of figures clearly imitates scenes in earlier paintings that portray the preparations for the crucifixion of Christ. In this work, however, it is the white-robed, bearded Kümmernis who is depicted as the centre and focus of this paint-

Plate 24
The Nailing to the Cross,
ca. 1820–30
Telfs, Austria

ing in a pose that recalls the traditional image of the Raising of
the Cross—i.e., with outstretched arms awaiting the nails that
will pierce his palms. In contrast to traditional images of Christ,
this figure is unmistakeably female, her full blond beard
notwithstanding. Her eyes are raised toward the sky, from which
two angels approach her with a wreath and a palm branch—
symbols of her impending martyrdom.

On the right side of the picture, her royal father is seen
supervising these activities with an expression of fury on his
face. His eyes are filled with rage; armed soldiers stand at atten-
tion on either side of him. In the far distance, several women can
be seen mourning, while in the left foreground a woman in a
blue dress is wiping her eyes while weeping, as a small fright-
ened child clings closely to her. Both the presence of these addi-
tional figures, as well as the fact that Kümmernis, atypically, is
shown prior to being nailed to the cross, make this work of art
especially unusual and noteworthy.

This painting marks the last known surviving example of a
Tyrolean Kümmernis representation. Although the Museum
Ferdinandeum in Innsbruck contains two depictions of the
bearded saint dating from the second half of the nineteenth cen-
tury, these are not Tyrolean in origin, but are instead from
Burghausen in Bavaria.[48] This town was one of the largest
Kümmernis pilgrimage sites in southern Germany, comparable
to Neufahrn in significance. In both of these locations, the ven-
eration of this saint continued into the twentieth century, even in
the face of considerable discouragement by the Church.[49]

These two modest panel paintings offer a potential glimpse
of what late-nineteenth-century Tyrolean Kümmernis paintings
might have looked like had they been preserved until the pres-
ent time. It should be noted, however, that in both cases the fid-
dler at the foot of the cross has been replaced by a praying
man—almost certainly the actual donor of the panel. As was
noted previously, this practice was quite common with regard to
such *ex voto* paintings in earlier centuries.

In spite of the unassuming dignity of these two small paint-
ings, however, it is evident that the vigour and complexity of
earlier images of Kümmernis had diminished by this time—a
decline mirrored by the waning popularity of a saint who had
once held such a significant position in the popular imagination.
Although she is currently little more than a largely forgotten his-
torical curiosity, she once enjoyed a status which, both visually

and spiritually, was almost Christlike and comparable to the Virgin Mary in stature and far-reaching influence.

Chapter 8

The Bearded Woman and the Phenomenon of Hirsutism: Past and Present

This chapter presents the Wilgefortis/Kümmernis phenomenon against a historical backdrop of depictions of bearded or otherwise sexually ambiguous women over the course of several millennia, commencing in antiquity. These depictions and written descriptions are to be found in the realms of mythology, literature, medical science and other areas, and have been indicative of prevailing societal attitudes towards seemingly "masculine" women during the past and present.

In addition to being described in ancient mythology, bearded women have also been portrayed in Western literature and art. The phenomenon of female hirsutism, defined as excessive female virilizing hair growth, is today the focus of psychological and medical research. In antiquity, a beard symbolized virility and power, and was therefore included in depictions of certain androgynous, and sometimes even female, deities. In various early civilizations, in fact, abundant growths of hair in general were regarded not only as a sign of vitality and sexual power but were also connected with various cultural values and religious symbols.[1]

In more recent centuries, however, excessive female facial hair has come to be viewed as grotesque, shocking and even

Notes to chapter 8 are on pp. 150–153.

monstrous — an offence against the laws of aesthetics and even of nature itself. In medieval society, however, the beards of saints such as Wilgefortis were still regarded as an awesome, divinely inspired miracle. This disfiguring feature was thought to have been granted in order to protect female virginity; it was also held to be a gift of grace that enabled Christ's female followers to more closely resemble him, and in the process, to become more Christlike overall. Wilgefortis was not the only saint to receive this divine gift of a beard; the legendary St. Paula of Avila[2] and St. Galla of Rome[3] were also described as being bearded. St. Agnes, in turn, was described as having been able to shroud her body in long hair; St. Mary Magdalene and St. Mary of Egypt were also said to have grown fleeces of body hair. All of these phenomena were commonly interpreted as constituting evidence of divine protection and favour.

One of the oldest sources of female hirsutism can be found in connection with the Babylonian goddess Ishtar, who was regarded as the queen of heaven and of the stars. Depicted as bearded and dressed as a warrior, she was also sometimes portrayed as hermaphroditic. Although she was commonly invoked as the fierce "Ishtar Barbata" in northern Babylonia, she was venerated as a gentle goddess of motherhood and love in the southern regions of the kingdom. Apart from depictions of Ishtar, there are various other ancient images that portray bisexual figures; one of the oldest of these has been found in Thessaly, dating from ca. 6000 B.C. Unfortunately, the head of this figure is missing, but its female breasts and male genitalia are unmistakeably apparent.[4]

The Egyptian queen Hatshepsut, who ruled from 1490 to ca. 1470 B.C., became famous for her Funerary Temple near Thebes as well as other monumental works of architecture. She was commonly depicted as wearing a ceremonial beard which was attached to her chin; she also demanded to be addressed as "His Majesty," and declared herself to be the "son" of the sun god Ra. Her life and times have fascinated both scholars and popular writers, especially since the discovery of her mummified body in 1902.[5]

In the works of ancient writers such as Homer and Ovid, gender transformations sometimes occurred as a result of affairs between gods and mortals. Thus, after Poseidon had sexually assaulted Caenis, she asked him to transform her in a way that would preclude him from ever desiring to do so again.

Consequently, Caenis became Caeneus. Having been granted invulnerability, he subsequently participated in the battle between the Lapiths and the Centaurs, recovering his original female form only in the underworld.[6] Another incident of gender transformation occurred with regard to Iphis, the daughter of Ligdus and Telethusa of Crete. Iphis was reared as a boy because her father had threatened to kill the newborn if it was female. With the help of the goddess Isis, Iphis was later transformed into a man, in order that he might respond to the love of a young woman called Ianthe.[7]

These legends have all been mentioned in connection with full gender transformations—i.e., from male to female, or vice versa. Even hermaphroditism, however—in other words, the simultaneous presence of both male and female sexual organs—was not only mentioned in various ancient legends but was actively condoned—and even, at times, celebrated. In various ancient cultures, for example, hermaphroditism was not seen as either a disturbing aberration or a medical problem but rather as an indication of divine, unlimited possibilities as well as the supreme integration of male and female qualities:

> Like India's Ardhanarisvara—Kali and Shiva united in one body—Hermes was the original "hermaphrodite" united in one body with Aphrodite. Priests of Hermes wore artificial breasts and female garments to preside over Aphrodite's Cyprian temple in the guise of the god Hermaphroditus.[8]

An image of a so-called "royal pair," symbolizing not only divinity but also the wholeness and perfection of humanity, can be found in examples of South Asian sculpture, in which Shiva and his spouse are united in a hermaphroditic manner, including both a single breast and male genitalia.[9] In historical Western imagery, various depictions of hermaphrodites were used to illustrate alchemical manuscripts; these portrayed the combination of male and female figures in the form of two equal halves, which were usually combined on a vertical axis. On the other hand, a seventeenth-century depiction of a hermaphrodite reveals a double-gendered figure divided horizontally and featuring two independent but joined heads.[10]

One of the most notable examples of an androgynous goddess is derived from the ancient cult of the hirsute Aphrodite, or "Venus Barbata," on the island of Cyprus.[11] This Cypriot goddess was worshipped by transvestites, and honoured in gender-

crossing rituals. Several recent archaeological findings point to the existence of bearded statues of this goddess. She was also, at times, referred to as the god Aphroditus, because it was believed that she could take the form of a man. Her cult was frequently associated with fertility rites, especially with regard to human reproduction.[12]

In a Renaissance compendium of images of the gods of antiquity, the bearded Aphrodite is described in the following manner:

> The ancients represented Venus not only with long flowing hair, but also with a beard.... A statue of the Bearded Venus was found in Cyprus. They made her bearded so that this goddess would have the mark of the male as well as that of the female as befitting the one who oversees the universal generation of the animate beings. Therefore, they made her in the form of a female from the waist down, and of male from the waist up. The ancients said this not only concerning Venus, but also concerning all the other gods as well, calling each of them by a male name as well as by a female one, as if among the gods there would exist no sex difference, which instead exists among the mortal human beings.[13]

This text is based on the *Suidas*, a tenth-century lexicon of literary history, in which the cult of Aphrodite is presented as providing a context in which her followers could plead for, among other things, a cure for baldness: "Praying to Aphrodite to be given hair again, they honour her with a statue which carries a comb and wears a beard, wherefore it has male and female genitals. For they say she is male while below she is female."[14]

Numerous images of bearded and androgynous figures, either standing or sitting, have been found on Cyprus. These artifacts date primarily from the Archaic period (750-600 B.C.). A terra cotta figurine of a standing Aphrodite, for example, features not only a bushy beard, but also a masculine torso along with a feminine lower body. This work dates from the sixth century B.C., and is now housed in the Metropolitan Museum in New York City.[15]

An explanation for the dual sexual nature of this goddess can be found in various cosmogonic narratives, particularly the myth of an androgynous divinity who had once symbolized the totality of creative powers by presiding over the universe before the splitting of the cosmic egg had occurred, thereby dividing the sexes. Plato, as well, believed that human beings had origi-

nally been hermaphroditic before they were split into separate halves. Certain early Christian theologians believed Adam to have been hermaphroditic, in the sense that Eve had been part of his body before she was fashioned from his "rib."[16] In a rare example of early medieval art that constitutes part of a ceiling fresco in St.-Savin-sur-Gartempe, France, and dates from around 1100, Eve was portrayed as having been bearded on the occasion of her marriage to Adam.[17] Even the Virgin Mary, in her role as the Mother of God, was occasionally represented as bearded, as certain images from the Carolingian era demonstrate. In later medieval developments, a symbolic reversal of gender roles was suggested by the occasional description of Jesus as a mother.[18]

Apart from the evidence of various myths and art objects, it can be argued that there was also a psychological component to the persistence of hermaphroditic figures throughout the ages — specifically the yearning of the human psyche to transcend sexual boundaries. The anticipation of such a union can be said to be inherent in the experience of love, for example, be it a sexual or purely mystical union. Religious rituals and visualizations have frequently been used in order to articulate these aspirations. Such creative activities can also be regarded as an attempt to both envision and achieve some form of eschatological completeness.[19]

During the Middle Ages, there was a particular fascination, especially in Germany, with regard to so-called "wild men" and their families. These mythical creatures were believed to inhabit remote mountainous and forested regions and were characterized by excessive growths of hair which supposedly covered their entire bodies. Their lore was partly based on various accounts from ancient times, in which monsters and grotesque races from foreign lands featured prominently. While wild women were not specifically portrayed as bearded in these accounts, they were nevertheless hirsute, symbolic of both their basic animality and their untamed procreative powers.[20]

A more concrete and seemingly value-free portrayal of the phenomenon of hirsutism can be found in the works of the Baroque Spanish artist Jusepe de Ribera (1591-1652). Famous for his religious paintings of the Counter-Reformation era, he also created a documentary painting of a bearded woman by the name of Magdalena Ventura of the Abruzzi. This painting was commissioned in Naples by the Duke of Alcalá, who had a particular interest in collecting portraits of "dwarfs and deformed

persons in the best Spanish tradition," and thereby earning Ribera the somewhat undeserved "reputation of a painter of abnormality and ugliness."[21]

In the portrait in question, dated 1631, the bearded woman is seen standing while dressed in a long gown and nursing her infant. She is accompanied by her husband, a marginal figure who is almost lost in the dark shadows surround them. Her unusual story is recorded on a prominent stone slab, which appears near the right edge of the painting. We learn that Magdalena began growing a moustache as well as a heavy beard in her late thirties; prior to this, she had given birth to three sons. According to the inscription, her appearance is "*EN MAGNU NATVM MIRACVLUM*," a great miracle of nature.[22] Magdalena's face displays severe, masculine features, while one bulbous breast is prominently exposed to suckle the child in her arms. The contrast between her stern, bearded face and her single large breast adds to the overall impression of abnormality. Both husband and wife are portrayed as prematurely aged, with furrowed brows and balding foreheads.

Her features are marked by a certain tragic dignity, however, thereby denoting a woman whose fate it was to become noteworthy as a curiosity and a freakish aberration. The presence of her husband and her baby indicate that she has still retained her female gender, in spite of her masculine face. In this portrait, her condition is portrayed as neither miraculous nor demonic; it is merely presented as an "objective" and historical commemoration of an accident of nature. Neither is her story imbued with greater symbolic significance, in that she is not accompanied by any of the bearded female saints who are found in the Catholic heritage which she shared with the artist. Rather, the life of this bearded mother appears to have become an isolating and relentless burden, to be endured with grim determination.

By the middle of the nineteenth century, however, the "Presenting [of] Human Oddities for Amusement and Profit," more commonly summed up as "Freak Shows," had become prevalent throughout the Western world, and particularly in the United States. These public presentations included not only "cannibals and savages" but also people whom we would now describe as intellectually challenged.[23] Included among these assorted "freaks" were "bearded ladies," midgets and Siamese twins. A number of these hirsute women were also photographed in respectable Victorian interiors and elegant costumes:

They were typically pictured striking feminine poses in elegant surroundings, wearing fashionable dresses and with their hair done in the latest style. Annie Jones, for example, appears in a number of photos sitting before a mirror, her long hair hanging down her back. For those who had husbands, and most did, a favourite photographic prop was their spouse. After all, being married and a devoted wife was the epitome of womanhood — which is what bearded women's presentations claimed to be. Some photographs — such as one of Mr. and Mrs. Meyers, he sporting a large handlebar mustache and she with her incongruous whiskers and feminine dress — represent the finest examples of formally posed Victorian normalcy.[24]

These women were exhibited on sideshow platforms and in circuses; they came to be known by assumed names, such as Lady Olga and Princess Gracie. A certain Madame Devere, in turn, possessed a beard that was fourteen inches long, and was believed to have set a record when measured in 1884. Another celebrity was "Madame Clofullia, The Bearded Lady from Geneva," who was featured during the course of the 1850s wearing formal dress and jewels. In order to test the authenticity of both her beard and her female gender, she was subjected to a hospital examination, which verified the genuine quality of her breasts. When she gave birth to a daughter in 1851, her doctors signed a statement to the effect that she was a normal mother in spite of her "abundant beard."[25] From another source, we learn that she had started to grow facial hair when she was only seven or eight years old, and that she had also developed a dark fleece which covered her entire body.

Another bearded lady shown at the circus was Barbara Urslerin, "the hairy-faced woman," who had long facial hair covering her cheeks and even parts of her nose. Typically, these bearded women did not have to learn any particular skills; they were merely expected to stand motionless for long periods of time, posing in fashionable clothing for the benefit of viewers and the occasional photographer.[26] In the resulting photographs, none of the hirsute women is ever seen smiling. There is, in fact, an element of melancholy and loneliness in their demure demeanour. They appear to be resigned to the fact that they constituted exotic sights in a society which, while mocking their appearance, also rewarded them (or their husbands) financially for their unusual features. Unfortunately, the culture of their time lacked any understanding of the mythological heritage or

hagiographic history of hirsutism. Consequently, these women were reduced to becoming a voiceless spectacle, gawked at by a partly fascinated and partly repulsed public.

Only in recent times have attempts been made to understand the causes of hirsutism in scientific terms. These causes range from psychological (for example, as a result of traumatic stress) to medical (e.g., as hormonal disturbances).[27] It is interesting to note that even in largely fictional accounts and legends of the past the phenomenon of hirsutism had frequently been linked to traumatizing incidents such as actual or attempted rape, incest or torture.

An example of severe distress and its physical consequences can be found in a fairy tale by the Brothers Grimm called "Allerleirauh." This name, literally translated as "all kinds of fur," referred to a princess who, at first, had been beautiful like her late mother; when she was sexually pursued by her father, however, she "put on her mantle of all kinds of fur," darkened her face and feet, and ran into the forest. Eventually, hunters found this "wondrous wild beast" and took her back to the castle, where she worked in the kitchen as an unnamed "hairy animal."[28]

Accounts of attempted incest have also been featured in various legends connected with St. Wilgefortis. These stories were especially popular in certain areas of Bavaria and South Tyrol. In 1649, for example, Karl Stengel, a Benedictine monk from Augsburg, characterized "St. Liberata called Wilgefortis" as a maiden "whose father desired to marry her, intending to force her; but God heard her prayer and transformed her female figure into that of a man, so that she developed, over night, hair and beard, and looked like a man."[29] This story appears to be the earliest recorded reference to incest in the legendary life of Wilgefortis; similar texts were also published in 1651 and 1712. The threat of violence appears to have been particularly prevalent in Baroque-era accounts of the life of this saint. It is possible that the popularity of Wilgefortis at this time was based at least in part on this factor, in the sense that she offered a source of spiritual support for women who found themselves in the midst of family conflicts or otherwise dysfunctional relationships. The widespread importance of this saint during this time is substantiated by a reference dating from 1678 in which the Augsburg Jesuit Benigius Kybler explains that, during his lifetime, an image of Wilgefortis has come to be found "in almost every church."[30]

In 1764, a publication from Mühringen in Württemberg described the life of "St. Kumerana, whose baptized name was Wilgefortis," in even more graphic terms: since her father had vexed her with sexual propositions, she had been changed "during her sleep," and received not only a beard and curly hair, but also "two horns on her head."[31] Popular booklets of Catholic devotion and so-called *Gebetszettel* (prayer leaflets), which were mass-produced during the eighteenth and nineteenth centuries, typically included accounts of attempted incest in connection with St. Wilgefortis. This motif also appeared in a legend originating from the South Tyrolean village of Kals in the Pustertal where, according to a local tradition, the saint's virginity had been threatened by the advances of her father. In the nearby city of Bozen, an even more dramatic account stated that the troubled princess, after having been approached by her father, had become not only wild but indeed insane. She was said to have lived out her life in the forest and was completely covered by hair like an animal.[32]

Accounts of attempted incest in connection with Wilgefortis have also been reflected in contemporary literature. For example, Michèle Roberts, in her book *Impossible Saints*, published in 1997, imaginatively retold the legend of "The Life of St. Uncumber" from a feminist point of view, focusing exclusively on the dysfunctional father-daughter relationship.[33] In this account, the "King of Portugal" is described as a morose, lonely and self-indulgent man whose only friend was his penis, which he commonly referred to as the "King of Sicily." Princess Uncumber attempted to hide from him; she was only thirteen, and had beautiful black hair. The King hoped his daughter would befriend the "King of Sicily," and attempted to rape her. But Uncumber used her long mane as a shield by covering "her face with her hair. She had turned herself upside down and had presented the "King of Sicily" with her beautiful mouth surrounded by her beautiful curly mane." This rather gruesome story, in which Uncumber goes on to bite off her father's penis and is able to escape to a nearby city, ends abruptly: "No one knew her name, so, when she died of exhaustion after fifty years working as a cleaner, she was buried in the common burial ground reserved for the poor."[34]

Hirsutism, in this story, is neither miraculous nor monstrous, and the saint does not go on to grow a beard. Nevertheless, hair is the central theme here. It constitutes the

only available source of protection for the young virgin, and is used as a shield for distraction and camouflage, thereby enabling the ultimate act of revenge against the male perpetrator.

In another work of contemporary literature, Wilgefortis is described in a more traditional manner, which includes a mention of her beard but excludes the account of attempted incest. Frank McCourt, in his 1997 book *Angela's Ashes*, wrote of his youthful fascination with the gory descriptions of female martyrdom contained in *Butler's Lives of the Saints*:

> Then there's St. Wilgefortis, virgin martyr...[she] was beautiful and her father wanted to marry her off to the King of Sicily. Wilgefortis was desperate and God helped her by allowing a beard and a moustache to grow on her face, which made the King of Sicily think twice but sent her father into such a rage he had her crucified beard and all.[35]

It would not be an exaggeration to suggest that detailed accounts of the torture of young virgin saints had traditionally been disguised, to some extent, as edifying and spiritually formative literature. Through the sober approach of Frank McCourt, however, such stories can be said to be unmasked, in that they are shown to provide an occasionally erotic and voyeuristic spectacle for the male mind. In this connection, the description of Wilgefortis's beard and moustache adds a bewildering note to the already fear-filled attraction towards the female body from the point of view of an impressionable and vulnerable young man.

In 1970, St. Wilgefortis made an appearance in Canadian fiction in Robertson Davies's *Fifth Business*. In this first book of the Deptford Trilogy, she is the focus of the narrator's passion for "saint-hunting, saint-identifying, and saint-describing." Here, the bearded lady is connected with the *Volto Santo*, while her story is presented in the larger context of both pre-Christian myths and modern science:

> I, however, had one or two new ideas about Uncumber, which I wanted to test. The first was that her legend might be a persistence of the hermaphrodite figure of the Great Mother, which was long worshipped in Cyprus and Carthage.... My other bit of information came from two physicians at the State University of New York, Dr Moses and Dr Lloyd, who had published some findings about abnormal growth of hair in unusually emotional women; they instanced a number of cases of beard-growing in

girls who had been crossed in love; furthermore, two English doctors attested to a thick beard grown by a girl whose engagement had been brutally terminated. Anything here for Uncumber? I was on my way to Europe to find out.[36]

Such sentiments, although expressed in fictional form, can be regarded as an invitation to investigate real-life scientific publications with regard to the phenomenon of hirsutism. Already in 1956, three medical doctors had published a book called *Dermatology*, which included a chapter on this topic of "Hirsutism." It begins with the following statement: "Excessive hairiness may be localized or diffuse, congenital or acquired, normal or pathological." Some lines further on, we find a more specific definition to the effect that "endocrinopathic hirsutism, much discussed but fortunately rare, is due to excessive secretion of androgenic hormones." "Localized hirsutism," on the other hand, is said to involve "prolonged trauma and irritation of the skin [which] may provoke localized hirsutism manifested by thicker, darker, and longer hairs." Simple and natural causes for this phenomenon are said to include severe rubbing or excessive massaging in certain areas of the body.[37]

In this publication, we are also informed that hirsutism constitutes one of the symptoms of Cushing's disease, an illness that "reflects hyperactivity of the adrenal cortex." Attention is also focused on the fact that "ovarian abnormalities, curiously enough, may be the cause of hirsutism accompanied by masculinizing states. The pathologic secretion of androgenic substances by the abnormal ovary underlies this disturbance."[38]

In the context of this same scientific study, an old photograph which reflects the formerly un-scientific interest in "The most Extraordinary Freak of Nature in the World" is included; this illustration serves to dramatize the contrast between past and present approaches to hirsutism. The "Bear Woman" in this photograph, whose real name was Julia Pastrana, was sixteen years old at the time of her first appearance in 1852. She was described as good-natured, educated and elegant. In spite of this, she was advertised as "The Greatest Living Curiosity." In 1877, P.T.Barnum clarified (in a letter to a certain Dr. Duhring) that he had previously exhibited the same lady as "Swiss," in spite of her Mexican origins, adding that she "was the most remarkable (and disgusting) hairy human being I ever saw. She was about as hairy all over as an American Black Bear." A

"Circus handbill" from this period, printed to draw attention to Barnum's exhibition of her, assured timid visitors that Miss Pastrana was "entirely devoid of any monstrosity in her appearance," and that she would "give the audience an opportunity of conversing with her and touching her beard."[39]

The 1976 edition of a book titled "Psychophysiological Aspects of Skin Disease" described "Hypertrichosis and Hirsutism" in females by observing that epileptic patients and those suffering from anorexia nervosa exhibited "increased facial hair" and "fine downy hypertrichosis." Additionally, some children who had suffered head injuries, encephalitis or experienced "severe emotional shock" were said to display abnormal hair growth. In one case, a twenty-five-year-old woman "developed excessive facial hair some six months after a disturbing sexual relationship." Another case involved "a girl who wished to become a boy.... After three months associated with thoughts of sex change she developed increased facial hair."[40]

A book about hirsutism, published in 1981, described "abnormal androgenization" as a "complete cover, light and heavy" of the chin. Also, "rapidly extensive hirsutism" was said to be "an indication of a virilizing tumour, particularly of adrenal origin."[41] A 1983 article, titled "Hirsutism — Ancestral Curse or Endochrinopathy," dealt with the thick coarse hair that was to be found both on the bodies and faces of certain women. It noted that the preoccupation with hair in general, and with female facial hair in particular, had had a long history: "In all generations, however, the bearded woman has been the object of great curiosity and the subject of much derision. The storied legends of the past have designated the bearded woman as an unnatural individual."[42]

The author of this article also makes a reference to Shakespeare, specifically about the three "weird sisters" who appear in Macbeth. In this play, these witches are, in fact, associated with demons and the devil. The fact that they are bearded provides additional evidence of their subversive and occult powers; their magic connects them to the underworld, in the sense that they conjure up apparitions and use cauldrons for the purpose of divination. In this play, the witches are addressed by Banquo, a nobleman in the company of Macbeth, with the following words: "You should be women,/ And yet your beards forbid me to interpret/ That you are so."[43]

Certain observers, in turn, have regarded the bearded St. Wilgefortis as an ugly monster and a subversive hybrid, and so her sudden disfigurement was sometimes attributed to witchcraft.[44] Perhaps her father's outrage, as well as his sudden decision to have her crucified, can be understood as a result of his shock at seeing his once beautiful daughter so drastically disfigured. During the course of the nineteenth century, at a time when the saint's popularity was on the decline, her appearance came to be increasingly regarded as embarrassing and repulsive — a perversion of the ideals of grace and beauty which were then associated with saintly womanhood. An example of this kind of aesthetic revulsion against the saint's beard can be found in a previously mentioned letter to the poet Justinus Kerner, written by a friend of his, a preacher from the German town of Gmünd, in 1817:

> What will you think when you see her hanging there with this repulsive moustache and beard?...Instead of a saint of music who has graceful and harmonious features, [one finds] hideous cheekbones and a mousy-pale grey beard shaded with black.[45]

The same scientist who had studied hirsutism in a historical context and had published his previously mentioned research in 1983 also took a closer look at the life of "St. Wilgefort," paying particular attention in his article to the fact that she was "betrothed against her will to a suitor she did not love." With regard to her desire to become unattractive for that reason, the question was raised as to whether there could be "a possible influence of the psyche as a factor in abnormal sexual hair growth," since an earlier medical study had collected evidence of "a temporary increase in facial hairiness in a woman following an ill-fated love affair."[46]

From this medical point of view, the information which is provided in the written text that appears on the portrait of the fifty-two-year-old "La Barbuda," painted by Ribera in 1631 and discussed earlier, can be said to yield some new conclusions. The fact that the subject of the painting, Magdalena Ventura, had experienced three spontaneous abortions and subsequently, at the age of thirty-seven, had become "markedly hirsute" may need to be taken into account in the sense that "the reproductive history of this woman suggests some hormonal disturbance." In any event, this work of art "serves to place on record that hirsute women have become and do become mothers." Today, this

painting is displayed in the Museum of the Tavera Hospital in Toledo, Spain, where it can be appreciated as the depiction of a medical condition. This approach is arguably more informed than viewing the portrait simply as a freakish curiosity.[47]

Another scientific study, also dating from 1983, draws attention to the fact that "hirsutism is occasionally the first sign of a very serious or even life-threatening disease." There can be "abnormalities within the adrenal glands and ovaries," with the result that hirsutism can result "from increased levels of testosterone."[48] In the context of ovarian tumours, "hirsutism may be the very first manifestation. . . . In such cases, hirsutism is usually rapidly progressive and is often soon followed by other signs of virilization." In spite of the fact that adrenal tumours which result in hirsutism are "quite rare," they may be malignant, at times, and are then described as "virilizing adrenal carcinomas."[49]

A third study from 1983, published in the journal *Psychological Reports,* focuses in particular on "Anxiety and Hirsutism." Its authors state that "patients with hirsutism have significantly higher state anxiety" levels than those without it. They also note that it had been suggested as early as 1969 that "emotional stress is related to hirsutism," in the sense that "intense and prolonged emotional stress could alter patterns of secretion of adrenal steroids."[50]

In a study of female-to-male transsexuals, it had been discovered that hirsutism had frequently been a prior symptom or condition experienced by such persons. Female transsexualism was therefore said to be connected with "significant endocrine dysfunction," and even with the largely unknown "effects of the prenatal hormonal environment."[51]

In summary, medical studies can be said to have "clearly linked hirsutism and other signs of virilism in women with excessive production of androgens, primarily testosterone." Moreover, there is substantial evidence to indicate that "elevated androgen levels in a large series of hirsute women are almost invariably ovarian in origin."[52] It should also be noted that a high incidence of hirsutism has been observed in schizophrenic women, as well as in those who have experienced severe stress or depression. It is justified, therefore, to speak of "stress-induced and depression-induced hirsutism."[53] In short, the causes for female hirsutism are complex and manifold.[54]

While the phenomenon of bearded women has been variously explained in the past with the help of ancient myths, and

with particular emphasis on heavenly miracles and supernatural gifts (or conversely on demonic activity, witchcraft or freakish accidents of nature) contemporary research has conclusively proven that hirsutism is neither an ancient legend nor a medieval superstition, but rather, part of an ongoing reality which is deserving of continued scientific consideration and attention.

Chapter 9

"Christa" and the Blending of Gender in Contemporary Society

This chapter continues the historical overview of depictions of "unfeminine" women featured in chapter 8 by examining images of crucified or otherwise tormented women throughout the course of the twentieth century. Such depictions are presented within the contexts of phenomena such as gender stereotyping, transsexualism and androgyny. It is argued that even though the veneration of St. Wilgefortis may have largely ceased, certain aspects of her sexually ambiguous legend, particularly as depicted in popular media such as art, literature and music, continue to be reflected and indeed celebrated in modern times.

In various fields of contemporary research and cultural inquiry—particularly in literature, theology, sociology, and the visual arts—attempts have recently been made to bridge the gender gap between male and female. This trend has been especially noticeable with regard to images, both verbal and visual, that have been created in an attempt to bridge the frequent gulf between human corporeality and spirituality. In other words, creative efforts have been made which seek to affirm and reclaim the human body as the basis for spiritual manifestations of the divine. This development has not been confined to the academic

Notes to chapter 9 are on pp. 153–154.

127

or arts communities alone, but has occurred throughout Western society as a whole. Popular trends can now be observed which challenge established norms of sex roles and gender stereotypes. Thus, phenomena such as androgyny, transsexualism, cross-dressing and transvestism can be understood, at least in part, as attempts to overcome the inflexible gender distinctions that have been enforced by entrenched traditions. Even so, there is always the risk of merely replacing one set of overly rigid norms or understandings with another. In a recent publication on the internet, "St. Uncumber (or Wilgefortis)" has been included in a sizeable group of "Lesbian, Gay, Bisexual, and Transgender Saints"; specifically, she has taken her place as one of fifteen "Transvestite Saints."[1] In spite of the fact that various depictions of this saint may give the impression of transvestism, it is somewhat limiting to define her in terms of this single category alone.

In the context of the visual arts, it is useful — and even essential — to examine modern-day feminist theological developments as well. This line of inquiry is particularly important in that it permits a greater understanding of the relevancy of the theme of the "female crucifix" in the context of contemporary North American culture. Books such as the 1991 publication *The Feminine Face of God* by Sherry Ruth Anderson and Patricia Hopkins also help to illuminate the ongoing search for a revised understanding of the divine; it is no accident that the subtitle of this book is *The Unfolding of the Sacred in Women*. In this work, the authors set out to assign new authority to individual female experience, while at the same time encouraging the cultivation of an interconnectedness with all beings. Such greater awareness is seen as superior to the traditional and exclusive focus on Christ as God:

> But what seems new to us, and particularly womanly, is that there is no single savior being awaited. Rather, the savior is spread out among us, emerging from each of us as we bring the fruits from our sacred garden into our daily lives. It is we who must save us.[2]

In the context of the modern visual arts, the feminist-inspired theme of the "Crucified Woman" has often been regarded as either a radical invention or the daring expression of a new androgynous consciousness. From the perspective of pre-twentieth century religious imagery, however, the theme of the crucified female martyr, of which St. Wilgefortis was merely the most prominent example, is neither radical nor new. Such images

have been created over many centuries, albeit only in small numbers and not by any of the so-called "great" artists. Unfortunately, these works have now become so obscure that they are no longer remembered as part of a shared cultural background. Consequently, these female crucifixes from the European folk art tradition of the past have not, as yet, been utilized as a basis for portraying Christ in new ways. The possibility of this, however, is limited only by the imagination of current and future artists.

Some contemporary artists, by depicting the unfamiliar figure of a woman on the cross, have also triggered intense reactions in some of their viewers. While these female crucifixes have generally been accorded an enthusiastic, or at any rate neutral, reception by many women, there have also been some critical voices. For some conservative male observers, in particular, female figures which serve as substitutes for Christ are offensive, particularly with regard to the aspect of nudity. Such images are also viewed as being theologically unsound, in the sense that they display an ordinary woman in a context that has been traditionally associated with the Son of God.

In spite of such objections, however, various artists and writers have continued to pursue the idea of "replacing" Christ with a crucified and ordinary mortal woman. An early description of such a crucified female can be found in the novel *My Name Is Asher Lev* by Chaim Potok, written in 1973. Here, the narrator describes a disturbing painting of his mother:

> I drew my mother in her housecoat, with her arms extended along the horizontal blind, her legs tied at the ankles to the vertical of the inner frame with another section of the cord of the blind. I arched her body and twisted her head.... The torment, the tearing anguish I felt in her, I put into her mouth, into the twisting curve of her head, the arching of her slight body, the clenching of her small fists, the taut downward pointing of her thin legs.[3]

Although most likely unknown to Potok and to most of his readers, these words could also serve a description of various depictions of St. Uncumber. She too was typically portrayed as being tied to a cross with ropes, and dressed in a long simple frock, as has been noted in an earlier chapter of this book. In his description of this painting, Potok also includes a reference to two men who are seen standing below the cross; they are intend-

ed to represent the narrator and his father, in the sense that the mother's loyalties had been torn between her two closest but estranged relatives. Seen from the perspective of Wilgefortis/Uncumber, the two men who are witnessing this crucifixion are part of the traditional iconography; they represent the furious father and the frustrated suitor, both of whom are consumed by their intense emotions.

In 1976, the artist Almut Lutkenhaus-Lackey completed an almost life-size bronze sculpture called *The Crucified Woman*. This work was exhibited in the sanctuary of Bloor Street United Church in Toronto in 1979, thereby providing a visual focus for Lent and Easter. Viewing this statue at that time, "women saw their suffering, their dying, and their resurrection embodied in a woman's body."[4] The presence of this sculpture triggered a major controversy, however; it challenged established Christian views, and was accordingly called blasphemous by some observers. By way of an explanation, the artist noted that her intention had not been to create a religious work of art — and certainly not a female Christ. Rather, she had intended to symbolically portray the suffering of women. It was for this reason alone that she had turned to the image of the crucifixion — albeit featuring only a figure, and not a cross as such. In 1986, in order to minimize further conflict, this sculpture was permanently installed in a garden behind Emmanuel College at the University of Toronto.

Since that time, women have gathered around this statue on many occasions for reflection and meditation; for example, many of them brought flowers and held vigils in the aftermath of the Montreal massacre in 1989. Many women also expressed their intense feelings about this statue in poetry and prose: some wrote that they felt closer to Christ than ever after seeing this memorial to universal female suffering. They observed in this sculpture a youthful body which had been stripped of its clothes and left vulnerable, assaulted, battered, violated, bleeding, torn and stretched. However, some observers also pointed to the hauntingly beautiful body, which in their view floated almost like a dancer, graceful and delicate, with an absence of nail marks on the palms or feet, and without a cross. The sorrowful face of the figure seemed to them to express resignation and peace rather than pain and grief. One male observer wrote enthusiastically: "Christ-like indeed! A passionate display of love for the world. Vulnerable, yet with a heaven-bound stare

that transcends her agonized pose and the jeering crowd below."[5]

Another commentator, this time female, described the transformative effect which this work had on her understanding of the divine:

> The usual image of a man hung on a tree really imprisoned me to the idea of a male God. The image of woman liberates me into the idea that my being a woman allows me to identify with God's act. Beautiful, powerful, a challenge to take up the cross and not be a passive bystander.[6]

This sculpture has also been prominently featured in various media reports over the years, among them a 1979 magazine article titled "Which Sex Is God?" This article included a reference to Naomi Goldberg's book *Changing of the Gods: Feminism and the End of Traditional Religions*, in which Goldberg was quoted as having condemned "the sexism that lies at the root of the Jewish and Christian religions": "God must be replaced by a deity of goddesses who can serve as role models for women in much the same way as He has served as a role model for men."[7]

A different but no less controversial sculpture was created in 1984, and is called *Christine on the Cross*. This female crucifix, two feet in height, is the work of sculptor James M. Murphy, and has been exhibited in St. James Chapel at the Union Theological Seminary in New York. This crucifix includes a crossbar on which the legs are spread apart and nailed down. The arms, in turn, stretch upward and are nailed above the figure's head. The artist commented on the process of creating this work as follows: "Last Easter my sketch in soft clay took the shape of a woman. I realized thereby that the world's rejection and hatred of women culminates in crucifying the female Christ."[8]

That same year, in 1984, Edwina Sandys created a sculpture of a crucified woman which she called *Christa*; this figure was initially exhibited at New York's Episcopal Cathedral of St. John the Divine. In order to ease the shock of the sight of a nude woman on the cross, the local Dean of the church reminded his congregation of the medieval mystic Dame Julian of Norwich, who had utilized female terminology in order to describe the experience of the divine. For instance, she had referred to Christ as "our mother," and had described the sacrament of Communion as issuing from the breasts of Christ. A more con-

temporary gender-inclusive perspective was subsequently offered by the theologian Carter Heyward:

> When we are most genuinely in touch with one another and most respectful of our differences, we most fully embody *Christa*. As members of her sacred body, we give and receive power to bless, to touch, and to heal one another, we who are lovers and friends, sisters and brothers, of all creatures and of the earth, our common home.[9]

The author Margaret Laurence, in turn, praised this work as "awesome and inspiring." In her opinion, the artist had not specifically attempted to portray Christ, but rather, had expressed "a deep feeling for the anguish and also the strength of women, and...the sense that there is a female aspect of the Holy Spirit."[10]

In contrast to these appreciative views, however, Margaret Miles, a contemporary theologian who specializes in religious imagery, has criticized this sculpture as being highly problematical and even counter-productive. From her perspective, it displays female nakedness to the male gaze in an almost pornographic way, and appears to celebrate female passivity and suffering:

> Edwina Sandy's *Christa* illustrates the danger of appropriating the naked female form to present women's experience. Here, a crucified woman droops on an implied cross, thus occupying what is perhaps the position of greatest honor in centuries of Christian depictions of Christ's redemption of the world. The image startles; it makes vivid the perennial suffering of women. As a private devotional image it may have great healing potential for women who have themselves been battered or raped. Yet as a public image, placed for some time in the Cathedral of St. John the Divine in New York City, there are fundamental problems with the image. The *Christa*, by its visual association with the crucified Christ, glorifies the suffering of women in a society in which violence against women has reached epidemic proportions. Equally disturbing is its association with pornography, which similarly fetishizes suffering women.[11]

Fortunately, such a critique cannot be said to apply to visual depictions of Wilgefortis, which portrayed her as both robed and bearded—not an erotic spectacle, in other words. Miles's argument concerning "the position of greatest honor" also needs to be assessed from a different perspective where Wilgefortis

is concerned. In spite of the fact that the bearded female saint was at times deliberately confused with Christ, this should not be misconstrued as having cast into doubt the special and exclusive nature of Christ's crucifixion. Although the "Kummernus/Kümmernis" phenomenon, discussed in a previous chapter, deliberately facilitated a double reading of gender — an ambiguity which resulted from the custom of robing crucifixes — this was never intended to diminish the redemptive nature of Christ on the cross. Nevertheless, the "transvestite clothing" which these figures are depicted as wearing can be said to have constituted an attempt to transform the figure of Christ into a more universal and gender-inclusive symbol, thereby deconstructing the fixed binary opposites of male and female, as well as those of the human body and of varying attire.[12]

A crucifix that is not limited to the depiction of only one gender can be said to offer another dimension of identification as well: by transcending gender, it encompasses and embraces problems resulting from human relationships, especially in the areas of love and intimacy. Through the visual unification of both genders, such a crucifix embodies the healing of gender divisions and of sexual dilemmas. While the "triumphant" male crucifix historically expressed the dignity of suffering by presenting an example of sacrificial love which could overcome death, the "addition" of the female gender can be said to render the crucifix even more universal and life-affirming in its overall significance.

However, while representation of androgynous crucifixes can legitimately be said to constitute an important and "enduring religious symbol,"[13] it does not follow that such images are meant to imply that an androgynous personality is somehow a prerequisite for human perfection. Psychological androgyny, in fact, has never been shown to be viable in solving sexual conflicts or other relational problems:

> For even if people were all to become psychologically androgynous, the world would continue to consist of two sexes, male and female would continue to be one of the first and most basic dichotomies that young children would learn, and no one would grow up ignorant of or even indifferent to his or her gender. After all, even if one is psychologically androgynous, one's gender continues to have certain profound physical implications.[14]

Since human beings are inherently incapable of achieving total physical or psychological gender integration, it is primari-

ly through images of art, as well as through other cultural mediums, that we are able to envision the blurring and even the ultimate disappearance of our various gender-based distinctions. This, in turn, permits us to transcend our conventional identities as male or female. As one commentator has observed:

> The function of images is to mediate so that we are not possessed either by spirit or by matter. They allow us to dwell in an intermediate world which is the world of soul-making, the domain of ritual. Ritual is the soul's journey through images, images which, while partaking of both spirit and matter, belong to neither, are possessed by neither.[15]

In his book *Gender*, published in 1982, the historian Ivan Illich expressed the opinion that "over long time periods, the line dividing the two genders can change its course, and under certain conditions may or even must be transgressed."[16] Paradoxically, he is convinced that "transvestism also functions to confirm the gender divide" and that "spontaneous group violations of gender-related strictures are rare and have always been experienced as something frightening." He goes on to note, however, that transvestism can also have a challenging, liberating, and even at times political effect.[17] For example, while transvestites, in our society, are said to consist primarily of men "who feel a compulsion to put on women's clothes for erotic satisfaction," women have used male clothing for very different ends, most notably "to have access to professional and economic opportunities seen as available only to men." As a result, "clothes can be used to misinform, and thus produce an incorrect gender attribution."[18] In a less politicized context, there is also a long history in literature and in theatrical performances of males impersonating female characters.[19]

Seen from a medical, rather than a political or cultural perspective, Wilgefortis's journey into masculinity was only limited to a beard, a feature that changed only her appearance, not her gender. Neither can she be accused of having engaged in crossdressing, since she never abandoned her female clothing. Nevertheless, the sexual ambiguity inherent in her various portrayals has attracted a certain amount of interest in the contemporary world. Various artists, including those working in the media of theatre, film, video and popular music, have attempted to bend the boundaries of gender stereotypes and oppressive sex roles. The play *Mr. D'Eon is a Woman*, for example, which is

based on "the true story of a transvestite aristocrat in the years before the French Revolution," has been well-received in a recent theatre review.[20]

Artists working in the medium of photography, such as Cindy Sherman and Diane Arbus, have in turn shocked, puzzled and intrigued the public with their controversial images. Arbus's *A Naked Man Being a Woman* of 1968 has challenged the traditional concept of the aesthetically perceived nude figure by suggesting bisexuality. Sherman's work *Untitled No. 122* from 1983 portrays a figure that is almost totally covered by a black coat, while the head is shrouded by long hair; in this way, the gender of the figure becomes ambiguous and disguised, while the clenched fists and the single piercing eye suggest "an over-powering individual."[21]

In a somewhat broader context, movies such as *Tootsie, Victor/Victoria* and *Mrs. Doubtfire* have demonstrated the enduring appeal of the blurring of gender distinctions as a source of popular entertainment over the course of the last few decades.

It is in the medium of rock music, however, that androgyny and transvestism, in particular, have arguably been most prevalently featured—and indeed, celebrated. Several prominent rock musicians, including Marc Bolan, Mick Jagger and David Bowie, have at various times adopted an androgynous look or image, including the wearing of women's clothing or the application of make-up. David Bowie, in particular, has been well-known for this—especially with regard to several of his album covers and stage personas during the early 1970s. In 1970, for instance, he was portrayed on the cover of his album *The Man Who Sold the World* posing in a long, flowing dress—a visual statement that has been variously described as an attempt at generating shock value[22] and, more intriguing from an art historical perspective, as a parody of a work by the Pre-Raphaelite artist Dante Gabriel Rossetti.[23] A similarly androgynous portrait appeared on the cover of his follow-up album *Hunky Dory* in 1971. It was with the release of his subsequent album *The Rise and Fall of Ziggy Stardust and the Spiders from Mars* in 1972, however, along with his adoption of the accompanying stage persona that same year, that Bowie's embrace of androgyny became complete. With his garishly dyed orange hair, Kabuki-inspired stage costumes and lavish applications of facial make-up, the Ziggy Stardust persona almost immediately became a milestone in the development of theatrical rock and roll. Although a largely secular creation,

Ziggy nevertheless embodied certain unmistakeably religious qualities as well. Given his depiction as a "leper messiah" during the album's title song, for example, the Ziggy persona can be viewed as an inadvertent, but nevertheless compelling, secular counterpart to the Wilgefortis legend. Here, as with the bearded female saint, we find elements of both a messianic and a medical nature: a strangely mutated, almost super-human figure serves to simultaneously intrigue and repel us. As with Wilgefortis, Ziggy ultimately meets (or at any rate, appears to meet) a tragic end; he is surrounded, like the bearded saint, by adoring supplicants—or, in late-twentieth-century terminology, fans. This is not, of course, to imply that Bowie was deliberately seeking to invoke the legend of St. Wilgefortis in his music (there is, in fact, no evidence to suggest that it has ever inspired any rock star's creative output, for that matter) but merely to point out that several of the key themes of the Wilgefortis legend—gender-blending, martyrdom and physical mutation, to name just three—continue to intrigue us centuries later, even though they are presented in completely different forms and guises at this time. The desire to engage in the exploration of what Bowie, for one, has described as "otherness"[24]—be it sexual or psychological or other—is also a factor that is common to both our current age as well as bygone centuries.

What is true of Bowie's work specifically is also true of modern-day artistic representations of the female *Christa* in general. Although the influence of previous portrayals of St. Wilgefortis on such works is largely non-existent at the moment, the themes and issues which the Wilgefortis legend raised continue to be a vital part of contemporary artistic efforts to integrate human corporeality, on the one hand, and spirituality, on the other. The cult of the bearded female saint may have come to an end, and her images may have been largely forgotten, but the questions and issues she once personified will likely continue to be artistically examined and depicted well into the future.

Conclusion

This book has been written in part as an attempt to shed some light on a long-forgotten, but nevertheless significant chapter in Western European religious folk art, namely the creation of paintings, sculptures and other visual representations of the legendary bearded female saint Wilgefortis — also known by the names Ontcommer, Uncumber, Liberata and Kümmernis. On a broader level, however, this book has sought to establish a historical reference point for contemporary efforts in various artistic media to develop links between corporeality or androgyny, on the one hand, and spirituality, on the other.

Given the exaggerations and inaccuracies inherent in the various local legends and folk tales on which the story of St. Wilgefortis is based, it is interesting to note the extent to which her images have come to reflect a remarkably consistent and enduring set of values and priorities. As has been noted elsewhere in this book, these values included the saint's alleged empathy for the oppressed, the lovelorn and the dying, together with her status as the patron saint of beings as diverse as musicians and livestock. With regard to the central tenet of the Wilgefortis legend — her "miraculous" acquisition of a beard prior to her crucifixion — it has been argued that subsequent

Note to Conclusion is on p. 154.

depictions of this strange metamorphosis were not based on irreverent or misguided fantasies. Rather, they originated as part of a conscientious effort to transcend the gender gap inherent in the most important of all religious images, namely the crucifix. In this way, the merged Christ/Wilgefortis figure could be made into a more universally applicable healing symbol and therapeutic image than would otherwise have been the case.

It is precisely the gender-inclusive and sexually ambiguous nature of the crucified figure that can be said to have accounted for "her" stature and pre-eminence in parts of Western Europe over several centuries. During periods in which her images became too obviously feminine, the reverence and awe that she had once inspired among her followers declined accordingly. On the other hand, during those periods when her images became too clearly masculine, her identity was paradoxically dissipated, becoming submerged by the more familiar and clerically acceptable image of the male crucifix.

In spite of the decline of her public visibility and overall popularity, St. Wilgefortis will continue to challenge us in future years, particularly in the sense that "what is unique about *Homo sapiens* as a human phenomenon is the constant incarnation of the symbolic duality of gender."[1] Through the creation of her various images over the course of several centuries, as well as through the custom of cross-dressing numerous crucifixes, artists and common people alike contributed to the elevation of this mysterious and ambiguous saint to the highest level of religious significance. Even in our so-called post-Christian era, the questions and concerns which the veneration of St. Wilgefortis has raised will continue to prove challenging and significant.

Notes

Chapter 1

1 Paul Diel, *Symbolism in the Bible: The Universality of Symbolic Language and Its Psychological Significance* (San Francisco: Harper & Row, 1975), 166.

2 Raymond E. Brown, Joseph A. Fitzmyer and Roland E. Murphy, eds., *The Jerome Biblical Commentary* (Englewood Cliffs, NJ: Prentice Hall, 1968), 812.

3 Joseph R. Strayer, ed. *Dictionary of the Middle Ages* (New York: Scribner's Sons, 1984), 4, 9; Ekkart Sauser, *Frühchristliche Kunst: Sinnbild und Glaubensaussage* (Innsbruck: Tyrolia, 1964), 233.

4 Andre Grabar, *Christian Iconography: A Study of Its Origins* (Princeton: Princeton University Press, 1968), xlviii, figs. 297 and 298.

5 Kurt Weitzmann, *The Icon: Holy Images — Sixth to Fourteenth Century* (New York: George Braziller, 1978), 70, plate 16; Erich Pattis and Eduard Syndicus, *Christus Dominator: Vorgotische Grosskreuze* (Innsbruck: Tyrolia, 1964), 224.

6 Pattis and Syndicus, 55.

7 Pattis and Syndicus, 214: "Morti vita datur, mortalis ne moriatur. In cruce dormit Adam de costa formet ut Evam. In cruce passus Adae nunc solvo crimen et Evae."

8 Pattis and Syndicus, 184 and 285: John of Cornwall, De crucis Dominicae virtute 1, PL 177, 455.

9 Sauser, 288.

10 Pattis and Syndicus, 9.

11 John Beckwith, *Early Christian and Byzantine Art* (Harmondsworth: Penguin Books, 1979), 62.

12 Isa Belli, *Guida di Lucca* (Lucca: Il Messaggero, 1953), 76.

13 Reiner Haussherr, "Volto Santo," in *Lexikon der Christlichen Ikonographie,* ed. E. Kirschbaum (Freiburg: Herder, 1972), 4, 471.

139

14 Reiner Haussherr, "Das Imerwardkreuz und der Volto-Santo Typ,"
 Zeitschrift für Kunstwissenschaft 16 (1962): 140.
15 Strayer, *Dictionary of the Middle Ages*, 12, 489.
16 Kathleen Corrigan, "Text and Image on an Icon of the Crucifixion at
 Mt. Sinai, in eds., R. Ousterhout and L. Brubaker, *The Sacred Image East
 and West. Illinois Byzantine Studies 4*, (University of Illinois Press 1995):
 45-62. This purple frock, also referred to a *colobium*, was often depict-
 ed with golden *clavi*, or fringes, as an indication of the sovereignty of
 Christ. Since this tunic was made of wool, it was, however, not con-
 sidered everlasting, while the white linen loincloth was thought to
 symbolize eternity.
17 Haussherr, "Das Imerwardkreuz und der Volto-Santo Typ," 166.
18 Pattis and Syndicus, 14.
19 Belli, 79-80.
20 Hausherr, "Volto Santo," 472.
21 Gustav Schnürer and J.M. Ritz, *St. Kümmernis und Volto Santo*
 (Düsseldorf: Schwann, 1934).
22 Sylvia Hahn, *Neufahrn bei Freising* (Munich: Schnell and Steiner 1983), 11.
23 Hahn, 2 and 6.
24 Pattis and Syndicus, 104-106, no. 46.
25 Ibid., 214, nos. 101-103.
26 Ibid., 206, nos. 97-98.
27 Ibid., 131, nos. 57-59.

Chapter 2

1 Galatians 3:26-27: "For in Christ Jesus you are all sons of God,
 through faith. For as many of you as were baptized into Christ have
 put on Christ."
2 Barbara Newman, *From Virile Woman to WomanChrist: Studies in Medieval
 Religion and Literature* (Philadelphia: University of Pennsylvania Press,
 1995), 3.
3 Thomas Heffernan, "The Passions of Saints Perpetua and Felicitas
 and the *Imitatio Christi*," in *Sacred Biography: Saints and Their
 Biographers in the Middle Ages* (Oxford: Oxford University Press, 1988),
 185-230.
4 Margaret R. Miles, "Becoming Male: Women Martyrs and Ascetics," in
 *Carnal Knowing: Female Nakedness and Religious Meaning in the Christian
 West* (Boston: Beacon Press, 1989), 53-55.
5 Miles, 57. Since Greek (male) athletes competed in the nude, and since
 Christ was seen to have achieved an athletic-like victory by dying
 naked on the cross, thereby redeeming humanity, women gladly went
 into martyrdom while in a state of nudity, thereby deliberately taking
 on the role of an athlete.
6 Newman, *From Virile Woman to WomanChrist*, 6.
7 The reference work concerning the lives of the saints, called the *Acta
 Sanctorum*, was officially begun in the seventeenth century by John
 van Bolland (1596-1665). Later Jesuit editors of this series called them-
 selves Bollandists; in 1868 a comprehensive edition in Latin was pub-
 lished in Paris and Rome.

8 Jacob of Voragine, *Golden Legend* (written between 1255 and 1266), trans. Granger Ryan and Helmut Ripperger (New York: Arno Press, 1969).

9 Fiona Bowie and Oliver Davies, eds., *Hildegard of Bingen: Mystical Writings* (New York: Crossroad, 1993).

10 Caroline Walker Bynum, *Jesus as Mother: Studies in the Spirituality of the High and Middle Ages* (Berkeley: University of California Press, 1982), 138. See also JoAnn McNamara, "Sexual Equality and the Cult of Virginity in Early Christianity," *Feminist Studies* 3 (Spring/Summer 1976): 145-158.

11 Newman, 167.

12 Thomas à Kempis, *The Imitation of Christ*, trans. Betty I. Knott (London: Collins, 1965), 13.

13 Ibid., 103-107.

14 Carol M. Schuler, "The Seven Sorrows of the Virgin: Popular Culture and Cultic Imagery in Pre-Reformation Europe," *Simiolus* 21, 1/2 (1992): 5-10.

15 F.O. Büttner, *Imitatio Pietatis: Motive der Christlichen Ikonographie als Modelle zur Verähnlichung* (Berlin: Gebr. Mann, 1983), 1-60.

16 Sarah Beckwith, *Christ's Body: Identity, Culture and Society in Late Medieval Writings* (London and New York: Routledge, 1993), 23.

17 Ibid., 116.

18 Caroline Walker Bynum, *Fragmentation and Redemption: Essays on Gender and the Human Body in Medieval Religion* (New York: Zone, 1991), 131.

19 Ibid., 235.

20 Ibid., 120-123.

21 Ibid., 131-133 and 186.

22 Ibid., 145 and 181.

23 Newman, *From Virile Woman to WomanChrist*, 162.

24 Bynum, 167-172 and 205.

25 Ibid., 174.

26 Ibid., 192-194.

27 Ibid., 182-184 and 220.

28 Thomas F. Mathews, "Christ Chameleon," in *The Clash of Gods: A Reinterpretation of Early Christian Art* (Princeton: Princeton University Press, 1993), 121-122.

29 Ibid., 128.

30 Ibid., 138.

31 Ibid., 141-142.

32 Erich Pattis and Eduard Syndicus, *Christus Dominator: Vorgotische Grosskreuze* (Innsbruck: Tyrolia, 1964), 13, fig. 86. See also my chapters on the *Volto Santo* and on the crucifix of Neufahrn, Bavaria.

33 Jeffrey F. Hamburger, *Nuns as Artists: The Visual Culture of a Medieval Convent* (Berkeley: University of California Press, 1997), xxi.

34 Ibid., 11-12.

35 Ibid., 56, plate 11.

36 Ibid., 56 and fig. 41 on 57.

37 Ibid., 90.

38 Ibid., 91.

39 Ibid., 103-106.

40 Ibid., 116-118.

41 Ibid., 138.

42 Ibid., 167.

43 Elizabeth Nightlinger, "The Female *Imitatio Christi* and Medieval Popular Religion: The Case of St. Wilgefortis," in Bonnie Wheeler, ed., *Feminea Medievalia: Representations of the Feminine in the Middle Ages,* (Dallas: Academia, 1993), 291-328.

44 Elizabeth Nightlinger, "Our Saint Died on the Cross Like Christ: Socio-Cultural and Iconographical Problems Associated with the Genesis of St. Eulalia of Barcelona," unpublished paper presented at the Thirty-First International Congress on Medieval Studies, Western Michigan University, May 1996.

45 One exception is the sixteenth-century altarpiece from Eltersdorf in southern Germany, illustrated in Schnürer and Ritz, plate 1, fig. 1.

46 Thomas J. Heffernan, *Sacred Biography: Saints and Their Biographers in the Middle Ages* (New York: Oxford University Press, 1988), 282.

47 Otto Wimmer, *Handbuch der Namen und Heiligen* (Innsbruck: Tyrolia, 1959), 560.

48 *The Comedy of Dante Alighieri the Florentine: Cantica II Purgatory*, trans. Dorothy L. Sayers (Harmondsworth and New York: Penguin Books, 1983), 307: Canto XXX:19. Bonnie MacLachlan, "The Cyprian Redeemed: Venereal Influence in *Paradiso*," unpublished paper 1998, Department of Classical Studies, University of Western Ontario, 4.

49 MacLachlan, "The Cyprian Redeemed," 4. See also Sayers, *Divine Comedy*, 312.

Chapter 3

1 According to Schnürer, 159, the oldest sources concerning these miracles were published in 1906.

2 Schnürer, 162-165. According to Johannes von Viktring, in his *Buch Wahrer Geschichten* written in 1343, the fiddler was not part of a group of pilgrims, but visited the crucifix on his own.

3 Schnürer, 167.

4 David Hugh Farmer, *The Oxford Dictionary of Saints* (Oxford: Oxford University Press, 1992), 194-195.

5 Schnürer, 169.

6 Ibid., 168.

7 Fridolin Plant, *Eine Volksheilige (St. Kummernus)* (Meran: F. Plant, 1897), 12.

8 Tom Chetwynd, *A Dictionary of Symbols* (London: Collins 1982), 90.

9 Barbara Walker, *The Women's Dictionary of Symbols and Sacred Objects* (San Francisco: Harper, 1988), 154, 155 and 358.

10 *The Interpreter's Dictionary of the Bible* (New York: Abingdon, 1962), vol. 4, 213-214.

11 Schnürer, 170: Ruth 4:7.

12 Ibid., 171.

13 Ibid., 175.

14 Karl von Spiess, *Marksteine der Volkskunst* (Berlin: Stubenrauch 1942), part 2, 202: These legends have been collected in Poigen-Au near Mannswörth and Kienberg-Gaming in Austria, and can also be found written on a painting dating from 1687 in the Volkskunde Museum in Innsbruck. Further stories have been recorded in Saalfeld (1667) and Henneberg near Memmingen (1834) in Germany.

15 Ibid., 227.

16 Peter Spranger, *Der Geiger von Gmünd: Justinus Kerner und die Geschichte einer Legende* (Schwäbisch Gmünd, Stadtarchiv Schwäbisch Gmünd, 1980). This book is richly illustrated with local examples from the fifteenth to the twentieth century.

17 Private archive of Dr. Mayr, 2/48, Gries near Bozen. In this handwritten document, it is also stated that Theobald Kerner owned two Kümmernis paintings during 1901, one from Lorch in Württemberg, where his father had been active as a medical doctor, the other acquired from an antique dealer in Stuttgart. Theobald's father was said to have been delighted when he saw this image.

18 Schnürer, 176.

19 Private archive of Dr. Mayr, 2/48. This poem was published in a "Festkalender" with a drawing by S. Sebastian.

20 Spranger, 64.

21 Spranger, *Der Geiger von Gmünd*, 1-19.

22 *Eines Fürsten Traum: Meinhard II- Das Werden Tirols* (Stift Stams and Schloss Tirol: Tiroler Landesausstellung, 1995), 481. In this catalogue, the crucifix is called "St. Kümmernis."

23 Bundesdenkmalamt Vienna, Bildarchiv P 4470. Here, as well, the crucifix is identified as "St. Kümmernis," with St. Anthony the Hermit and the Virgin with the Child in the adjoining panel.

24 Photographic archive of the "Bundesdenkmalamt," Vienna, P 4470.

25 Spranger, *Der Geiger von Gmünd*, fig. 22: "St. Hulpe."

26 Karl v. Spiess, *Marksteine*, fig. 174 In this work, the fresco is dated to the middle of the fourteenth century. This is in contrast to Magnus Backes, *Hessen* (Munich-Berlin: Deutscher Kunstverlag, 1982), 520. Here, only fragments of various late Gothic wall paintings are mentioned. These date, according to an inscription on the choir, from 1483; in 1897-98 they were largely repainted.

27 Emanuel Dejung and Richard Zürcher, *Die Kunstdenkmäler des Kantons Zürich*, vol. 6: Die Stadt Winterthur (Basel: Birkhäuser 1952), 296-310. Hans Jenny, *Kunstführer durch die Schweiz*, vol. 1 (Wabern: Büchler, 1971), 865.

28 Ilse Friesen, *Frau am Kreuz: Die Hl. Kümmernis in Tirol* (Telfs: Hörtenbergdruck, 1998), figs. 4, 6, 8-11, 13-15, 17-19.

29 See chapter 5.

30 Friesen, *Frau am Kreuz*, 38-41.

Chapter 4

1 Karl von Spiess, *Marksteine der Volkskunst* (Berlin: Stubenrauch, 1942), part 2, 192.

2 Schnürer and Ritz, *Sankt Kümmernis und Volto Santo*, 39. This Martyrologium, or collection of names and stories of martyrs, is preserved in the Library of Leyden, based on a ninth-century Martyrologium of Usuard. It was printed in Cologne in editions of 1515 and 1521 by the Carthusian monk Greven. Fernand Cabrol and Henri Leclerq, *Dictionnaire d'Archeologie Chretienne* (Paris: Letouzey et Ane, 1932), vol. 10, 2610.

3 *Bibliotheca Sanctorum* (Rome, 1969), vol. 12, 1094. Schnürer and Ritz, 41.

4 Arthur Burkhard, *Hans Burgkmair der Ältere* (Berlin: Klinkhardt and Biermann, 1932), 29. Tilman Falk, *Hans Burgkmair: Studien zu Leben und Werk des Augsburger Malers* (Munich: Bruckmann, 1968), 64.

5 *Kunstreisboek voor Nederland* (Amsterdam: Van Kampen, 1965), 593. Schnürer and Ritz, *Sankt Kümmernis und Volto Santo*, 13.

6 Schnürer and Ritz, 37-38: It is also suggested here that the name "the King of Sicily," to whom the saint was betrothed against her will, was perhaps derived from "Seeland," imaginatively recast as "Sicilia."

7 Private archive of Dr. Mayr, Bozen, 2/13.

8 Karl von Spiess, *Marksteine der Volkskunde* (Berlin: Stubenrauch, 1942), vol. 2, 194 and 206. A comprehensive study of pilgrimage sites in the Netherlands has recently been published. Only volume I has been completed; it does not include North Brabant but focuses on North and Central "Nederland." See Peter Jan Margry and Charles Caspers, eds. *Bedevaartplaatsen in Nederland* (Amsterdam and Hilversum: P. J. Meertens Instituut, 1997), vol. I, 508. Kralingen near Rotterdam once featured a former Wilgefortis- or Ellebrechts-Chapel dating from the early fifteenth century, which existed until 1672, and which was favoured by herring fishermen hoping to get a good catch. An image of the saint, portrayed in an engraving in this book, portrays her as rather masculine, but with female breasts. She is crucified, with nails piercing her hands, while her feet are covered by her gown. She wears a full beard, but has no halo. The *Volto Santo* of Lucca is depicted next to her, clearly establishing the Italian origin of the image.

9 Karl von Spiess, *Marksteine der Volkskunst* (Berlin: Stubenrauch, 1942), part 2, 196.

10 Ibid. The manuscript is in the collection of Brussels, number 21875.

11 Schnürer and Ritz, *Sankt Kümmernis und Volto Santo*, 11.

12 Spiess, *Marksteine*, plate 63, fig. 175.

13 James H. Marrow, *The Golden Age of Dutch Manuscript Painting* (Stuttgart: Belser, 1989), 64-65, fig. 22, cat. no. 15.

14 Ibid. 61, fig. 18, cat. no.13.

15 Ibid. 62.

16 Ibid. 9 and 57-58.

17 Ilse Friesen, "Saints as Helpers in Dying: The Hairy Holy Women Mary Magdalene, Mary of Egypt and Wilgefortis in the Iconography of the Middle Ages," in Barbara Gusick and Edelgard DuBruck, eds., *Death and Dying: Testimony, Belief, Ritual and Imaging in the Late Middle Ages* (New York: Peter Lang, 1999), 239–256.

18 Kunsthistorisches Museum, *Illustrated Guide, The Secular and Ecclesiastical Treasuries* (Vienna: Kunsthistorisches Museum, 1991), 208.

19 Manfred Leithe-Jasper and Rudolf Distelberger, *Kunsthistorisches Museum, Wien, I: Schatzkammer und Sammlung für Plastik und Kunstgewerbe* (Munich: Beck, 1982), 42.

20 Hermann Fillitz, *Die Schatzkammer in Wien* (Vienna: Schroll, 1964), 71-72.

21 Max Dvorak, "Das Rätsel der Kunst der Brüder Van Eyck," *Jahrbuch der Kunsthistorischen Sammlungen des Allerhöchsten Kaiserhauses*, vol. 24, 1903, 288-292.

22 Julius von Schlosser, *Der Burgunder Paramentenschatz des Ordens des Goldenen Vliesses* (Vienna: Schroll, 1912), 25, plates 28 and 29.

23 Ibid.

24 Franz Unterkirchner, *Burgundisches Brevier: Die Schönsten Miniaturen aus dem Stundenbuch der Maria von Burgund (Codex Vindobonensis 1857)* (Graz: Akademischer Verlag, 1974), 127.

25 Franz Unterkirchner and Antoine de Schryver, *Gebetbuch Karls des Kühnen vel potius Stundenbuch der Maria von Burgund, Codex 1857 der Österreichischen Nationalbibliothek* (Graz: Akademische Verlagsanstalt, 1969), 11.

26 Otto Pächt and Dagmar Thoss, *Die Illuminierten Handschriften und Inkunabeln der Österreichischen Nationalbibliothek: Flämische Schule II* (Vienna: Verlag der Österreichischen Akademie der Wissenschaften, 1990), 69-71.

27 Dirk de Vos, *Hans Memling: The Complete Works* (London: Thames and Hudson, 1994), 170.

28 Ibid.

29 Ludwig Baldass, *Hans Memling* (Vienna: Schroll, 1942), 38.

30 Walter Bosing, *Hieronymus Bosch (um 1450-1516): Zwischen Himmel und Hölle* (Cologne: Taschen, 1987), 84.

31 Herbert Thurston and Donald Attwater, *Butler's Lives of the Saints* (London: Burn and Oates, 1956), 367.

32 Carl Linfert, *Hieronymus Bosch* (Cologne: Du Mont, 1970), 72, fig. 17.

33 Walter S. Gibson, *Hieronymus Bosch* (New York: Praeger, 1973), 17.

34 Dino Buzzati, *L'Opera Completa di Bosch* (Milan: Rizzoli, 1966), 96.

35 George Kaftal, *Iconography of the Saints in Tuscan Painting* (Florence: Sansoni, 1952), 588. No. 173 illustrates an altarpiece with episodes from the life of St. Julia in Leghorn, Arciconfraternità di S. Giulia, Sala Magistrale. This work is attributed to an early-fourteenth-century Florentine master.

36 Linfert, *Bosch*, 72.

37 Bosing, *Bosch*, 76.

38 F.O.Büttner, *Imitatio Pietatis: Motive der Christlichen Ikonographie als Modelle zur Verähnlichung* (Berlin: Gebr.Mann, 1983), 59, fig. 48: "Christus und die kreuztragende Minne," Einsiedeln, Stiftsbibliothek.

39 Büttner, *Imitatio Pietatis*, 179, figs. 202 and 203: "Christus und die Anima."

40 David Hugh Farmer, *The Oxford Dictionary of Saints* (Oxford: Oxford University Press, 1992), 494.

41 Edward A.Freeman, *The Reign of William Rufus and the Accession of Henry the First* (Oxford: Clarendon Press, 1882), vol. 1, 108, 112, 164, 289, 391 and 511; vol. 2, 61, 503 and 650.

42 Arthur Gardner, *English Medieval Sculpture* (New York: Hacker, 1973), fig. 70, 44-45.

43 *Acta Sanctorum*, Paris and Rome 1868, vol. 5, no. 20: "De S. Liberata alias Wilgeforte virgine et martyre," 64. The bulk of the Latin hymn is translated in: Elizabeth Nightlinger, "The Female 'Imitatio Christi' and Medieval Popular Religion: The Case of St. Wilgefortis," in Bonnie Wheeler, ed., *Feminea Medievalia: Representations of the Feminine in the Middle Ages* (Dallas: Academic Press, 1993), 293.

44 Sara Maitland and Wendy Mulford: *Virtuous Magic: Women Saints and Their Meaning* (London: Mowbray, 1998), 122-129.

45 Gardner, *English Medieval Sculpture*, 5 (quote) and fig. 4 on 6; compare also 240 and 247.

46 Ibid., 5-6.

47 Friesen, "Saints as Helpers in Dying: The Hairy Holy Women Mary Magdalene, Mary of Egypt and Wilgefortis in the Iconography of the Middle Ages," in *Death and Dying: Testimony, Belief, Ritual and Imaging in the Late Middle Ages*.

48 Gardner, *English Medieval Sculpture*, 240: "Robert Vertue, Robert Jenins and John Lebons were the King's master masons, but they were probably more concerned with the marvellous architectural structure than with the images that adorned it, and Lawrence Ymber, who made estimates for the images of the tomb, is a more likely candidate for the honour of having carved some of them."

49 John Shinners, ed. *Medieval Popular Religion. 1000-1500. A Reader* (Peterborough: Broadview Press, 1997), 201-202.

50 Internet, "Tom Feise/tomwors.htm," "Worstead," 1.

51 Eamon Duffy, *The Stripping of the Altars: Traditional Religion in England c. 1400-1580* (New Haven: Yale University Press, 1992), 179.

52 Elizabeth Nightlinger, "The Female 'Imitatio Christi' and Medieval Popular Religion: The Case of St. Wilgefortis," in Bonnie Wheeler, ed., *Feminea Medievalia: Representations of the Feminine in the Middle Ages,* 317, plate 8.

53 Internet, "Tom Feise/tomwinf.htm," "Winfarthing," 1.

54 Margaret Aston, *England's Iconoclasts: Laws Against Images* (Oxford: Clarendon Press, 1988), vol. 1, 163: In William Roye's *Brief Dialogue between a Christian Father and His Stubborn Son*, written in 1527, a father is quoted as having "taught his son to regard images as idols and to reject as prohibited by God's commandment prayers to such saints as St. Uncumber."

Chapter 5

1 Sylvia Hahn, *Neufahrn bei Freising* (Munich: Schnell and Steiner, 1983), 2 and 6.

2 Ibid., 11.

3 Gustav Schnürer and J. Ritz, *St. Kümmernis und Volto Santo* (Düsseldorf: Schwann, 1934), 30.

4 Hahn, 11.

5 Ibid., 2-3.

6 Handwritten notes concerning "Kümmernis," dated January 1928, private archive of Dr. Mayr, Gries near Bozen, South Tyrol (Italy), part 1, 23.

7 Kannamüller and Siebert, *Neufahrn* (Freising: Frisingia, n.d.), 15.

8 Ibid., 15.

9 A handwritten copy of the Neufahrn Legend is preserved in the private archive, Gries near Bozen, South Tyrol.

10 Hahn, 6.

11 Handwritten archive, Gries near Bozen, part 1/26. No explanation is provided why a church was dedicated to St. Scholastica. The reference to "Steinwart" or "Pöringen" cannot be taken as factual, but only connect the saint to Holland in a general sense. Also mentioned in this record is the first miracle attributed to St. Kümmernis which was that involving a poor fiddler who received the gift of her precious shoe. It is further specified that he prayed in front of the statue, rather than in the presence of the dying martyr.

12 Hahn, 6.

13 Ibid., 12.

14 Ibid., 9.

15 Ibid., 10. This event was believed to have occurred as early as 1397 in the vicinity of Mintraching/Grüneck.

16 Schnürer and Ritz, 30 and plate 61, fig. 173. Although this panel of Eltersdorf, dated 1513, depicts various scenes of the legend of "Sant Kumernuss," this saint was not crucified naked, tortured with fire or mutilated with forks. These tortures were characteristic of St. Eulalia with whom St. Kümmernis was here confused. See Elizabeth Nightlinger, "Our Saint Died on the Cross Like Christ: Socio-Cultural and Iconographical Problems Associated with the Genesis of St. Eulalia of Barcelona," unpublished paper presented at the Thirty-First International Congress on Medieval Studies, Western Michigan University, May 1996, 11.

17 Hahn, 5.

18 These works can be found on the Bahnhofstrasse 8.

Chapter 6

1 Some of these documents are now in the archives of Passau and Munich; this information has been provided by Ulla Kendlinger, Stadtarchiv of Burghausen.

2 Johann Georg Bonifaz Huber, *Geschichte der Stadt Burghausen in Oberbayern* (Burghausen: J. Lutzenberger, 1862), 402.

3 Heidinger: *Materialien zur Burghauser Geschichte (1860-1890)*, 1865, 50.

4 *Tagzeiten und Litanei von der heiligen Jungfrau u. Martyrin Wilgefort, der insgemein sogennanten heiligen Kümmernis*, Altötting: J. Lutzenberger.

5 Ibid.

6 Georg Sailer, *Gebetszettel* (Burghausen: Altbayerische Verlagsanstalt, 1909).

7 E. Jung, *Germanische Götter und Helden in Christlicher Zeit: Beiträge zur Entwicklungsgeschichte der Deutschen Geistesform* (Munich: J.F. Lehmann, 1922), 131-133.

8 Ilse Friesen, *Frau am Kreuz: Die Hl. Kümmernis in Tirol* (Telfs: Hörtenbergdruck, 1998), 38-40. Two small *ex voto* panels, dating from 1860 and 1869, and originally located in the Kümmernis Chapel near Burghausen, were later acquired by the Tyrolean Museum of Folk Art in Innsbruck, where they are still housed at the present time.

9 Karl Huber, "St. Kümmernis, eine Volksheilige," *Burghauser Geschichtsblätter* 15 (1925), 2-29.

10 Ibid., 6-7.

11 Ibid., 14: Andreas Strobl, *Diskurse*, 1628.

12 Ibid., 16. The text of this hymn to St. Wilgefortis is quoted in chapter 4 of this book.

13 Ibid., 23.

14 *Burghauser Zeitung*, August 25, 1949 (initials "ik").

15 *Burghauser Nachrichten: Alt-Neuöttinger Zeitung*, nr.130, August 20, 1955: "Ein Beitrag für Völkerfrieden und Rückkehr der Gefangenen" (no page number).

16 *Alt-Neuöttinger Anzeiger*, nr. 219, September 23, 1963, "Die Kümmerniskapelle in Burghausen ersteht in neuem Glanz," n.p.

17 Ibid., nr. 198, August 28, 1965.

18 *Burghauser Anzeiger*, nr .220, September 25, 1970, "Zum hunderdsten Mal Wallfahrt auf die Kümmernis," n.p.

19 Ibid., nr. 223, September 29, 1970, "Die Kümmernis lebt in dieser technisierten Welt wie eh und je," n.p.

20 *Burghauser Anzeiger*, nr. 227, October 2, 1971.

21 R. Wittgräfe, "Kümmernis ist 50 Jahre bei St. Konrad," *Burghauser Anzeiger*, nr. 300, New Year 1987/1988.

22 *Burghauser Anzeiger*, nr. 186, August 14, 1993, "Gehen bald Hochzeitspaare ein und aus?" n.p.

Chapter 7

1 Josef Tremmel, "Der Kunstfreund," 1910/1911; in this Tyrolean journal more than 70 images were counted; today, only less than forty can be documented.

2 According to the *Acta Sanctorum* 4, 62 (Paris and Rome, 1868), the name Kummernus is an abbreviation of "Ohnkummer" or "Ohnkummernus," which means "without anxiety."

3 Arthur Burkhard, *Hans Burgkmair der Ältere* (Berlin: Klinkhardt, 1932), 29, no. 3: "Kreuzbild der Hl. Kümmernis," Munich, Staatsbibliothek.

4 The most prominent example of this activity is the crucifix on the high altar of the parish church of Neufahrn, Bavaria, which was changed to become St. Wilgefortis during the Baroque era.

5 Erich Pattis and Eduard Syndicus, *Vorgotische Grosskreuze* (Innsbruck: Tyrolia, 1964), 22. The crucifix of Uznach in the Landesmuseum of Zürich, Switzerland, eleventh century, is an example of a double identification, since both male and female characteristics have been observed on the carving. Another example is the crucifix of Neufahrn, Bavaria, which is the subject of chapter 4.

6 Gustav Schnürer and J. Ritz, *Sankt Kümmernis und Volto Santo* (Düsseldorf: Schwann, 1934), plate 24.

7 Ilse Friesen, *Frau am Kreuz: Die Hl. Kümmernis in Tirol* (Museum Stift Stams and Telfs: Hörtenbergdruck, 1998), 54. This special exhibition was made possible through the enthusiastic support and dedication of Pater Norbert Schnellhammer, the curator of the collections of the abbey "Stift Stams" in Tyrol.

8 Gustav Gugitz, *Fest- und Brauchtumskalender für Österreich, Süddeutschland und Schweiz* (Vienna: Hollinek, 1955), 82-83 and *Österreichs Gnadenstätten in Kult und Brauch, vol. 3: Tirol and Vorarlberg* (Vienna: Hollinek, 1956), 4-201.

9 Friesen, *Frau am Kreuz*, 12-57.

10 The most outstanding example is the late-eighteenth-century painting currently found in the parish church at Uderns in Northern Tyrol.

11 Friesen, *Frau am Kreuz*, 56.

12 *Eines Fürsten Traum: Meinhard II-Das Werden Tirols* (Stift Stams and Schloss Tirol: Tiroler Landesausstellung, 1995), 481, nr. 19.6.

13 Friesen, *Frau am Kreuz*, 14-19 and 56-57.

14 The question of the origin of the fiddler is discussed in chapter 3.

15 Bundesdenkmalamt Vienna, Photoarchiv nr. P 4470.

16 Friesen, *Frau am Kreuz*, 51-53 and 57.

17 Ibid., illustrations on 21, 25 and 43.

18 Ibid., 52-53.

19 Erich Pattis and Eduard Syndicus, *Christus Dominator: Vorgotische Grosskreuze* (Innsbruck: Tyrolia, 1964), figs. 12, 24, 30, 34, 67 and 69.

20 Thomas F. Mathews: *The Clash of Gods: A Reinterpretation of Early Christian Art* (Princeton, NJ: Princeton University Press, 1993), 121-123: "But alongside his virile manifestations, Christ in Early Christian art often showed a decidedly feminine aspect which we overlook at our own risk.... for once this feminine aspect of Christ has gained an acceptability, later artists, whether in the Middle Ages or beyond, felt free to exploit it without apologies. Judging from the rich tradition of the effeminate imagery of Christ, it appears that people were not uncomfortable with such a Saviour."

21 Gustav Schnürer and Joseph M. Ritz, *Sankt Kümmernis und Volto Santo* (Düsseldorf: Schwann, 1943), fig. 115. See also Karl von Spiess, *Marksteine der Volkskunst II* (Berlin: Stubenrauch, 1942), fig. 188.

22 Gustav Gugitz, *Österreichische Gnadenstätten in Kult und Brauch*, 85.

23 Josef Kessler, *Basilika Unserer Lieben Frau, Rankweil/Vorarlberg* (Munich: Schnell & Steiner, 1990), 14.

24 Ibid., 14. Maria Barbara v. Grenzing and her husband also sponsored the building of the Loreto-Chapel adjoining the church in 1657.

25 Ibid., 14.

26 Pattis and Syndicus, *Christus Dominator*, figs. 42, 65, 94, 98, 101, 108 and 114. Only these figures show crucifixes in which the crown is part of the original carving.

27 Mathias Frei, *St. Georgen ob Schenna* (Bozen: SB-Verlag, 1996), n.p.

28 Friesen, *Frau am Kreuz*, 56-57.

29 Private Collection, Dr. Mayr, St. Oswald Chapel at Troyenstein.

30 Gustav Gugitz, *Das Jahr und seine Feste im Volksbrauch Österreichs. Studien zur Volkskunde II* (Vienna: Hollinek, 1950), 59.

31 Johanna Gritsch, *Axams-Tirol* (Munich and Zurich: Schnell-Steiner, 1983), 10 and illustration on 13.

32 Gustav Gugitz, *Österreichs Gnadenstätten in Kult und Brauch,* 8.

33 Friesen, *Frau am Kreuz*, 30-31.

34 Ibid., 44-45.

35 See chapter 4.

36 This restoration was sponsored by the author in 1997/1998. The image is the frontispiece of the catalogue *Frau am Kreuz*, an exhibition held in Stams from June 15 to September 27, 1998.

37 Collection of the *Stiftssammlung Stams*, Inventory Number 359. In this painting with the title "Hl. Kümmernis," the second woman is called "princess," while the main figure is described as "Gekreuzigte(r)," which means either a male or a female crucified person. Friesen, *Frau am Kreuz*, 12-13.

38 Friesen, *Frau am Kreuz*, 32-33.

39 Gugitz, *Fest-und Brauchtumskalender*, 83, and *Gnadenstätten*, 187.

40 Ibid.

41 Friesen, *Frau am Kreuz*, 22-23.

42 Karl Rahner, ed., "Mariology," *Encyclopedia of Theology: The Concise Sacramentum Mundi* (New York: Seabury Press, 1975), 899.

43 Carl M. Schuler, "The Seven Sorrows of the Virgin in Popular Culture and Cultic Imagery in Pre-Reformation Europe," *Simiolus* 21, 1/2 (1992): 5-28.

44 Compare the history of self-portraiture since Renaissance art, especially in the art of Albrecht Dürer.

45 Friesen, *Frau am Kreuz*, 48-49.

46 Gugitz, *Fest-und Brauchtumskalender*, 83.

47 Friesen, *Frau am Kreuz*, 34-35. See also Schnürer and Ritz, 42, fig. 4. The composition is based on an engraving by A. Collaert, Antwerp 1608. A similar composition can be found in the *Schedelsche Weltchronik* (Nuremberg World Chronicle), Nuremberg 1493, specifically in the "Crucifixion of the Boy Guilbelmus," or "Guilhelm," who is depicted as being dressed in a long gown which is tied by ropes around his ankles.

48 Friesen, *Frau am Kreuz*, 38-41.

49 See chapter 6.

Chapter 8

1 Marina Warner, *From the Beast to the Blonde: On Fairy Tales and Their Tellers* (London: Chatto & Windus, 1994). Chapter 2 (353-369) is titled "The Language of Hair: Donkeyskin III"; on 360, "the virgin martyr Uncumber, or Liberada, or Kummernis" is illustrated in the form of a Bavarian statue dating from the seventeenth century.

 A brief cultural history of hair, including during the Middle Ages, is included in an article by Ilse Friesen, titled "Saints as Helpers in Dying: The Hairy Holy Women Mary Magdalene, Mary of Egypt and Wilgefortis in the Iconography of the Middle Ages," in Barbara Gusick and Edelgard DuBruck, eds., *Death and Dying: Testimony, Belief, Ritual and Imaging in the Late Middle Ages* (New York: Peter Lang, 1999). See

also Ilse Friesen, *Frau am Kreuz: Die Hl. Kümmernis in Tirol*, 14-17. Prayers for growth of hair were directed to St.Wilgefortis, while votive offerings, among them braided strands of hair, were hung around her statues, especially in Axams, Tyrol (see also chapter 7).

2 Schnürer and Ritz, 43 and 75: "Paula barbata" was a legendary creation of the seventeenth century; the miracle of her beard in answer to her prayers occurred when she was pursued in her hermitage by an impertinent knight.

3 Odo John Zimmerman, *Saint Gregory the Great: Dialogues* (New York: Fathers of the Church Inc., 1959), 205, "Dialogue 4," no. 14: Galla, a young widow, "preferred a spiritual marriage with the Lord.... she was told by her doctors that, if she did not marry again, she would grow a beard even though she was a woman. And that is what happened. But the saintly woman was not disturbed by this external disfigurement." Wimmer, *Handbuch der Namen und Heiligen*, 220: Galla of Rome died in a monastery in 550 A.D.; she is a patron of widows. She has been portrayed with a long beard, a feature that served to diminish her beauty and thus protect her from male advances.

4 Marija Gimbutas, *The Language of the Goddess* (San Francisco: Harper, 1991), 183, fig. 283.

5 Philipp Vandenberg, *Nofretete* (Bern: Scherz Verlag, 1975), 253-256; her bearded head (height with beard ca. 1.22 m) from a colossal statue at Der el-Bahari is illustrated on 256.

6 William Smith, *Everyman's Smaller Classical Dictionary* (London: J.M.Dent, 1956), 64-65.

7 Ovid, *Metamorphoses* ix, 666 f.

8 Barbara G. Walker, *The Woman's Encyclopedia of Myths and Secrets* (San Francisco: Harper & Row, 1983), 395.

9 Carl G. Jung, Marie-Louise von Franz, Joseph L. Henderson, Jolande Jacobi and Aniela Jaffé, *Der Mensch und seine Symbole* (Olten and Freiburg im Breisgau: Walter-Verlag, 1985), 203.

10 Ibid., 31. Wendy Doniger O'Flaherty, *Women, Androgynes and Other Mythical Beasts* (Chicago: University of Chicago Press, 1980), 283.

11 Bonnie MacLachlan, "The Ungendering of Aphrodite," unpublished paper, Department of Classics, University of Western Ontario, 1998.

12 The main Roman authors who refer to a bisexual, bearded Aphrodite are Virgil (Aeneid 2.632-33), the commentator Servius, and Macrobius (Saturnalia III.vii.1-3). See MacLachlan, "The Ungendering of Aphrodite," 22.

13 Vicenzo Cartari, *Imagini Degli Dei de gl'Antichi*, trans. Frank J. Gilardi, (Graz: Akademische Druck-und Verlagsanstalt, 1963), 283-284.

14 See MacLachlan, 23-24.

15 Elizabeth Nightlinger, "The Female *Imitatio Christi* and Medieval Popular Religion: The Case of St.Wilgefortis," 311, plate 5.

16 Margaret Miles, "Adam and Eve," in *Carnal Knowing* (Boston: Beacon Press, 1989), 108.

17 Kirschbaum, *Lexikon der Christlichen Ikonographie*, vol. 1, 1968, 118.

18 Bynum, *Jesus as Mother*, 138. See also JoAnn McNamara, "Sexual Equality and the Cult of Virginity," *Feminist Studies* 33, 4 (1976): 145-158.

19 MacLachlan, "The Ungendering of Aphrodite," 13-19.

20 These "wilde Männer" can be found in the *Nuremberg World Chronicle*, published by Hartmann Schedel in 1493, especially under the heading "secunda etas mundi." Roger Bartra, *Wild Men in the Looking Glass: The Mythic Origins of European Otherness* (Ann Arbor: University of Michigan Press, 1994).

21 Elizabeth Du Gue Trapier, *Ribera* (New York: Hispanic Society of America, 1952), 71, fig. 45.

22 Du Gue Trapier, *Ribera*, 72.

23 Robert Bogdan, *Freak Show: Presenting Human Oddities for Amusement and Profit* (Chicago: University of Chicago Press, 1988), table of contents.

24 Ibid., 224-226, figs. 67 and 68.

25 Ibid., 226. Felix Sutton, *The Big Show: A History of the Circus* (New York: Doubleday, 1971), 47. Barnum had actually initiated a lawsuit concerning the authenticity of the bearded lady in order to publicize her appearance and make it into a sensation.

26 Peter Verney, *Here Comes the Circus* (New York: Paddington Press, 1978), 237.

27 Nightlinger, "The Female *Imitatio Christi* and Medieval Popular Religion: The Case of St. Wilgefortis," 306.

28 Marion Woodman, *Leaving My Father's House: A Journey to Conscious Femininity* (Boston: Shambala, 1993), 367-371; on p. 10, Marion Woodman interprets this fairy tale as "a story of the feminine releasing herself from patriarchy," and explains the significance of hair in the following manner: "Hair comes straight from the head as ideas come straight from the head. In dreams, as in life, the coiffure, the cutting, growing, and dyeing of hair are symptomatic of significant changes in the psyche (soul) or persona (the mask we show to the world)."

29 Schnürer and Ritz, 44.

30 Ibid., 46.

31 Ibid., 47. It should be pointed out that in spite of the apparently demonic aspect of the description of horns, there is no evidence to suggest that this legend was intended to portray the saint as anything other than virtuous.

32 Ibid., 48-50. This local legend of Bozen may be the basis for fairy tales such as "Allerleirauh," mentioned above.

33 Michèle Roberts, *Impossible Saints* (London: Little, Brown and Company, 1997), 225-230.

34 Ibid., 229-230.

35 Frank McCourt, *Angela's Ashes: A Memoir of a Childhood* (London: Flamingo, 1996), 352-353.

36 Robertson Davies, *Fifth Business* (Penguin Books, 1977), 143.

37 Donald M. Pillsbury, Walter B. Shelley and Albert M. Kligman, *Dermatology* (Philadelphia and London: W. Saunders Company, 1956), 1004-1005.

38 Ibid., 1007-1008.

39 Ibid., 1008-1009.

40 Francis Antony Whitbock, *Psychophysiological Aspects of Skin Disease* (London: W.B.Saunders, 1976), vol. 8, 188-190.
41 P. Mauvais-Jarvis, *Hirsutism* (Berlin and New York: Springer, 1981), 31-32.
42 Robert Greenblatt, "Hirsutism—Ancestral Curse or Endochrinopathy?" in Visendra B. Mahesh and Robert B. Greenblatt, eds. *Hirsutism and Virilism: Pathogenesis, Diagnosis and Management* (Boston: John Wright, 1983), 1-2.
43 William Shakespeare, *The Tragedy of Macbeth*, act I, scene 3, line 46. Sylvan Barnet, ed. (New York: Penguin, 1987), 42.
44 David Williams, *Deformed Discourse: The Function of the Monster in Medieval Thought and Literature* (McGill and Queen's University Press, 1996), 309 and 316, in which a description of "St. Wilgeforte" is included.
45 Spranger, *Der Geiger von Gmünd*, 64. For a specific discussion of the Fiddler of Gmünd and this letter, see chapter 3.
46 Greenblatt, "Hirsutism—Ancestral Curse or Endocrinopathy," *Hirsutism*, 2.
47 Ibid., 2-3.
48 Alan N. Elias and Grant Gwinup, *Hirsutism* (New York: Praeger, 1983), Preface, xiii-xiv.
49 Ibid., 9, 23 and 31 as well as 60-75.
50 Stanley (Shmuel) Rabinowitz, Robert Cohen and Dereck Le Roith, "Anxiety and Hirsutism," *Psychological Reports* (1983): 827.
51 Walter Futterweit, Richard A. Weiss and Richard M. Fagerstrom, "Endocrine Evaluation of Forty Female-to-Male Transsexuals: Increased Frequency of Polycystic Ovarian Disease in Female Transsexualism," *Archives of Sexual Behavior*, 15, 1 (1986), 69-76.
52 Frederick D. Malkenson and Roger W. Pearson, "Diseases of Hair and Nails and Related Studies," *The Yearbook of Dermatology* (Chicago: Year Book Medical Publishers, 1977), 311.
53 Caroline S. Koblenzes, *Hirsutism: Psychocutaneous Disease* (Orlando: Grune & Stratton, 1987), 260.
54 See also Dimitri A. Adamapoulos, Sophia Kampyli, Fotis Georgiacodis, Niki Kapolla and Anahit Abrahamian-Michalakis, "Effects of Antiandrogen-Estrogen Treatment on Sexual and Endocrine Parameters in Hirsute Women," *Archives of Sexual Behavior*, 17, 5 (1988): 421-422. Also of interest in this regard is the article by J.Hubert Lacey, "Anorexia nervosa and a bearded female saint," *British Medical Journal*, 285 (December 18-25, 1982): 1816-1817, which deals with anorexia nervosa as a cause of hirsutism.

Chapter 9

1 Paul Halsall, December 1995. This essay on saints is 38 pages long, including Wilgefortis on 37.
2 Sherry Ruth Anderson and Patricia Hopkins, *The Feminine Face of God: The Unfolding of the Sacred in Women* (New York: Bantam, 1991), 228.
3 Chaim Potok, *My Name Is Asher Lev* (New York: Ballantine Books, 1973), 218.

4 Doris Jean Dyke, *Crucified Woman* (Toronto: The United Church Publishing House, 1991), 1-2.

5 Ibid., 23.

6 Ibid., 26.

7 Judith Finlayson, "Which Sex Is God?" *Fanfare*, July 28, 1979, 5.

8 Dyke, *Crucified Woman*, 41.

9 Ibid., 42-43.

10 Ibid., 43.

11 Miles, *Carnal Knowing*, 177-178, fig. 30.

12 This is a paraphrase of a description of a French work of literature, discussed in *Sexuality and Masquerade*, Emma Wilson (Sawtry, CB, UK: Dedalus, 1996), 12.

13 Wendy Doniger O'Flaherty, *Women, Androgynes, and Other Mythical Beasts* (Chicago: University of Chicago Press, 1980), 283.

14 Sandra Lipsitz Bem, "Probing the Promise of Androgyny" and "Gender Schema Theory and Its Implications for Child Development: Raising Gender-aschematic Children in a Gender-schematic Society," in Mary Roth Walsh, ed., *The Psychology of Women: Ongoing Debates* (New Haven and London: Yale University Press, 1987), Question 7: "Is Androgyny a Solution?", 222. See also June Singer, *Androgyny: Toward a New Theory of Sexuality* (New York: Anchor Books, 1977).

15 Marion Woodman, *The Pregnant Virgin: A Process of Psychological Transformation* (Toronto: Inner City Books, 1985), 83.

16 Ivan Illich, *Gender* (New York: Pantheon, 1982), 142.

17 Ibid., 144-145.

18 Anne Herrmann, "Passing Women, Performing Men," in Laurence Goldstein, ed., *The Female Body: Figures, Styles, Speculations* (Ann Arbor: University of Michigan Press, 1991), 179-181.

19 Emma Wilson, ed., *Sexuality and Masquerade: The Dedalus Book of Sexual Ambiguity* (Sawtry, CB, UK: Dedalus, 1996).

20 Ray Conlogue, "Transvestite Tale Not Merely Trendy," *The Globe and Mail*, March 13, 1999, C 10.

21 Graham Clarke, *The Photograph* (Oxford: Oxford University Press, 1997), figs. 64 and 65, 118-119.

22 Jerry Hopkins, *Bowie* (New York: Macmillan, 1985), 63. I would like to thank my son George for having brought these examples of popular culture to my attention.

23 Peter and Leni Gillman, *Alias David Bowie: A Biography* (London: Hodder and Stoughton, 1986), 277.

24 David Bowie in an interview with Alan Yentob, featured in the television documentary *Changes: Bowie at 50,* broadcast on CBC-TV as part of the series *Adrienne Clarkson Presents* on September 24, 1997.

Conclusion

1 Ivan Illich, *Gender*, 76.

Bibliography

Acta Sanctorum. Paris and Rome, 1868.

Adamapoulos, Dimitri A., Sophia Kampyli, Fotis Georgiacodis, Niki Kapolla and Anahit Abrahamian-Michalakis. "Effects of Antiandrogen-Estrogen Treatment on Sexual and Endochrine Parameters in Hirsute Women." *Archives of Sexual Behavior* 17, 5 (1988): 421-429.

Alt-Neuöttinger Anzeiger 219, September 23, 1963.

Anderson, Sherry Ruth and Patricia Hopkins. *The Feminine Face of God: The Unfolding of the Sacred in Women*. New York: Bantam, 1991.

Apostolos-Capadona, Diane. *Encyclopedia of Women in Religious Art*. New York: Continuum, 1996.

Aston, Margaret. *England's Iconoclasts: Laws Against Images*. Oxford: Clarendon Press, 1988.

Backes, Magnus. *Hessen*. Munich-Berlin: Deutscher Kunstverlag, 1982.

Baldass, Ludwig. *Hans Memling*. Vienna: Schroll, 1942.

Baracchini, Clara and Maria Teresa Filieri, eds. *Il Volto Santo: Storia e Culto*. Lucca: Maria Pacini Fazzi Editore, 1982.

Bartra, Roger. *Wild Men in the Looking Glass: The Mythic Origins of European Otherness*. Ann Arbor: University of Michigan Press, 1994.

Beckwith, John. *Early Christian and Byzantine Art*. Harmondsworth: Penguin Books, 1979.

Beckwith, Sarah. *Christ's Body: Identity, Culture and Society in Late Medieval Writings*. London and New York: Routledge, 1993.

Belli, Isa. *Guida di Lucca*. Lucca: Il Messaggero, 1953.

Bem, Sandra Lipsitz. "Probing the Promise of Androgyny" and "Gender Schema Theory and Its Implications for Child Development: Raising Gender-aschematic Children in a Gender-schematic Society." In *The Psychology of Women: Ongoing Debates*, ed. Mary Roth Walsh. New Haven and London: Yale University Press, 1987.

Bibliotheca Sanctorum. Rome, 1969.

Bogdan, Robert. *Freak Show: Presenting Human Oddities for Amusement and Profit*. Chicago: University of Chicago Press, 1988.

Bolte, Johannes, ed. *Handwörterbuch des Deutschen Märchens*. Berlin and Leipzig: De Gruyter, 1934.

Bosing, Walter. *Hieronymus Bosch (um 1450-1516): Zwischen Himmel und Hölle*. Cologne: Taschen, 1987.

Bowie, Fiona and Oliver Davies, eds. *Hildegard of Bingen; Mystical Writings*. New York: Crossroad, 1993.

Brown, Raymond E., Joseph A. Fitzmyer and Roland E. Murphy, eds. *The Jerome Biblical Commentary*. Englewood Cliffs, NJ: Prentice Hall, 1968.

Büttner, F.O. *Imitatio Pietatis: Motive der Christlichen Ikonographie als Modelle zur Verähnlichung*. Berlin: Gebr. Mann, 1983.

Burghauser Anzeiger, 220, 25 September 1970.

_____. 223, 29 September 1970.

_____. 227, 2 October 1971.

_____. 186, 14 August 1993.

Burghauser Nachrichten: Alt-Neuöttinger Zeitung 130, 20 August 1955.

Burghauser Zeitung, 25 August 1949.

Burkhard, Arthur. *Hans Burgkmair der Ältere*. Berlin: Klinkhardt and Biermann, 1932.

Buzzati, Dino. *L'Opera Completa di Bosch*. Milano: Rizzoli, 1966.

Bynum, Caroline Walker. *Fragmentation and Redemption: Essays on Gender and the Human Body in Medieval Religion*. New York: Zone, 1991.

_____. *Jesus as Mother: Studies in the Spirituality of the High and Middle Ages*. Berkeley: University of California Press, 1982.

Cabrol, Fernand and Henri Leclerq. *Dictionnaire d'archéologie chrétienne*. Paris: Letouzey et Ane, 1932.

Cartari, Vicenzo. *Imagini Degli Dei de gl'Antichi*. Translated by Frank J. Gilardi. Graz: Akademische Druck-und Verlagsanstalt, 1963.

Chetwynd, Tom. *A Dictionary of Symbols*. New York: Collins, 1982.

Clarke, Graham. *The Photograph*. Oxford: Oxford University Press, 1997.

Conlogue, Ray. "Transvestite Tale Not Merely Trendy." *The Globe and Mail*, 13 March 1999, C 10.

Corrigan, Kathleen. "Text and Image on an Icon of the Crucifixion at Mt. Sinai." In *The Sacred Image East and West*, ed. R. Ousterhout and L. Brubaker, 45-62. Champaign, IL: *Illinois Byzantine Studies* 4, University of Illinois Press, 1995.

Davies, Robertson. *Fifth Business*. Toronto: Penguin Books, 1977.

Dejung, Emanuel and Richard Zürcher. *Die Kunstdenkmäler des Kantons Zürich*. Basel: Birkhäuser, 1952.

Delehaye, Hippolite. *The Legends of the Saints*. New York: Fordham University Press, 1962.

Diel, Paul. *Symbolism in the Bible: The Universality of Symbolic Language and Its Psychological Significance*. San Francisco: Harper & Row, 1975.

Doniger, Wendy O'Flaherty. *Women, Androgynes and Other Mythical Beasts*. Chicago: University of Chicago Press, 1980.

Duffy, Eamon. *The Stripping of the Altars: Traditional Religion in England c.1400-1580*. New Haven: Yale University Press, 1992.

Dvorak, Max. "Das Rätsel der Kunst der Brüder Van Eyck." *Jahrbuch der Kunsthistorischen Sammlungen des Allerhöchsten Kaiserhauses* 24 (1903), 288-292.

Dyke, Doris Jean. *Crucified Woman*. Toronto: The United Church Publishing House, 1991.

Eines Fürsten Traum: Meinhard II – Das Werden Tirols. Stift Stams and Schloss Tirol: Tiroler Landesausstellung, 1995.

Elias, Alan N. and Grant Gwinup. *Hirsutism*. New York: Praeger, 1983.

Falk, Tilman. *Hans Burgkmair: Studien zu Leben und Werk des Augsburger Malers*. Munich: Bruckmann, 1968.

Farmer, David Hugh. *The Oxford Dictionary of Saints*. Oxford: Oxford University Press, 1992.

Fillitz, Hermann. *Die Schatzkammer in Wien*. Vienna: Schroll, 1964.

Finlayson, Judith. "Which Sex Is God?" *Fanfare*, July 28, 1979, 5.

Freeman, Edward A. *The Reign of William Rufus and the Accession of Henry the First*. Oxford: Clarendon Press, 1882.

Frei, Mathias. *St. Georgen ob Schenna*. Bozen: SB-Verlag, 1996.

Friesen, Ilse. *Frau am Kreuz*. Museum Stift Stams and Telfs: Hörtenbergdruck, 1998.

_____. "Saints as Helpers in Dying: The Hairy Holy Women Mary Magdalene, Mary of Egypt and Wilgefortis in the Iconography of the Middle Ages." In *Death and Dying: Testimony, Belief, Ritual and Imaging in the Late Middle Ages*, ed. Barbara Gusick and Edelgard DuBruck. New York: Peter Lang, 1999, 239–256.

Futterweit, Walter, Richard A. Weiss, and Richard M. Fagerstron. "Endocrine Evaluation of Forty Female-to-Male Transsexuals: Increased Frequency of Polycystic Ovarian Disease in Female Transsexualism." *Archives of Sexual Behavior* 15, 1 (1986): 69-78.

Gardner, Arthur. *English Medieval Sculpture*. New York: Hacker, 1973.

Gibson, Walter S. *Hieronymus Bosch*. New York: Praeger, 1973.

Gillman, Peter and Leni. *Alias David Bowie: A Biography*. London: Hodder and Stoughton, 1986.

Gimbutas, Marija. *The Language of the Goddess*. San Francisco: Harper, 1991.

Grabar, Andre. *Christian Iconography: A Study of Its Origins*. Princeton: Princeton University Press, 1968.

Greenblatt, Robert and Visendra B. Mahesh, eds. *Hirsutism and Virilism: Pathogenesis, Diagnosis and Management*. Boston: John Wright, 1983.

Gritsch, Johanna. *Axams-Tirol*. Munich and Zurich: Schnell & Steiner, 1983.

Gugitz, Gustav. *Das Jahr und Seine Feste im Volksbrauch Österreichs. Studien zur Volkskunde II*. Vienna: Hollinek, 1956.

_____. *Fest-und Brauchtumskalender für Österreich, Süddeutschland und Schweiz*. Vienna: Hollinek, 1955.

_____. *Österreichs Gnadenstätten in Kult und Brauch, 3: Tirol und Vorarlberg*. Vienna: Hollinek, 1956.

Hahn, Sylvia. *Neufahrn bei Freising*. Munich: Schnell and Steiner, 1983.

Hamburger, Jeffrey F. *Nuns as Artists: The Visual Culture of a Medieval Convent*. Berkeley: University of California Press, 1997.

Hausherr, Reiner. "Das Imerwardkreuz und der Volto-Santo Typ." *Zeitschrift für Kunstwissenschaft* 16 (1962): 129-167.

_____. "Volto Santo." In *Lexikon der Christlichen Ikonographie*, edited by E. Kirschbaum, 471-472. Freiburg: Herder, 1972.

Heffernan, Thomas. "The Passion of Saints Perpetua and Felicitas and the *Imitatio Christi*." In *Sacred Biography: Saints and Their Biographers in the Middle Ages*, 185-230. Oxford: Oxford University Press, 1988.

_____. *Sacred Biography: Saints and Their Biographers in the Middle Ages*. New York: Oxford University Press, 1988.

Heidinger. *Materialien zur Burghauser Geschichte (1860-1890)*, 1865.

Herrmann, Anne. "Passing Women, Performing Men." In *The Female Body: Figures, Styles, Speculations*, ed. Laurence Goldstein, 178-189. Ann Arbor: University of Michigan Press, 1991.

Hopkins, Jerry. *Bowie*. New York: Macmillan, 1985.

Huber, Johann Georg Bonifaz. *Geschichte der Stadt Burghausen in Oberbayern*. Burghausen: J. Lutzenberger, 1862.

Huber, Karl. "St. Kümmernis, eine Volksheilige." *Burghauser Geschichtsblätter* 15, 1925.

Illich, Ivan. *Gender*. New York: Pantheon, 1982.

Interpreter's Dictionary of the Bible, The. New York: Abingdon, 1962.

Jenny, Hans. *Kunstführer durch die Schweiz*. Wabern: Büchler, 1971.

Jung, Carl G., and Marie-Louise von Franz, Joseph L. Henderson, Jolande Jacobi and Aniela Jaffe. *Der Mensch und Seine Symbole*. Olten and Freiburg im Breisgau: Walter-Verlag, 1985.

Jung, E. *Germanische Götter und Helden in Christlicher Zeit: Beiträge zur Entwicklungsgeschichte der Deutschen Geistesform*. Munich: J.F. Lehmann, 1922.

Kaftal, George. *Iconography of the Saints in Tuscan Painting*. Florence: Sansoni, 1952.

Kannamüller and Siebert. *Neufahrn*. Freising: Frisingia, n.d.

Kempis, Thomas à. *The Imitation of Christ*. Translated by Betty Knott. London: Collins, 1965.

Kessler, Josef. *Basilika Unserer Lieben Frau. Rankweil/Vorarlberg*. Munich: Schnell & Steiner, 1990.

Kirschbaum, Engelbert. *Lexikon der Christlichen Ikonographie*. Freiburg im Breisgau: Herder, 1968-1974.

Koblenzer, Caroline S. *Hirsutism: Psychocutaneous Disease*. Orlando: Grune & Stratton, 1987.

Kraatz, Martin. "Die Kümmernis im Volto Santo?" In *Kirche Zwischen Schloss und Markt: Die Luthersche Pfarkirche St. Marien zu Marburg*, ed. H.-J. Kunst and E. Glockzin, 160-165. Marburg, 1997.

Kunstreisboek voor Nederland. Amsterdam: Van Kampen, 1965.

Lacey, J. Hubert. "Anorexia Nervosa and a Bearded Female Saint." *British Medical Journal* 285 (December 18-25, 1982), 1816-1817.

Leithe-Jasper, Manfred and Rudolf Distelberger. *Kunsthistorisches Museum, Wien: I: Schatzkammer und Sammlung für Plastik und Kunstgewerbe*. Munich: Beck, 1982.

Linfert, Carl. *Hieronymus Bosch*. Cologne: Du Mont, 1970.

MacLachlan, Bonnie. "The Cyprian Redeemed: Venereal Influence in Paradiso." Unpublished paper, Department of Classical Studies, University of Western Ontario, 1998.

_____. "The Ungendering of Aphrodite." Unpublished paper, Department of Classics, University of Western Ontario, 1998.

Maitland, Sara and Wendy Mulford. *Virtuous Magic: Women Saints and Their Meaning*. London: Mowbray, 1998.

Malkenson, Frederick D. and Roger W. Pearson "Disease of Hair and Nails and Related Studies," 311-314. *The Yearbook of Dermatology*. Chicago: Yearbook Medical Publishers, 1977.

Manguel, Alberto. *Reading Pictures: A History of Love and Hate*. Toronto: Alfred A. Knopf, 2000.

Margry, Peter Jan and Charles Caspers, eds. *Bedevaartplaatsen in Nederland*. Amsterdam and Hilversum: P. J. Meertens Instituut, 1997.

Marrow, James H. *The Golden Age of Dutch Manuscript Painting*. Stuttgart: Belser, 1989.

Mathews, Thomas F. *The Clash of Gods: A Reinterpretation of Early Christian Art*. Princeton: Princeton University Press, 1993.

Mauvais-Jarvis, P. *Hirsutism*. Berlin and New York: Springer, 1981.

McCourt, Frank. *Angela's Ashes: A Memoir of a Childhood*. London: Flamingo, 1996.

McNamara, JoAnn. "Sexual Equality and the Cult of Virginity in Early Christianity." *Feminist Studies* 3 (Spring/Summer 1976): 145-158.

Miles, Margaret R. *Carnal Knowing: Female Nakedness and Religious Meaning in the Christian West*. Boston: Beacon Press, 1989.

Newmann, Barbara. *From Virile Woman to WomanChrist: Studies in Medieval Religion and Literature*. Philadelphia: University of Pennsylvania Press, 1995.

Nightlinger, Elizabeth. "The Female *Imitatio Christi* and Medieval Popular Religion: The Case of St. Wilgefortis." In *Feminea Medievalia: Representations of the Feminine in the Middle Ages,* ed. Bonnie Wheeler, 291-328. Dallas: Academia, 1993.

_____. "Our Saint Died on the Cross like Christ: Socio-Cultural and Iconographical Problems Associated with the Genesis of St. Eulalia of Barcelona." Unpublished paper presented at the Thirty-First International Congress on Medieval Studies, Western Michigan University, May 1996.

Pächt, Otto and Dagmar Thoss. *Die Illuminierten Handschriften und Inkunabeln der Österreichischen Nationalbibliothek: Flämische Schule II*. Vienna: Verlag der Österreichischen Akademie der Wissenschaften, 1990.

Pattis, Erich and Eduard Syndicus. *Christus Dominator: Vorgotische Grosskreuze*. Innsbruck: Tyrolia, 1964.

Pillsbury, Donald M., Walter B. Shelley and Albert M. Kligman. *Dermatology*. Philadelphia and London: W. Saunders Company, 1956.

Plant, Fridolin. *Eine Volksheilige (St. Kummernus)*. Meran: F. Plant, 1897.

Potok, Chaim. *My Name Is Asher Lev*. New York: Ballantine Books, 1973.

Rabinowitz, Stanley (Shmuel), Robert Cohen and Dereck Le Roith. "Anxiety amd Hirsutism." *Psychological Reports* (1983): 827-830.

Rahner, Karl. "Mariology." *Encyclopedia of Theology: The Concise Sacramentum Mundi*. New York: Seabury Press, 1975.

Roberts, Michèle. *Impossible Saints*. London: Little, Brown and Company, 1997.

Sauser, Ekkhart. *Frühchristliche Kunst: Sinnbild und Glaubensaussage.* Innsbruck: Tyrolia, 1964.

Sayers, Dorothy, trans. *The Comedy of Dante Alighieri the Florentine: Cantica II Purgatory.* Harmondsworth, U.K. and New York: Penguin Books, 1983.

Schedel, Hartmann. *Schedelsche Weltchronik (Nuremberg World Chronicle).* Nuremberg, 1493.

Schlosser, Julius von. *Der Burgunder Paramentenschatz des Ordens des Goldenen Vliesses.* Vienna: Schroll, 1912.

Schnürer, Gustav, and J.M. Ritz. *St. Kümmernis und Volto Santo.* Düsseldorf: Schwann, 1934.

Schuler, Carol M. "The Seven Sorrows of the Virgin: Popular Culture and Cultic Imagery in Pre-Reformation Europe." *Simiolus* 21, 1/2 (1992): 5-28.

Schweizer-Vüllers, Regine. *Die Heilige am Kreuz: Studien zum Weiblichen Gottesbild im späten Mittlealter und in der Barockzeit.* Bern and Vienna: Peter Lang, 1997.

Secular and Ecclesiastical Treasuries: Illustrated Guide, The. Vienna Kunsthistorisches Museum, 1991.

Shakespeare, William. *The Tragedy of Macbeth,* edited by Sylvan Barnet. New York: Penguin, 1987.

Shinners, John, ed. *Medieval Popular Religion.1000-1500. A Reader.* Peterborough: Broadview Press, 1997.

Singer, June. *Androgyny: Toward a New Theory of Sexuality.* New York: Anchor Books, 1977.

Smith, William. *Everyman's Smaller Classical Dictionary.* London: J.M. Dent, 1956.

Spiess, Karl von. *Marksteine der Volkskunst.* Berlin: Stubenrauch, 1942.

Spranger, Peter. *Der Geiger von Gmünd: Justinus Kerner und die Geschichte einer Legende.* Schwäbisch Gmünd: Stadtarchiv, 1980.

Strayer, Joseph R., ed. *Dictionary of the Middle Ages.* New York: Scribner's Sons, 1984.

Sutton, Felix. *The Big Show: A History of the Circus.* New York: Doubleday, 1971.

Thurston, Herbert and Donald Attwater. *Butler's Lives of the Saints.* London: Burn and Oates, 1956.

Trapier, Elizabeth Du Gue. *Ribera.* New York: Hispanic Society of America, 1952.

Tremmel, Josef. "Der Kunstfreund." 1910/1911.

Unterkirchner, Franz. *Burgundisches Brevier: Die Schönsten Miniaturen aus dem Stundenbuch der Maria von Burgund (Codex Vindobonensis 1857).* Graz: Akademische Verlagsanstalt, 1974.

Unterkirchner, Franz and Antoine de Schryver. *Gebetbuch Karls des Kühnen vel potius Stundenbuch der Maria von Burgund, Codex 1857 der Österreichischen Nationalbibliothek.* Graz: Akademische Verlagsanstalt, 1969.

Vandenberg, Philipp. *Nofretete.* Bern: Scherz Verlag, 1975.

Verney, Peter. *Here Comes the Circus.* New York: Paddington Press, 1978.

Voragine, Jacob of. *Golden Legend.* Translated by Granger Ryan and Helmut Ripperger. New York: Arno Press, 1969.

Vos, Dirk de. *Hans Memling: The Complete Works*. London: Thames and Hudson, 1994.

Walker, Barbara G. *The Woman's Encyclopedia of Myths and Secrets*. San Francisco: Harper & Row, 1983.

_____. *The Women's Dictionary of Symbols and Sacred Objects*. San Francisco: Harper, 1988.

Warner, Marina. *From the Beast to the Blonde: On Fairy Tales and Their Tellers*. London: Chatto & Windus, 1994.

Weitzmann, Kurt. *The Icon: Holy Images – Sixth to Fourteenth Century*. New York: George Braziller, 1978.

Whitlock, Francis Antony. *Psychophysiological Aspects of Skin Disease*. London: W.B. Saunders, 1976.

Williams, David. *Deformed Discourse: The Function of the Monster in Medieval Thought and Literature*. Montreal and Kingston: McGill and Queen's University Press, 1996.

Wilson, Emma, ed. *Sexuality and Masquerade: The Dedalus Book of Sexual Ambiguity*. Sawtry, CB, UK: Dedalus, 1996.

Wimmer, Otto. *Handbuch der Namen und Heiligen*. Innsbruck: Tyrolia, 1959.

Wittgräfe, R. "Kümmernis ist 50 Jahre bei St. Konrad." *Burghauser Anzeiger* 300, New Year 1987/1988.

Woodman, Marion. *Leaving My Father's House: A Journey to Conscious Femininity*. Boston: Shambala, 1993.

_____. *The Pregnant Virgin: A Process of Psychological Transformation*. Toronto: Inner City Books, 1985.

Wrede, A. "Kümmernis." *Handwörterbuch des Deutschen Aberglaubens*. Berlin: W. De Gruyter, 1987, Vol. 5.

Zänker, Jürgen. *Crucifixae: Frauen am Kreuz*. Berlin: Mann, 1998.

Zimmerman, Odo John. *Saint Gregory the Great: Dialogues*. New York: Fathers of the Church Inc., 1995.

Index

Date Due